CHEMISTRY
and *Art*

Second Edition

Anne Gaquere-Parker | Cass Parker
University of West Georgia | Clark Atlanta University

Kendall Hunt
publishing company

Cover image © Shutterstock, Inc.

Kendall Hunt
publishing company

www.kendallhunt.com
Send all inquiries to:
4050 Westmark Drive
Dubuque, IA 52004-1840

CONTENTS

ACKNOWLEDGMENTS

The authors would like to thank, for this second edition, Jill Stallings for her words of encouragement as always, Warren Andrew Vinyard and Todd Kaminski for creating questions for each chapter and Brett J. Kimbrell for working them out. Also, the authors are very grateful to chemistry professor Dr. Patricia Hill at Millersville University for having developed and facilitated NSF-funded chemistry and art workshops, which were the starting point of this adventure. Finally, the authors would like to acknowledge NSF support for the development of a chemistry and art laboratory course that is linked to this project (TUES#1043847). Although no funds were received to write this textbook, the momentum created by teaching the laboratory course is greatly appreciated.

INTRODUCTION

Art surrounds us, gives us pleasure, and provides a certain vibrancy that fuels us in its many forms. But some might ask, how? How did we achieve the vibrant colors, the lasting works? What is the future of these works? This book was written with the intent of providing students with the relationship and use of chemistry and science in general in the production of works of art. The focus is to give the reader an understanding of chemical principles that are important and necessary when one looks beyond the beauty and vibrancy of a work of art. This book is not intended to supplant a regular chemistry book, but to provide the reader with an understanding of terminology and science phenomenon that drive our senses and answer some basic questions. Why do we see colors? What are chemicals that produce colors? How were these materials made? What is the chemical difference between paint binders? Of what is bronze made?

The book has sections to provide the student with the basic concepts of light, the construct of atoms and matter, elements of the periodic chart, ionic compounds, oxidation-reduction, acids and bases, nuclear chemistry, an introduction to organic chemistry and polymers, and, finally, techniques used in the analysis of works of art. These topics were chosen so that students will be able to understand and perhaps look deeper into the physiochemical makeup of a work of art and realize that beauty is not just in what we view but what we understand.

Light and Color

HUMANS AND LIGHT

Light, its many description and effects, has always been a part of what humans revere and sometimes fear. Historical evidence shows that since earliest known history human beings have always found themselves drawn to the power of light. As a simple example, we can look at the Incas Sun God or King Louis XIV at the castle of Versailles where he chose the sun as his emblem. This occurred when young Louis XIV had to play the sun in the "Ballet de la Nuit." After that performance, he decided to choose the sun as his symbol and had it represented in many places at the castle like on the golden gate shown below. The sun was associated with Apollo, the god of peace and arts, and was the heavenly body that gave life to all things, regulating everything on earth as it rose and set, a perfect symbol for an almighty king.

Light is also the symbol of great developments in knowledge and its propagation, so when in 18th-century Europe, Diderot and D'Alembert, with contributions from Voltaire and Rousseau, among others, wrote the first encyclopedia when scientific discoveries were made, this overall movement was called the enlightenment.

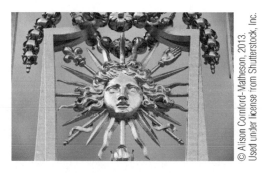

During our modern age, light can be produced from a variety of sources and has led humans to create an endless day scenario. When looking at the night sky in the city, the viewer sees very few stars, but as the viewer ventures away from the city, more stars are seen. What has changed is the amount of ambient light that interferes with the viewer's ability to see very dim lights, like the stars. This phenomenon that prevents people, but also astronomers, from observing the night sky is called light pollution, and it explains why observatories are always away from urban centers. Humankind has indeed adopted the permanent day scenario as more and more of each continent at night shows less and less absence of light, darkness, with each passing year.

Where does light actually come from? Light is emitted directly from luminous objects as the result of chemical or nuclear reactions or electromechanical excitation of electrons. Light is the energy that is being emitted. The luminous objects we see are the stars, the sun, or a flame. On the other hand,

Table 1.1 Units of light as an electromagnetic wave

	Definition	Unit
Frequency	Number of oscillations per second	Hertz, Hz
Wavelength	Distance between two consecutive identical points, like two crests	Meter, m
Amplitude	Distance between the x-axis and the crest, it measures intensity	Lumen, lm

we also receive or see light from illuminated objects, those objects that reflect externally supplied light, like the moon. In the ancient times, certain Greek philosophers, including Plato (427–347 B.C.E.) believed that one could see because the eye emits light rays from within.

DEFINITION OF LIGHT

Light can be described as an electromagnetic radiation, a form of energy that has both an electrical field component and a magnetic field component perpendicular to each other (Figure 1.1). Electromagnetic radiations are characterized by their speed, noted as c, frequency noted by the Greek letter υ (pronounced nu), wavelength also noted by a Greek letter λ (pronounced lambda), and amplitude A.

Although amplitude always measures the intensity of a wave, its unit depends on the type of wave studied. In the case of light, the intensity measured is the brightness and the unit is lumen. Frequency and wavelength are inversely proportional and are related to each other by the speed of light c:

$$\upsilon = c/\lambda$$

Although the official unit for wavelengths is the meter, it is often measured in nanometers, a much smaller but more appropriate unit. Nano is derived from the Greek word *nanos*, or dwarf, and carries the definition of $1/1000000000$ or 10^{-9}, so a nanometer is 10^{-9} of a meter or .000000001 meter or 1 nm. The waves in Figure 1.2 all have the same amplitude, but their wavelength and frequency are different: Going from left to right and from top to bottom, the wavelength decreases and therefore the frequency increases.

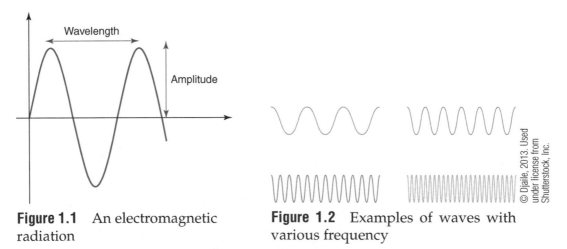

© Djaile, 2013. Used under license from Shutterstock, Inc.

Figure 1.1 An electromagnetic radiation

Figure 1.2 Examples of waves with various frequency

Learning Check

1. If an electromagnetic wave has a frequency of 3.0×10^{19} Hz, what is its wavelength? The speed of light is rounded up to $c = 3.0 \times 10^{8}$ m/s.

 Ans: Start with the formula:

$$\lambda \upsilon = c$$

To solve for the wavelength, divide both sides by frequency:

$$\lambda = \frac{c}{\upsilon}$$

Then plug in the given values:

$$\lambda = \frac{3.0 \times 10^8 \ \text{m/s}}{3.0 \times 10^{19} \ \text{Hz}} = 1.0 \times 10^{-11} \ \text{m}$$

2. The wavelength of a green light is found to be 532 nm (5.32×10^{-7} m). What is the frequency of this light? The speed of light is rounded up to $c = 3.0 \times 10^8$ m/s.

 Ans: Start with the general formula:

$$\lambda \upsilon = c$$

To solve for the frequency, divide both sides by the wavelength:

$$\upsilon = \frac{c}{\lambda}$$

Then plug in the given values:

$$\upsilon = \frac{3.0 \times 10^8 \ \text{m/s}}{5.32 \times 10^{-7} \text{m}} = 5.6 \times 10^{14} \ \text{Hz}$$

This relationship shows that as the wavelength becomes longer, the frequency is shorter, or as the wavelength becomes shorter, the frequency is higher. In looking at the wavelength of light, one should be familiar with how light is described. Light may be considered to be low frequency and long wavelength and low energy or high frequency and short wavelength and high energy. Depending on its frequency or wavelength, the type of radiation differs. The wavelengths that we see and refer to as light takes up only a very short segment of the total electromagnetic spectrum. What we refer to as light takes up the region from 380–750 nm, visible light, as shown in Figure 1.3.

Since the longer a wavelength of light, the lower its frequency, and vice versa, and since the wavelength for ultraviolet is 400 nanometers long, it is a very high-frequency wave. Just the opposite, the wavelength for infrared is 750 nanometers, a longer wavelength and thereby a lower frequency wave, just a bit lower than we can see; that's why it works well in TV remote controls. Since British scientist Isaac Newton (1642–1727) separated white light with a prism into its individual components, it is known that white light contains many colors, all of which have a different wavelength (Figure 1.4).

The relationship between frequency and energy is seen in the following expression, $E = h\upsilon$, and given that we previously stated that the speed of light can be seen as $c = \upsilon \lambda$, the above equation can also be written as $E = hc/\lambda$. In the above equations, E is the energy of a photon, h is Planck's

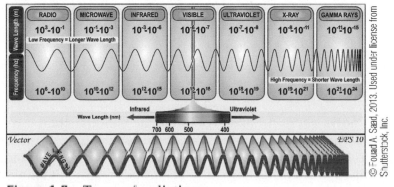

Figure 1.3 Types of radiations

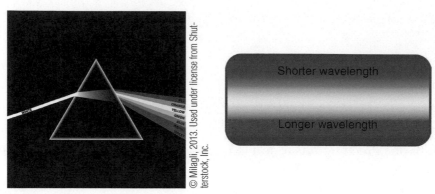

© Milagli, 2013. Used under license from Shut-terstock, Inc.

Figure 1.4 Light dispersion through a prism

constant (6.626 × 10⁻³⁴ Joule second), c is the speed of light (2.998 × 10⁸ meters per second), λ is the wavelength in meters, and υ is the frequency in per seconds. The visible range that we can see shows that the red end of the spectrum from 650–750 nm is of longer wavelength than the violet-blue end from 380–490 nm that is of shorter wavelength. A photon of energy at the blue end of the spectrum is more energetic than one at the red end.

Learning Checks

1. Calculate the energy of a light wave that has a frequency of 1.0×10^{17} Hz.

 Ans: Since the frequency is given, the following equation should be used:

$$E = h\upsilon$$

 where $h = 6.626 \times 10^{-34}$ J /s and $\upsilon = 1.0 \times 10^{17}$ Hz $= 1.0 \times 10^{-17}$ s⁻¹:

$$E = (6.626 \times 10^{-34} \text{Js}) (1 \times 10^{17} \text{s}^{-1}) = 6.626 \times 10^{-17} \text{J}$$

2. Calculate the energy of a light wave that has a wavelength of 1.0×10^{-11} m.

 Ans: Since the wavelength is given, the following equation should be used:

$$E = hc/ \lambda$$

 where $h = 6.626 \times 10^{-34}$ J/s, $c = 3.00 \times 10^{8}$ m/s and $\lambda = 1.0 \times 10^{-11}$ m:

$$E = 6.626 \times 10^{-34} \text{ Js } 3.00 \times 10^{8} \text{m}/\text{s} 1.0 \times 10^{-11} \text{m} = 2.0 \times 10^{-14} \text{ J}$$

3. Calculate the energy of a blue light with a wavelength of 646 nm (6.46×10^{-7} m). The speed of light is rounded up to $c = 3.0 \times 10^{8}$ m/s and Plank's constant is $h = 6.62 \times 10^{-34}$ J/s.

 Ans: The formula to solve this problem is:

$$E = \frac{hc}{\lambda}$$

$$E = \frac{(6.626 \times 10^{-34} \text{ J}/\text{s})(3.0 \times 10^{8} \text{ m}/\text{s})}{6.46 \times 10^{-7} \text{m}} = 3.1 \times 10^{-19} \text{ J}$$

Consider what one knows about a flame: A blue flame is hotter than a red flame. Light and temperature are related, because as temperature increases, "white light" is emitted from the object. This simply means that more wavelengths are emitted from hotter objects than from cold objects. Color temperature is defined in scientific terms as a black body—a hypothetical object that absorbs all of the energy that falls on it. In theory, a black body will also emit all wavelengths. When heated, the black body emits different wavelengths, i.e., colors, as the temperature increases. At first, it will

turn red, then yellow, then white, and ultimately blue and violet (Figure 1.5). The temperature at which the black body matches the colors emitted by a given light source is said to be the color temperature of that light. The result of this relationship can be seen in the temperature of a light and photography. Many times one takes a picture in what seems to be normal, white light. However, when the photo is reviewed, the colors are not normal. If a given wavelength is not being emitted, that wavelength, color, will not be recorded and seen in the photograph. This is the reason that many times the color of a photograph is not correct.

The temperature scale noted in the relationship is the Kelvin temperature scale. The Kelvin temperature scale was devised by Scottish scientist Lord William Thomson Kelvin (1824–1907) in the late 1800s. The Kelvin temperature scale precisely defines absolute zero and does not depend on the properties of any substance (most other scales are in some way related to the behavior of water). The relationship between the Kelvin scale and the Celsius scale is:

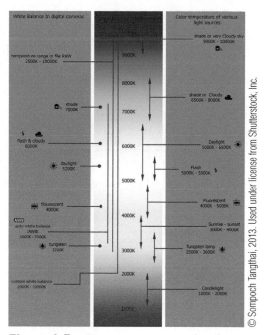

Figure 1.5 Temperature and color relationship

$$K = °C + 273.15$$

When discussing light, one must venture into the physics of light. Light has properties that make it unique from many perspectives. In the next section we will present a short discussion of the properties of light: *reflection, transmission, refraction, dispersion, total internal reflection, diffraction, polarization,* and *interference.*

Learning Checks

1. With respect to a black body emitter, describe the relationship between heat, color. and light.

 Ans: A black body absorbs all frequencies of light, and as temperature increases, the black body will emit higher energy light waves. The color of light that an object is emitting is directly related to the temperature of an object; this is why it is possible to know the amount of heat produced by different colored stars. Black bodies are used to correlate temperature with the frequency of light emitted.

2. Convert 112.85°C to Kelvin.

 Ans: Use the following equation to convert from Celsius to Kelvin:

 $$K = °C + 273.15$$

 $$K = 112.85° + 273.15 = 386 \text{ K}$$

3. Absolute zero, 0 Kelvin, is the temperature at which all molecular motion stops. What is this temperature in Celsius?

 Ans: The formula to solve this problem is:

 $$°C = K - 273.15$$

 Therefore:

 $$°C = 0 - 273.15 = -273.15 °C$$

 273.15 °C is absolute zero.

PROPERTIES OF LIGHT

Reflection

Reflection is when light bounces off of an object. Reflection is considered as specular or diffused. Specular light reflection occurs when the surface is smooth and shiny, like still water or polished metal. Here the light will reflect at the same angle as it strikes the surface. However, sometimes the surface is not smooth and the light is scattered in many different directions upon reflection. When light is reflected in this manner, we refer to it as *diffused reflection* of light. When diffused light hits an object, it reflects in angles different from that of the original incident ray because the surface is rough, making the reflected image distorted (Figure 1.6).

Learning Check

1. From what you just read, explain why it is important for mirrors to have smooth uniform surfaces.

 Ans: On the microscopic level, most surfaces are very rough, appearing almost mountainous with peaks and valley. These peaks and valleys cause the light to reflect at different angles, producing distorted images. Mirrors are shaped and polished so that the surface is relatively flat, ensuring that light rays will reflect at similar angles. Household mirrors still have some imperfections, but they are not noticeable to the human eye. However, the mirrors used in telescopes must be almost perfectly smooth—in fact, if the mirror used in the Hubble telescope was made to the scale of the earth, the largest difference in height from the lowest point to highest would only be about 13 cm.

Transmission

Transmission refers to the ability of light to pass through a particular material. In the process of passing through that material, we consider if there is any interaction. In the case where light passed through with little or no interference, we consider the material to be transparent. Transparent material allows light to pass through, and we can see what is on the other side distinctly. Materials such as glass, water, or air do not interact with light significantly via absorption or scattering and are considered to be transparent. Transparency for these materials varies as each has a different level of interaction with light. For instance, sunlight can travel up to 1,000 meters below the surface of the ocean, depending on conditions. However, very little light is seen below 200 meters due to the absorbing nature of water. Air by its nature allows light to pass significantly further without distortion or loss.

If the light passes through a material, but is reflected at multiple surfaces in multiple directions, scattered, one can ascertain that there is an object on the other side, but cannot determine what the object is. Multiple deflection points within a material are caused by irregular surfaces in the materials, and the material is considered translucent. Examples of translucent materials are wax paper, frosted glass, and some plastics.

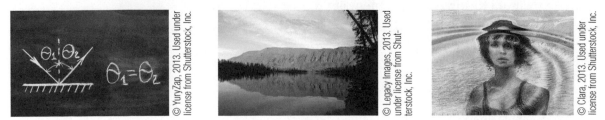

Figure 1.6 Angle of reflection of light, examples of specular and diffused light

If the material completely reflects or absorbs light, it is called opaque. These materials do not transmit any light at all, so it is impossible to see what is on the other side. Examples of opaque objects include wood, metal, and any other objects that allow no light to pass through.

In describing materials' interaction with light as being transparent, translucent, or opaque, what was considered was the property of deflection or absorption. In certain cases, due to the chemical nature of the material, transmission may be limited to certain wavelengths. These waves penetrate the object for a certain distance and are absorbed by the object.

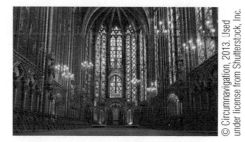

Figure 1.7 Sainte Chapelle in Paris

The wavelengths that are not absorbed are transmitted. The transmitted wavelengths are the colors that we see. By utilizing these properties, one can create spectacular works such as the stained glass in Gothic-style cathedrals or churches, like the Sainte Chapelle in Paris (Figure 1.7).

Learning Checks

1. How do structural irregularities affect the way in which light passes through an object?

 Ans: Structural deformities such as cracks or abrasions contribute to the amount of scattering and interference that occurs when a light beam hits the surface; also, internal irregularities can lead to more interference.

2. How do stained glass windows produce such a large array of colors?

 Ans: Certain chemicals are added to the glass while it is being made During the heating process, the chemicals combine with the glass, forming a structure that only allows certain wavelengths of light to pass through it.

Refraction

Refraction is the bending or change in direction of light as it passes from a medium of one density into another medium of different density. When describing the interaction of light with materials, one of the properties not discussed earlier is the variation in the speed of light through different materials. Light travels fastest through a vacuum and slows when it moves through more dense matter or matter with a higher refraction index. The change in speed of light can be measured as the refractive index of matter. The *refractive index* is a quantitative measure of the bending of light that can be used to identify the material. The higher the refractive index of the material, the more the light is bent by matter. A few examples are listed below in Table 1.2.

Table 1.2 Refraction index of different media and corresponding speed of light

Medium	Refraction index	Speed of light
Vacuum	1.0000	2.99×10^8 m/s
Water	1.333	2.25×10^8 m/s
Crown Glass	1.52	1.97×10^8 m/s
Diamond	2.417	1.24×10^8 m/s

This slowing gives rise to the property commonly referred to as refraction. When light rays enter a new medium at an angle, it refracts, or bends. This happens because the speed that the light is traveling changes making the light change direction. You probably have seen refraction take place when you've been swimming. Objects on the bottom of the pool look different because the light reflected off them changes direction when it leaves the water and begins traveling through air. A common effect of this action is seen when looking at a spoon in a glass of water and it appears to be broken or cut (Figure 1.8). Another example would be the observed location of a fish underwater versus its actual location.

Figure 1.8 Example of refraction of light in everyday life

Learning Check

1. What affect does the density of a medium have on refraction?

 Ans: The refractive index is a measurement of how much bending occurs when a beam of light travels from one medium to another. Denser mediums cause light to bend more. This is because the speed of light decreases as it travels from a low-density medium to a high-density medium.

Dispersion

Because light bends differently according to its wavelength, blue light is bent more than red light. Thus, when white light passes through a prism, it produces a rainbow spectrum. This difference in refraction as a function of wavelength is the concept behind prisms (recall white light dispersion by Isaac Newton [Figure 1.4]).

What is clearly observed here with white light is that higher frequencies of light (shorter wavelengths) are bent more than lower frequencies of light; again, the blue light is dispersed more than red light.

Learning Check

1. Why does blue light bend more than red light?

 Ans: Because higher frequencies of light bend more than lower frequencies; red light (lower frequency) bends less than blue light (higher frequency).

Total Internal Reflection

If the light hits the interface at a certain angle, it will not pass through to the second medium at all. Instead, all of it will be reflected back into the first medium, a process known as total internal reflection. Total internal reflection is the principle behind fiber optics, a transparent fiber made of high purity glass coated with plastic that is used to carry light large distances (Figure 1.9). When the light is shone on the glass at a shallow angle, almost parallel to the glass, it is totally reflected and can be carried for miles. Modern telecommunication systems use lasers that can carry the information for up to 60 miles, after which the signal is reinforced and resent further.

Figure 1.9 Fiber optic

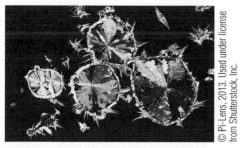

Figure 1.10 Crystals of citric acid under polarized light

Learning Check

1. Fiber optics relies on what process to transfer light over long distances?

 Ans: Fiber optics relies on total internal inflection to transfer light over long distances.

Polarization

Light propagates from its source normally in all directions. Light propagating at 360° or in all planes is referred to as non-polarized light. If the light is allowed to propagate in only one plane, it is referred to as polarized light. Light can be polarized by using special filters that allow it to pass in only one particular plane. Most are familiar with polarized sunglasses that remove glare. Glare is light scattered in multiple directions. The use of a polarizing filter restricts light transmission to a limited direction and the scattered light, or glare, is removed. In reality, it is absorbed by the polarizing material. This polarizing effect has a number of uses. For instance, some chemicals display specific color patterns when viewed with a microscope fitted with a polarized filter and can be identified that way. Figure 1.10, a picture of crystals of citric acid under polarized light clearly illustrates this phenomenon.

Not only can chemicals be analyzed for identity, purity, or defects, but fibers can also be studied that way. This technique is not only of great use for forensic science, but also in art conservation when the scientist has to identify a textile before cleaning or repairing it.

Learning Check

1. What is the difference between plane polarized light and non-polarized light?

 Ans: Non-polarized light can be thought of as propagating in a spherical pattern in all directions. Plane polarized light only propagates in one plane and does not produce a spherical pattern.

Diffraction and Interference

Light can be bent when dispersed through a prism, for example, as discussed earlier. Another way to create this rainbow effect is with diffraction. Diffraction is the bending of light as it passes through a narrow opening or past a sharp edge of an object. In a similar way to dispersion, short wavelength light is bent more than long wavelength light. Unless there is only one narrow opening, diffraction is always accompanied by interference. Interference is easily observed with mechanic waves, waves created by throwing a pebble on a water surface. If one throws two pebbles on the surface, the two waves will interact and interfere, creating a resulting wave that has higher crests and lower troughs than the original ones had separately. A similar effect can occur with electromagnetic waves like light. If light is passed through two slits as in Figure 1.11, the resulting light waves will

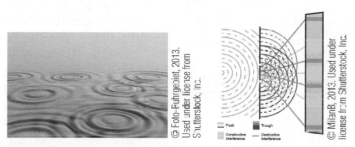

Figure 1.11 Interference on a water surface and on a screen

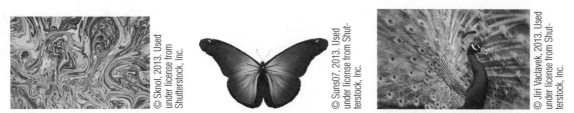

Figure 1.12 Combination of diffraction and interference in everyday life

interfere, creating patterns on a screen where the intensity will be sometimes stronger (constructive interference) or lower (destructive interference).

This combination of phenomena is observed when one looks at a compact disc, a soap bubble, nacre on seashells, butterfly wings, or at certain bird feathers (Figure 1.12).

Learning Check

1. What type of interference is occurring if the interaction of two light waves produces a pattern that has a lower intensity than that of the two original waves?

 Ans: Destructive interference means that the interaction of the two waves creates a new pattern that has a lower intensity than that of the original wave pattern.

APPLICATION OF LIGHT PHENOMENA TO GEM CUTTING

To conclude this chapter, let's discuss briefly the application of the phenomena observed with light to the field of gemology. When gemologists cut a gem, they need to ensure the results will produce a dazzling effect. Three properties are used to describe a gem: *brilliance*, which is the return of light; *fire*, which corresponds to the dispersion of light; and *twinkling*, which is the scintillation. Brilliance is obtained when light rays are caught and sent back to the viewer, what we earlier called reflection. Fire is the ability of the gem to create a rainbow effect when light passes through, what we called dispersion. This dispersion is only important for diamonds, a material with a high refractive index (other gems have only very little dispersive power). Finally, the twinkling effect is linked to diffraction and interference (Figure 1.13). All these characteristics can only be achieved if the gem is cut in a perfect way, in terms of shallowness and number of facets.

COLOR THEORY AND HISTORICAL FIGURES

Figure 1.13 Light and a gem

Colors are characterized by their hue, their brightness, and their saturation. In terms of electromagnetic light, the hue corresponds to the wavelength, the brightness or value to the amplitude of the wave, and the saturation to the monochromaticity of the color, in other terms, to its purity or chroma. A saturated hue has one dominant wavelength and as the color is desaturated, it looks grayer or less pure as other colors are mixed.

In Ancient Greece, Greek philosopher Aristotle (384–322 B.C.E.) developed the first known theory of color. Aristotle believed that there were seven simple colors and that any of the other colors

could be produced from these colors by blending with black or white paint: yellow, red, purple, green, blue, white and black. He also postulated that God sent to Earth the colors from the heavens. He also associated four colors with the four elements: earth with black, fire with white, air with red, and water with yellow. Several centuries later, Italian renaissance scholar Leonardo da Vinci (1452–1519) (Figure 1.14) was the first to suggest an alternative color system. In his "Treatise on Painting," he associated light with white, darkness with black, earth with yellow, water with green, fire with red, and air with blue, a system of color that is closer to what we are used to nowadays.

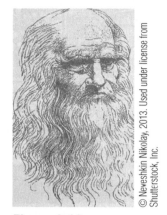

Figure 1.14
Leonardo da Vinci

But it is not until 1666 that Sir Isaac Newton, as explained earlier, dispersed white light using a prism, showing that it is made of various colored lights. He then recombined them to produce white light again, demonstrating it was not a destructive process, but just a mixing of lights. He coined the word *spectrum* to describe this array of colors. German artist and writer, Johann Wolfgang von Goethe (1749–1832) then added in 1810 an emotional aspect to the physical description of light by Newton, asserting colors of an object depend on the object itself, the lighting, and our own perception. He created his own color wheel.

COLOR SYSTEMS

Colors seem to be quite subjective; however, artists, paint industries, printmakers, interior designers, and dye industries, to cite only a few, need to be able to quantify it in a less subjective way. So color systems and classifications were invented. It is not our goal here to describe in details all of them, but just to give an idea of what some of them are. For instance, the Munsell color tree and the CIE (Commission Internationale de l'Eclairage) chromaticity diagram (which has been replaced by the L.A.B. color system) provide a way to quantify color by the use of various axes and data. This allows for a precise matching of the colors. One example of such a system is shown in Figure 1.15.

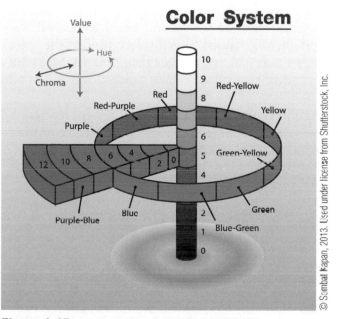

Figure 1.15 Example of a color system

Primary, Secondary, and Complementary Colors

In traditional color theory used in paint and pigments, the primary colors are the three pigment colors that cannot be mixed or formed by any combination of other colors. The other colors, called secondary colors, have to be derived from these three hues. A primary color can be mixed with another primary color to produce a secondary color. Mixing a secondary color with the nearest primary color produces a tertiary color, and further combinations lead to a broader variety of colors. A complementary color is the color located across the color wheel from that initial color (Figure 1.16).

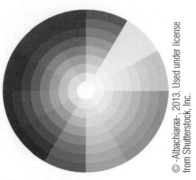

Figure 1.16 Primary, secondary, and complementary colors

A common misconception is to believe that yellow, red, and blue are the primary colors. However, this is not quite the case, and it actually depends on what is being studied: pigments or light.

CYMK: The Subtractive Color Mixing for Pigments, Paints, and Inks

The color red can be produced by mixing magenta and yellow pigments, and the color blue can be produced from cyan and magenta pigments, so neither red nor blue are primary colors when discussing pigments. Cyan, magenta, and yellow are the primary colors in this subtractive system. A *subtractive system* means that the color we see is what is reflected by the pigment after the pigment has absorbed colors from white light; a pigment thereby acts as a filter. For instance, a red pigment absorbs all colors but red, a green pigment absorbs all colors but green and so forth. Moreover, if one were to mix cyan, magenta, and yellow pigments together, they would all remove the color complementary to them, creating a black color, i.e., the absence of color since nothing is being reflected, indicated with the letter K for black in the acronym.

RGB: The Additive Color Mixing for Colored Lights

Yellow light can be produced by mixing green and red light; cyan light can be produced by mixing green and blue light; magenta light can be produced by mixing red and blue light. According to the definition of a primary color, it means that with light, red, blue, and green are the primary colors. This system is called the RGB additive system because when starting with no light, and gradually adding red, green, and blue, the desired color is obtained. When all the colored lights are added together, it forms white light, just like when Newton recombined the colors of the rainbow with his prism. Computer monitors, TV screens, techniques using pixels, Maxwell disks, and the four-color process printing all use the additive system where colored lights are added and mixed until the desired color is obtained.

Note that by comparing the two systems in Figure 1.17, subtractive CMYK and additive RGB, they are exact opposites one of the other. Note also that the pair of complementary colors of light and pigments are the same: red and cyan, magenta and green, yellow and blue. A final difference between the two systems is that the subtractive one provides for a less intense aspect since colors are filtered off, whereas the additive one provides a stronger intensity since the colors are added.

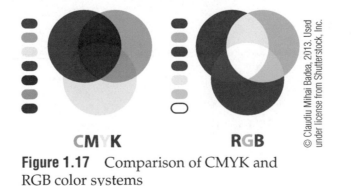

CMYK　　　　**RGB**

Figure 1.17 Comparison of CMYK and RGB color systems

The Special Case of Pointillism

Pigments in paints can be made to behave as additive colors. In order to do so, the artists do not mix the colors on the palette prior to applying them, but they place dots of pure color on the canvas. In that case, and from a distance, the viewer's eye combines the colors and sees the additive result. This technique is referred to as *pointillism*. French neoimpressionist painter George Seurat (1859–1891) spent his life studying color theories and developed this style of painting known as pointillism, painting more than 500 works of art. Some of his most famous paintings include "Bathing at Asnieres," "A Sunday Afternoon on the Island of la Grande Jatte," and "Le Chahut or Poseuse de Profil," which is shown in Figure 1.18 as an illustration on a stamp.

Figure 1.18 "Le Chahut or Poseuse de Profil" (Seurat) on postage stamp

LIGHT SCATTERING AND OPACITY IN PAINTINGS

The scattering of light by the pigments in a painting controls its opacity. The scattering can be increased by modifying the particle size, down to 0.2 micrometers (or 200 nanometers), which corresponds to half the wavelengths of the colors found in white light. To understand this phenomenon, let's consider glass. A perfect piece of glass is transparent, but as the glass is broken down, it appears to be more opaque. When the glass is actually ground to a powder, it appears completely opaque.

Another factor that affects light scattering is the difference of refractive indices between the paint binder and the pigment. If the two are very different, light will be highly scattered, making for an opaque effect, but if the two indices are similar, the paint will appear to be transparent because of the low scattering. This also explains why sometimes paintings become more transparent as they age, because the refractive index of the paint changes as it ages, thus allowing for the apearance of underlayers and corrections that the painter added when the work of art was created.

PROBLEMS

1. Calculate the frequency of a light wave that has a wavelength of 9.8×10^{-10} m.

2. If an electromagnetic wave has a frequency of 5.6×10^{17} Hz, what is its wavelength?

3. Calculate the energy of a light wave that has a wavelength of 2.3×10^{-7} m.

4. What is the frequency of a light wave that has energy of 3.4×10^{-18} J?

5. How does the Kelvin temperature scale differ from the Celsius scale? In what ways are they similar?

6. Which is hotter, a blue flame or a red flame?

7. In your own words, describe a black body emitter.

8. In your own words, describe the process of reflection.

9. What is the difference between specular and diffused light reflection?

10. Describe the difference between transparent, translucent, and opaque.

11. In your own words, describe the process of refraction.

12. What is the refractive index?

13. If water is denser then air, what happens to the speed of light when it transitions from air to water?

14. Why does a beam of light separate into different colors when passing through a prism?

15. In order for internal reflection to occur, should the light source be shone onto a surface at steep or shallow angle?

16. What does the term *polarized* mean with respect to light?

17. In what way is polarized light useful for studying art?

18. In your own words, describe the effects of diffraction and the difference between constructive interference and destructive interference.

19. Who created the first color wheel?

20. What is the difference between primary, secondary, and complementary colors?

21. What is meant by the term *subtractive* when referring to subtractive color mixing?

22. Compare subtractive color mixing for pigments with that of additive color mixing for light.

23. Describe how pigments can be made to behave as additive colors.

24. Who is given credit for developing pointillism?

25. How does particle size relate to the amount of scattering?

ANSWERS

1. Find v. Speed of light in a vacuum equation: $c = v \cdot \lambda$

 Given information: $\lambda = 9.8 \times 10^{-10}$ m. (Also, $c = 2.998 \times 10^8$ m/s)

 Rearrange the equation to solve for v. Now, $v = c/\lambda$.

 $v = (2.998 = 10^8 \text{ m/s}) / (9.8 \times 10^{-10} \text{ m/s}) = 3.1 \times 10^{17} \text{ 1/s} = \mathbf{3.1 \times 10^{17} \text{ Hz}}$

2. Find λ. Speed of light in a vacuum equation: $c = v \cdot \lambda$

 Given information: $\lambda = 5.6 \times 10^{17}$ Hz. (Also, $c = 2.998 \times 10^8$ m/s)

 Rearrange the equation to solve for v. Now, $\lambda = c/v$.

 $\lambda = (2.998 = 10^8 \text{ m/s})/(5.6 \times 10^8 \text{ Hz}) = \mathbf{5.4 \times 10^{-10} \text{ m}}$

3. Find E. Energy of a photon equation: $E = h \cdot v$.

 Given information: $\lambda = 2.3 \times 10^{-7}$ m. (hint: combine the speed of light and energy of a photon equations. They have a common variable in v.)

 Substitute (c/λ) into the variable, v, for the energy equation.

 Now: $E = (h \cdot c)/ \lambda$. Planck's constant, h, is $6.626 = 10^{-34}$ J·s

 $E = [(6.626 \times 10^{-34} \text{ J·s})(2.998 \times 10^8 \text{ m/s})]/(2.3 \times 10^{-7} \text{ m}) = \mathbf{8.6 \times 10^{-19} \text{ J}}$

4. Find v. Energy of a photon equation: $E = h \cdot v$.

 Given information: $E = 3.4 \times 10^{-18}$ J. Planck's constant, h, is $6.626 = 10^{-34}$ J·s

 Solve for v. $v = E/h$.

 $v = (3.4 \times 10^{-18} \text{ J})/(6.626 = 10^{-34} \text{ J·s}) = 5.1 \times 10^{15}/\text{s} = \mathbf{5.1 \times 10^{15} \text{ Hz}}$

5. The Kelvin temperature scale contains all positive values. 0 kelvin is considered absolute zero, and no temperature in the universe can drop any lower. However, the Celsius temperature scale can drop into negative values for its range. The relationship between Kelvin and Celsius temperatures is as follows:

 $K = C + 273$. As a each Kelvin value increases in temperature, the Celsius value increases proportionally. One can also observe from the equation that absolute zero temperature on the Celsius temperature scale would be −273 °C.

6. A blue flame is "hotter" than a red flame because blue light contains more energy than red light. A simple calculation with the energy of a photon equation can prove this conclusion. For example:

 Blue light is roughly 450 nm in wavelength. Red light is roughly 650 nm in wavelength.

 Solve for the energy of blue light, E_B, and the energy of red light, E_R.

 $E_B = [(6.626 \times 10^{-34} \text{ J·s})(2.998 \times 10^8 \text{ m/s})]/(4.5 \times 10^{-8} \text{ m}) = \mathbf{4.4 \times 10^{-18} \text{ J}}$

 $E_R = [(6.626 \times 10^{-34} \text{ J·s})(2.998 \times 10^8 \text{ m/s})]/(6.5 \times 10^{8} \text{ m}) = \mathbf{3.1 \times 10^{18} \text{ J}}$

 $E_B > E_R$, therefore, more energy is given off by a blue flame than a red flame.

7. A black body emitter is an object that absorbs all wavelengths of color light and emits all wavelengths of color light. You can see all of these different wavelengths of light as the black body emitter is heated. The relationship between color and temperature of emission is shown in Figure 1.5.

8. Reflection can be simply described as light bouncing or deflecting off the surface of an object. The object that is reflecting the light can have a smooth or inconsistent surface.

9. An object that possesses a smooth, shiny surface when light is shined upon is known as specular light reflection. This involves the light hitting the surface of the object and reflecting back on

the same angle. If the object does not possess a smooth surface, then the light that is shined upon this object will undergo diffused reflection where the light will not be reflected back in the original angle that it was shined upon. This phenomenon distorts the reflected image.

10. Transparent, translucent, and opaque are all different types of transmission. A transparent object will allow the transmission of light to pass completely through without any interference. A translucent object reflects light that is trying to pass through at multiple surfaces, which redirects the light in multiple directions. Irregular surfaces cause multiple deflections points to occur, which make up the light scattering process for translucent objects. Finally, if an object completely reflects or absorbs the incident light, then the material is considered opaque.

11. Refraction is the bending or changing direction of light as it passes between two mediums with different densities. Refraction also accounts for the slowing of light as it travels from a less dense medium to a denser medium.

12. The refractive index is a quantitative measure of how different mediums bend light as it passes through. The refractive index is measured in respect to a vacuum medium, which is 1.0000. No other medium can be less than 1.0000. The reasoning for this is in a vacuum system, there is no matter to interfere with the passing of light. However, as particles are added, the speed of light becomes increasingly hindered.

13. Since liquid water is significantly denser than gaseous air, water provides a medium that considerably inhibits the speed of light. The speed of light in a vacuum is 2.998×10^8 m/s. However, when light is taken outside of vacuum conditions and placed into a water medium, the speed of the light passing through is significantly slowed down due to the absorption and re-emission of the hydrogen and oxygen atoms between the molecules of water.

14. The reason why light that passes through a prism separates out into individual visible and invisible colors is because of refraction. As a single beam of light enters in one side of a prism, it undergoes refraction while passing through the prism. Each frequency of light, embedded in the incoming beam, slow down to a different speed while passing through the prism. This allows for the separation of light into individual sections as it exits the prism.

15. To increase the probability of obtaining total internal reflection, a shallow angle between the medium and the incident light must be obtained. As the angle between the incident light and the medium becomes smaller, the internal reflection becomes greater. This is the idea behind fiber optics.

16. Light from a light source propagates in all direction, which is considered non-polarized light. However, if a light source were able to only propagate light in a single plane, then the light can be considered plane polarized.

17. Plane polarized light can be used to identify different chemical components in pieces of art. Many chemicals absorb polarized light, which will display a distinct color pattern for the specific substance. The absorption of polarized light by a citric acid crystal demonstrates this phenomenon in Figure 1.10.

18. Diffraction, in simple terms, is how light or a beam of light behaves when it comes into contact with something that can impede the passing of light, or it describes the behavior in which light travels through a slit between two objects that impede its travel.

19. Sir Issac Newton is credited for inventing the first color wheel in 1666. However, Greek philosopher, Aristotle, and Italian renaissance scholar, Leonardo da Vinci, were credited for contributions to color theory. Sir Isaac Newton was the one that demonstrated the light dispersion through a prism to help support his theory in addition to recombining the dispersed light into white light with another prism.

20. Primary colors, in art, are the three colors that cannot be mixed/formed by the any combination of other colors. Secondary colors are derived from the different mixing of the three primary colors. Finally, complementary colors are two colors that are located directly across from one another on Newton's color wheel.

21. A subtractive color that we see is one that is reflected by a pigment after the pigment has already absorbed colors from white light. For example: A blue pigment absorbs all colors except blue.

22. The primary colors of subtractive mixing pigments are cyan, yellow, and magenta (CMYK system). The primary colors of additive mixing for colored light are red, green, and blue (RGB system). When the three primary colors for the CMYK system are mixed together (cyan, magenta, and yellow), the color yielded is black. However, for the RGB system, the mixing of red, green, and blue light results in the formation of white light. The subtractive system provides for a less intense aspect since the colors are filtered off, and the additive system allows for a stronger intensity since the colors are added.

23. Pigments in paint can be made to behave like additive colors. To achieve this, artist can place dots of pure color on the canvas, instead of mixing the colors on the palette prior to application. This process allows for the viewer's eye to combine the colors and see the additive result. This method is known as pointillism.

24. The French impressionist painter, George Seurat, is credited for developing the painting style known as pointillism.

25. The scattering of light by pigments in a painting controls its opacity. The scattering process can be increased by modifying the particle size. The example of glass is a great one. A "perfect" piece of glass is completely transparent. However, if we were to take that perfect piece of glass and grind it down into very small pieces, then the resulting glass would be completely opaque.

Matter and Atoms

MATTER

Every day, humans are in constant contact with matter: the food we eat, the car we drive, and the plants surrounding us. Any object is made up of matter. In fact, we ourselves are made up of matter. So what is matter? *Matter* is defined as anything that occupies space and has mass. *Mass* is a measure of the quantity of matter. Mass is not to be confused with weight because an object's weight depends on gravity and its mass does not. Matter can only be transmuted into energy or changed in its chemical composition. The permanency of matter is seen every day in the material around us or the art we view, be it from the last century or 30 centuries prior as seen in rock paintings from early man. When not transmuted into energy, we will come to understand that the change, or more specifically the lack of change, in composition is a distinguishing feature of chemical compounds (matter) that are used in art to create a lasting image for us to enjoy.

Different kinds of matter are distinguished by comparison of their properties. A property of any sample of matter is a characteristic that describes it. For example, human properties would be hair color, skin complexion, height, and so on. In general, a substance's properties can be broadly categorized as either a chemical property or a physical property. A chemical property defines the way a compound may react with another compound—in other words, its preference for undergoing a specific chemical reaction. One example of chemical properties would be that potassium, chemical symbol K, reacts in the presence of water, chemical formula H_2O, to form potassium hydroxide, chemical formula KOH, and hydrogen gas, chemical formula H_2. Hence, a chemical property of potassium is that it can react with water, and a chemical property of water is that it can react with potassium.

Physical properties are properties that are observed in the absence of a chemical reaction. Properties such as color, density, melting point, freezing point, ductility (whether a substance can be spun into wire), hardness, electrical and thermal conductivities are all examples of physical properties. It is interesting to note here that most physical properties can be directly obtained by simple measurements (Figure 2.1).

A practical way to distinguish between physical and chemical properties is to answer the following questions: Has the object been altered in a way that a new compound was obtained or is it only the appearance

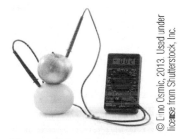

Figure 2.1 Measuring the electrical conductivity of fruits

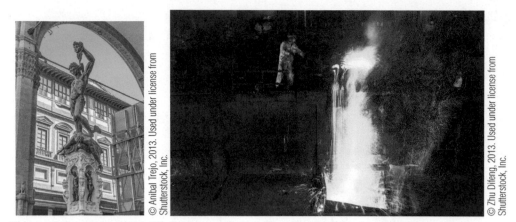

Figure 2.2 Perseus with Medusa's head sculpture and molten metal

Figure 2.3 Liquid and solid states of matter

that has changed? In other words, has the chemical nature of the object been changed? If so, then it was a chemical change and the property affected was a chemical property. For instance, when a mixture of copper and tin is heated so as to melt it and pour it as a liquid into a mold during the production of a bronze sculpture, the change is physical. The mixture of copper and tin is still a mixture of tin and copper regardless if it is a solid or a liquid. However, when the bronze sculpture is left outside for some period of time, it will develop a green patina, which represents a chemical change since the copper and tin mixture has been chemically changed by reacting with oxygen and carbon dioxide in the air (Figure 2.2).

Another classification for matter is whether the property is dependent on the amount of substance present. Properties that depend on the amount of sample being examined are classified as extensive, and properties that do not depend on the amount of sample being examined are classified as intensive. The mass and volume of a sample are directly dependent on the amount of sample, while density and color are independent of the amount of the sample. The two former properties are classified as extensive and the latter two properties are classified as intensive; also, all chemical properties are intensive properties. Matter can be in four possible states: *solid, liquid, gas,* and *plasma (Figure 2.3).* The state of matter at a specific temperature and pressure is the result of interactions between the particles making up the sample; these interactions are called the *intermolecular forces.*

When matter is in a solid state, it has a rigid structure; therefore, solids have a fixed shape and volume. Liquids do not have such a rigid structure; therefore, a liquid will mold itself into the shape of whatever rigid container it is poured into. Thus liquids are defined as having a fixed volume but variable shape. For instance, if one gallon of water is poured into an empty milk jug, it will take the shape of the jug; if that water is transferred into a bucket, it will take the shape of the bucket.

However, provided there is no loss during the transferring, the actual volume, one gallon, is unchanged throughout the process. Gases have neither a fixed shape nor a fixed volume. Gaseous molecules will, thus, be evenly distributed throughout the inside of a container. The volume of the gas can be readily changed simply by changing the pressure and/or the temperature. For instance, imagine filling a balloon with helium from a tank. The helium goes from the shape of the tank to that of the balloon. The actual volume of the balloon is dependent on the amount, temperature, and pressure of the gas inside (Figure 2.4). If a sealed helium balloon is left in the sun, it will expand, i.e. its volume will increase. If it is placed in a refrigerator, its volume will decrease; however, the amount of hemarylium in the sealed balloon has not changed.

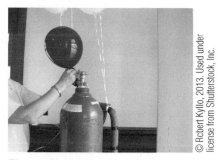

Figure 2.4 Gas in a balloon

The fourth state of matter, plasma, is rarely seen in everyday life, although lightning would be one example of plasma in nature. Just as gaseous compounds have neither a fixed volume nor shape, neither does plasma; however, unlike gases plasmas are made up of ionized (charged) particles, which are sensitive to electromagnetic fields because of their charge. On the contrary, plasma is the most visible of the four states of matter encountered in space as all stars, including the sun, are made of plasma (Figure 2.5). In the very last chapter, the use of an instrument based on plasma technology is described as part of the analysis of the works of the cultural heritage.

Figure 2.5 Plasma in stars

Learning Checks

1. Categorize the following properties as physical or chemical.
 a. Magnesium (Mg) reacts in the presence of oxygen gas (O_2).
 b. A copper block is easily spun into copper wire.
 c. Chromium enriched iron (stainless steel) is highly resistant to corrosion.
 d. Gold is very dense.
 e. Copper in the presence of UV light produces an electrical current (solar cell).
 f. Bromine is a reddish-colored liquid at room temperature.
 g. A cast iron skillet releases heat for an extended period of time.
 h. A kilogram of water takes up a volume of one liter.

 Ans: a. chemical property; b. physical property, c. chemical property (While at first glance this may appear as a physical property, it is because of stainless steel's ability to resist corrosion, which is due to the iron-chromium alloy's lack of reactivity in the presence of water and oxygen); d. physical property; e. physical property; f. physical property, g. physical property; h. physical property.

2. Categorize the following properties from example question 1 as intensive or extensive.

 Ans: a. intensive property; b. intensive property, c. intensive property; d. intensive property; e. intensive property; f. intensive property, g. intensive property; h. extensive property.

NAMING ELEMENTS

Currently, 118 elements are known; 92 of them are naturally occurring and 26 are synthetic, i.e., man-made. Elements are represented by symbols that consist of one or two letters, with the first letter always capitalized. Each element has its unique symbol so that that no two elements may have the same representation. Knowing and being able to recognize the elements, their symbols, and their names is a necessary task for everyone learning chemistry. The symbols for the elements are the first letters of the name of the element, which would be very easy if all their names had an English root. However, some elements' names are derived from Latin, Greek, Arabic, or German, and some of them are named after a scientist, making the memorization of all the names and symbols somewhat more complicated.

Table 2.1 lists all the currently known elements, their symbols, and the meaning of their name in the language from which it is derived.

Learning Checks

1. What is the symbol for the following elements?

 a. Calcium; b. Aluminum; c. Magnesium; d. Bromine

 Ans: a. Ca, b. Al, c. Mg, d. Br

2. What is the name for the following elemental symbols?

 a. Mn; b. Au; c. Hg; d. Ag

 Ans: a. Manganese, b. Gold, c. Mercury, d. Silver

ATOMIC STRUCTURE

Now that we have looked at the properties of matter and the four different states of matter, we need to ask a question that ancient Greek philosophers pondered and theorized about often: What is matter made up of? Plato, a pupil of Socrates and a teacher for Aristotle (384–322 B.C.E.), believed that matter was continuous, meaning that it could be broken down into infinitely smaller pieces and that it would still retain its identity. As a matter of fact, the three of them agreed on this fact, sometimes called continuum. For instance, if a piece of gold was treated this way, an infinitively smaller piece of gold would be obtained, thus retaining its identity as a piece of gold. Democritus, a contemporary of Plato's, disagreed with the continuous theory of matter and instead claimed that if matter were to be halved enough times, eventually a point would be reached in which the matter could no longer be halved. From this, Democritus (460–370 B.C.E.) coined the word *atomos*, referring to the indivisibility of atoms. Although Democritus was correct, in his time period, he was largely unrecognized. Pictures representing respectively Plato, Democritus and Aristotle are shown in Figure 2.6.

More than 2,000 years later, in 18th-century Europe, some of the first modern chemists used experimental results to support the existence of atoms. British chemist John Dalton (Figure 2.7) developed the atomic theory in 1803, which largely supported Democritus' view of matter and atoms.

Dalton formulated three hypotheses as follows: (1) Matter is made up of small indestructible particles, which he named atoms in honor of Democritus (2) all atoms of the same element are the same, and finally, (3) atoms of different elements are different. This theory is still valid today, although it has received minor modifications since it was first developed. Dalton's atomic theory described atoms as the basic building blocks of matter, defining the atom as the smallest identifiable

Table 2.1 The elements

Name	Symbol	Language of Origin	Original Word	Meaning
Actinium	Ac	Greek	Aktinos	Ray
Aluminum	Al	Latin	Alumen	Bitter salt
Americium	Am	English	America	America
Antimony	Sb	Greek	Anti monos	Not alone
Argon	Ar	Greek	Argon	Inactive
Arsenic	As	Greek	Arsenikon	Orpiment
Astatine	At	Greek	Astatos	Unstable
Barium	Ba	Greek	Barys	Heavy
Berkelium	Bk	English	Berkeley	Berkeley
Beryllium	Be	Greek	Beryllos	A blue-green spar
Bismuth	Bi	German	Bisemutum	White mass
Bohrium	Bh	Niels Bohr		
Boron	B	English	Buraq	NA
Bromine	Br	Greek	Bromos	Dirt or stench
Cadmium	Cd	Greek/Latin	Cadmia	Calamine
Caesium	Cs	Latin	Caesius	Blue-gray
Calcium	Ca	Greek/Latin	Calx	Pebble
Californium	Cf	English	California	California
Carbon	C	Latin	Charbone	Charcoal
Cerium	Ce	Latin	Ceres	Grain, bread
Chlorine	Cl	Greek	Chloros	Pale green
Chromium	Cr	Greek	Chroma	Color
Cobalt	Co	German	Kobold	Evil spirit
Copernicium	Cn	Nicolaus Copernicus		
Copper	Cu	Greek	Kyprios	Cyprian
Curium	Cm	Marie and Pierre Curie		
Darmstadtium	Ds	German	Darmstadt	Intestine city
Dubnium	Db	Russian	Dubna	NA

(*continued*)

Table 2.1 The elements (Continued)

Name	Symbol	Language of Origin	Original Word	Meaning
Dysprosium	Dy	Greek	Dysprositos	Hard to get
Einsteinium	Es	Albert Einstein		
Erbium	Er	Swedish	Ytterby	Outer village
Europium	Eu	Ancient Greek	Europe	Broad-faced
Fermium	Fm	Enrico Fermi		
Flerovium	Fl	Georgyi Flerov		
Fluorine	F	Latin	Fluere	To flow
Francium	Fr	French	France	France
Gadolinium	Gd	Johan Gadolin		
Gallium	Ga	Latin	Gallia	Gaul
Germanium	Ge	Latin	Germania	Germany
Gold	Au	Medieval English	Gold	Yellow and bright
Hafnium	Hf	Latin	Hafnia	Copenhagen
Hassium	Hs	Latin	Hassia	Hessen
Helium	He	Greek	Helios	Sun
Holmium	Ho	Latin	Holmia	Stockholm
Hydrogen	H	Greek	Hydro and gen	Water generator
Indium	In	Latin	Indigo	Indigo
Iodine	I	Greek	Iodes	Violet
Iridium	Ir	Greek	Iris	Rainbow
Iron	Fe	Medieval English	Yren or yron	Holy metal
Krypton	Kr	Greek	Kryptos	Hidden
Lanthanum	La	Greek	Lanthanein	To lie hidden
Lawrencium	Lr	Ernest Lawrence		
Lead	Pb	English	Lead	Liquid silver
Lithium	Li	Greek	Lithos	Stone
Lutetium	Lu	Latin	Lutetia	Former Paris
Magnesium	Mg	Greek	Magnesia	Greek region
Manganese	Mn	Greek	Magnesia nigri	Black magnesia
Meitnerium	Mt	Lise Meitner		

Table 2.1 The elements (Continued)

Name	Symbol	Language of Origin	Original Word	Meaning
Mendelevium	Md	Dmitri Mendeleyev		
Mercury	Hg	Latin	Mercurius	Mercury
Molybdenum	Mo	Greek	Molybdos	Lead-like
Neodymium	Nd	Greek	Neos Didymos	New twin
Neptunium	Np	Latin	Neptunus	Neptune
Nickel	Ni	Swedish	Kopparnickel	Copper-colored
Niobium	Nb	Greek	Niobe	Greek queen
Nitrogen	N	Greek	Nitro Genes	Soda generator
Nobelium	No	Alfred Nobel		
Osmium	Os	Greek	Osme	Smell
Oxygen	O	Greek	Oxy genes	Acid forming
Palladium	Pd	Greek	Pallas	Greek goddess
Phosphorus	P	Greek	Phoros	Light-bearer
Platinum	Pt	Spanish	Platina	Silver
Plutonium	Pu	Greek	Pluto	God of Hades
Polonium	Po	Latin	Polonia	Poland
Potassium	K	English	Potash	Pot ashes
Praseodymium	Pr	Greek	Prasios	Green twin
Promethium	Pm	Greek	Prometheus	Greek hero
Protactinium	Pa	Greek	Protos Aktinos	First Actinium
Radium	Ra	Latin	Radius	Ray
Radon	Rn	Latin	Nitens	Shining
Rhenium	Re	Latin	Rhenus	Rhine
Rhodium	Rh	Greek	Rhodon	Rose
Roentgenium	Rg	Wilhelm Conrad Roetgen		
Rubidium	Rb	Latin	Rubidius	Dark red
Ruthenium	Ru	Latin	Ruthenia	Russia
Rutherfordium	Rf	Ernest Rutherford		

(*continued*)

Table 2.1 The elements (Continued)

Name	Symbol	Language of Origin	Original Word	Meaning
Samarium	Sm	French	Samarskite	Mineral
Scandium	Sc	Latin	Scandia	Scandinavia
Selenium	Se	Greek	Selene	Moon
Silicon	Si	Latin	Silex	Flint
Silver	Ag	Medieval English	Seolfor	Silver color
Sodium	Na	Medieval English	Soda	Soda
Strontium	Sr	Gaelic	Strontian	Scottish village
Sulfur	S	Sanskrit	Sufra	Yellow
Tantalum	Ta	Greek	Tantalus	Greek hero
Technetium	Tc	Greek	Technetos	Artificial
Tellurium	Te	Latin	Tellus	Earth
Terbium	Tb	Swedish	Ytterby	Swedish village
Thallium	T1	Greek	Thallos	Green twig
Thorium	Th	Old Norse	Thor	Scandinavian god
Thulium	Tm	Greek	Thule	Scandinavia
Tin	Sn	English	Tin	Tin
Titanium	Ti	Greek	Titan	Sons of the Earth
Tungsten	W	Swedish	Tung sten	Heavy stone
Ununoctium	Uno	Latin	Temporary name	
Ununpentium	Uup	Latin	Temporary name	
Ununseptium	Uus	Latin	Temporary name	
Ununtrium	Uut	Latin	Temporary name	
Vanadium	V	Scandinavian	Vanadis	Goddess of beauty
Xenon	Xe	Greek	Xenos	Foreign
Ytterbium	Yb	Swedish	Ytterby	Swedish village
Yttrium	Y	Swedish	Ytterby	Swedish village
Zinc	Zn	German	Zink	Musical cornet
Zirconium	Zr	Arabic	Zargun	Gold-like

Figure 2.6 Plato, Democritus, and Aristotle

Figure 2.7 John Dalton

Figure 2.8 A raisin pudding—used as analogy for atomic structure

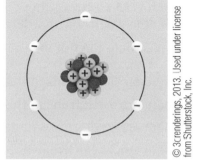

Figure 2.9 Depiction of nucleus of an atom with electrons occupying the rest of the volume

unit of an element. He realized that the physical and chemical properties of a substance were due to atoms or their arrangements one with another. Therefore, to understand matter and its properties, atoms themselves must first be understood.

In 1898, after an English physicist J.J. Thomson had proven the existence of electrons and even calculated their mass, he proposed the "raisin-pudding" or "plum-pudding" model to explain the atomic structure. In this model, the electrons are embedded in the atomic structure in the same way raisins are embedded in a pudding (Figure 2.8).

The next important discovery in terms of the determination of the atomic structure is the one by New Zealand physicist Ernest Rutherford in 1911, who, using the results from the gold-foil experiment, realized that all the positive charges in an atom are located in the center, also called nucleus, whereas the electrons occupy the rest of the volume that makes an atom (Figure 2.9). He also proposes the existence of a neutral particle, the neutron, although it would not be discovered until 1932 by an English physicist James Chadwick.

After Rutherford's discovery, it was important to provide the exact location of the electrons around the positively charged nucleus. Danish physicist Niels Bohr published to that effect in 1913 his explanation of how electrons are orbiting around the nucleus and are located in orbitals, like the planets are orbiting around the sun in their orbits. Bohr was awarded the 1922 Nobel Prize for physics for this theory. Each atomic orbital has a defined energy level, so it is said to be quantized. Electrons under the right energetic conditions can travel up and down these orbitals. Also, each energy level may contain only a specific number of electrons depending to the energy level, also called the shell. The number 1 is assigned to the shell closest to the nucleus and so on (Figure 2.10).

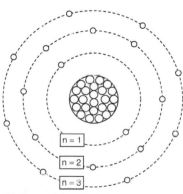

Figure 2.10 Bohr's atomic model

The maximum number of electrons contained in a specific shell is given by the following formula: $2 n^2$ with n being the shell number. For instance, the first shell can contain only a maximum of 2 electrons, the second shell 8 electrons, and so forth. When electrons fill up the orbitals, they are always placed first in the lowest levels of energy available, this rule is called the *aufbau* rule.

Learning Checks

1. How many electrons are present in shell n = 5?

 Ans: The maximum number of electrons in that shell is: $2 \times 5^2 = 50$ electrons.

2. If one atom has 24 electrons, how many shells would be necessary to accommodate all of them? Show the electronic distribution.

 Ans: Let's calculate the number of electrons in each shell:

 n = 1, there are 2 electrons in this shell

 n = 2, there are 8 electrons in this shell, for a total of 2 + 8 = 10 electrons in all the shells

 n = 3, there are 18 electrons in this shell, for a total of 10 + 8 = 18 electrons in all the shells

 n = 4, there are 32 electrons in this shell, for a total of 18 + 32 = 50 electrons in all the shells, which is enough to accommodate all the 24 electrons. The first three shells will be completely filled and the last shell, n = 4, will be only partially filled.

When atoms or ions are heated, as they absorb the energy, the electrons are excited from lower to higher energy levels. When these electrons return from higher to lower energy levels, they emit a radiation. Depending on the nature of the element, the radiation may be in the visible range, thus observable by the human eye, and its color varies. If one knows the color of emission of a special element, one can test for its presence in a given sample. This test is used in very common experiments that students do in a chemistry laboratory and is called the flame test. Outside the chemistry laboratory, one may also see this process since it is the basis for fireworks.

Finally, the Austrian physicist Erwin Schrödinger, using complex mathematical equations beyond the scope of this book, described the behavior of the sub-atomic particles in 1926, opening the door of a new field where physics and chemistry meet: quantum mechanics.

ATOMIC AND MASS NUMBER

As mentioned earlier, by 1932 it was known that the atom is composed of protons (p^+), neutrons (n^0), and electrons (e^-) and that the protons and neutrons are grouped in a central positively charged nucleus, while the electrons are located around the nucleus in orbitals, forming a negatively charged electron cloud. Both the proto n and the neutron have similar masses of approximately one atomic mass unit (amu) while the electron is two thousand times lighter. The neutron has no electrical charge and the proton has a positive one charge; while the electron is defined as having a negative one charge. The atomic mass for each element is provided in the periodic table as we will see in Chapter 3. Table 2.2 summarizes these data and provides the correspondence of the mass in grams.

Two quantities are used for describing how many protons, neutrons, and electrons are found in a given atom: the mass number (A) and the atomic number (Z). The atomic number represents the identity of an element by the number of protons in its nucleus. Carbon has 6 protons in its nucleus, and no other element has 6 protons. By the same principle, any element with 6 protons in its nucleus has to be carbon. This also means that in order to keep its identity, an element must never lose or

Table 2.2 Atomic particles with respective masses and charges

Particle	Mass (amu)	Mass (Grams, g)	Charge (Coulomb, C)	Charge
Neutron	1.008665	1.67495×10^{-24}	0	0
Proton	1.007277	1.6726×10^{-24}	1.6022×10^{-19}	+1
Electron	0.00054858	9.10940×10^{-28}	$^-1.6022 \times 10^{-19}$	$^-1$

gain a proton; if this occurs, it will become a different element. Moreover, for a neutral element, the number of protons is equal to the number of electrons, so Z can also be used to find the number of electrons.

The mass number, A, is number of neutrons plus proton, $A = \#p^+ + \#n^0$ A common notation that includes the chemical symbol, the atomic number, and the mass number is called *nuclear notation*. Nuclear notation has the following format:

$$^A_Z X$$

For example: Carbon-13 has an atomic number (Z) of 6 and a mass number (A) of 13. The nuclear representation of carbon-13 would be written as:

$$^{13}_6 C$$

Learning Checks

1. What is the nuclear representation for iron-54?

 Ans:

 $$^{54}_{26} Fe$$

2. Give nuclear representations for cobalt-59 and nickel-60. What do the two elements have in common?

 Ans: These two elements have the same number of neutrons: Number of neutrons for cobalt = 59 – 27 = 32 neutrons; number of neutrons for nickel = 60 – 28 = 32 neutrons. These two elements can be symbolized as follows:

 $$^{59}_{27} Co \text{ and } ^{60}_{28} Ni$$

3. Is $^{82}_{36} Br$ a valid notation for bromine if Z = 35 and A = 82? Why or why not?

 Ans: It is not valid for bromine since the atomic number Z = 35, it should be written as:

 $$^{82}_{35} Br$$

4. Is $^{93}_{41} Nb$ a valid notation for niobium if Niobium has 41 protons and 52 neutrons? Why or why not?

 Ans: Since there are 41 protons and 52 neutrons in the Niobium atom, the atomic number Z and the mass number A, respectively, are equal to 52 and 93; therefore this is the correct notation.

ISOTOPES

Elements can lose or gain both neutrons and electrons and still keep their identity. Samples of the same elements that have different numbers of neutrons are called *isotopes*. In the atomic representation of two or more isotopes, the atomic number (Z) is the same; however, the mass numbers are not the same. Remember that an atom's mass depends on the number of protons and neutrons that reside in its nucleus. It is important to understand that elements have only a certain number of stable isotopic forms, depending on the neutron to proton ratio. Stable isotopes only exist in ranges of neutron to proton ratio of about 1 to 1.5; this is discussed in further detail in Chapter 7.

To better comprehend the concept of isotopes, let's examine carbon. Carbon always has 6 protons; this is what makes it carbon. However, it can have 6, 7, or even 8 neutrons. In these cases, carbon can exist as carbon-12, carbon-13, and carbon-14, where 12, 13, 14 stand for the mass number A. Carbon-12 is the most abundant, carbon-13 is used in some chemical analysis, and carbon-14 can be used for carbon dating. We can thus write the symbol for these three isotopes as:

$$\,^{12}_{6}C\ \,^{13}_{6}C\ \,^{14}_{6}C$$

Learning Checks

1. How many electrons, protons, and neutrons are present in calcium-42 ($^{42}_{20}Ca$)?

 Ans: In order to find the number of protons, subtract the atomic number from the mass number. The mass number (A) = 42 and the atomic number (Z) = 20. The number of neutrons = mass number (A) – atomic number (Z). The number of neutrons for calcium-42 = 42 – 20 = 22. The number of protons is equal to the atomic number and for a neutral element the number of electrons also equals the atomic number, hence the number of electrons = 20 and the number of protons also equals 20.

2. Uranium-238 is the most common isotope of uranium found in nature. How many protons, electrons, and neutrons does uranium-238 have?

 Ans: $^{238}_{92}U$ The number of electrons and protons are equal to the atomic number; hence, uranium-238 has 92 electrons and 92 protons. The number of neutrons is found by taking the difference between the mass number and the atomic number: 238 – 92 = 146 neutrons.

3. Fill in the following table.

Element	Z	A	# protons	# neutrons
Chlorine		35		
Potassium				41
	92	235		
	1	1		

 Ans:

Element	Z	A	# protons	# neutrons
Chlorine	17	35	17	18
Potassium	19	22	19	41
Uranium	92	235	92	143
Hydrogen	1	1	1	0

4. Fill in the following table.

Number of protons	Name of element, chemical symbol
12	
115	
	Rhodium, Rh

Ans:

Number of protons Z (atomic number)	Identity of element and chemical symbol
12	Magnesium, Mg
115	Ununpentium, Uup
45	Rhodium, Rh

THE MOLE

Atoms are extremely small, so it is very difficult to work with them on a macroscopic level. Clearly when chemists work with elements or compounds, they use huge numbers of particles, and it would be very cumbersome to manipulate such large numbers. Therefore, the concept of *mole* is used. The value of a mole is the number of atoms present in exactly 12 grams of carbon-12. It is called Avogadro's number after the Italian scientist Amedeo Avogadro (1776–1856), has the symbol N_A, and equals 6.0221415×10^{23}. It is often rounded to 6.022×10^{23}. In the same way that a dozen eggs contains 12 eggs, a mole of eggs would contain 6.022×10^{23} eggs. Simple calculations are carried out with Avogadro's number. The molar mass of an element is also defined as the mass of one mole of that element and is provided in the periodic table.

Learning Checks

1. How many aluminum atoms are present in 3.40 moles of aluminum?

 Ans: The calculation is as follows:

$$\# Al \ atoms = 3.4 \times 6.022 \times 10^{23} = 2.047 \times 10^{24} \ atoms$$

 It is interesting to note too that the identity of the metal was not used, so the question could have been rephrased: How many atoms are present in 3.40 moles?

2. How many moles of sulfur atoms are present in 9.458×10^{19} sulfur atoms?

 Ans: The calculation is as follows:

$$\# moles \ of \ sulfur = \frac{9.458 \times 10^{19}}{6.022 \times 10^{23}} = 1.57 \times 10^{-4} \ moles \ of \ sulfur \ atoms$$

 Since moles represent huge numbers of atoms, it is possible to consider fractions of moles, just like one would consider half a dozen eggs. Of course, the only impossibility would be to have negative numbers of moles since they do represent a quantity and thus would have to be a positive number.

3. How many atoms of chlorine are present in 2.35 moles of Cl_2? How many molecules does it represent?

Ans: First let's calculate the number of molecules:

$$\# molecules\ of\ Cl_2 = 2.35 \times 6.022 \times 10^{23} = 1.41 \times 10^{24}\ molecules$$

The molecule of chlorine contains 2 atoms of chlorine per molecule so the calculation is as follows:

$$\#Cl\ atoms = 2.35 \times 6.022 \times 10^{23} \times 2 = 2.83 \times 10^{24}\ atoms$$

It is important here to recalculate everything and not use the intermediate value because it could introduce rounding errors.

PROBLEMS

1. What three states can matter exist as? How are these states alike? How are they different?

2. Of the following properties, which are extensive and which are intensive? Freezing point, density, mass, volume, color.

3. An unknown element is found to be brittle, rough to the touch, and highly reactive in the presence of water; furthermore, the unknown element has a reflective surface and is unreactive in the presence of nitrogen. Of the previously listed properties, which are physical and which are chemical?

4. List the three subatomic particles that make up the atom. Describe the properties of each subatomic particle such as charge and relative contribution to the mass of the atom.

5. What does the atomic number represent? What about the mass number?

6. What is the nuclear representation for mercury-202?

7. What contribution did Rutherford give to the model of the atom?

8. In the planetary model, the neutrons, protons, and electrons are located in what part of the atom?

9. What is the formula to find the maximum number of electrons per shell in an atom?

10. How many totally filled shells are used for an atom with 68 electrons?

11. What is the electronic distribution for an atom that has 86 electrons?

12. In your own words describe the concept of isotopes.

13. How does the concept of isotopes allow for samples of the same element to have different atomic masses?

14. How many protons, neutrons, and electrons are present in mercury-202?

15. Fill in the following table.

Element	Z	A	# protons	# neutrons
Magnesium		24		
Silver				60
	50	118		
		127	53	

16. How many moles are in 3.642×10^{33} atoms of manganese?

17. How many atoms are present in 5.89 moles of argon?

18. How many moles are in 8.99×10^{26} atoms of ozone O3?

19. How many molecules of bromine Br_2 are present in 10.55 moles? How many atoms of bromine does this correspond to?

ANSWERS

1. The three states of matter are solid, liquid, and gas. Matter in the solid state has a rigid structure and possesses a fixed shape and volume. Matter in the liquid phase does not have a rigid structure; therefore, the volume is fixed, but the shape of a liquid conforms to whatever rigid container it is placed into. Matter in the gas phase has neither a fixed shape nor a volume. Gaseous molecules try to evenly distribute inside of a solid container. The volume of gas can be easily changed with the change in its pressure.

2. Intensive properties do not depend on the amount of substance present. Extensive properties depend on the amount of substance present. Color, density, and freezing point of a substance are intensive properties. Mass and volume are examples of extensive properties of a substance.

3. Being brittle, rough to touch, possess a reflective surface are all examples of physical properties. Highly reactive in the presence of water and being uncreative in the presence of nitrogen are examples of chemical properties.

4. Protons are subatomic particles that possess a positive charge, are located in an atom's nucleus, and contribute 1 mass unit to an atom. Neutrons are subatomic particles that possess a neutral charge, are located in an atom's nucleus, and contribute 1 mass unit to an atom. Electrons are subatomic particles that possess a negative charge, are located outside of the nucleus in a surrounding cloud, and do not contribute to the mass of an atom.

5. The atomic number gives the identity of an element by the number of protons in the nucleus. The mass number is the number of protons plus the number of neutrons in an element's nucleus.

6. The nuclear representation for Mercury-202 is: $^{80}_{202}\text{Hg}$

7. In 1911, Ernest Rutherford discovered that all positive charges are located at the center of an atom in the nucleus, and all electrons take up the rest of the volume of the atoms in a cloud surrounding. His conclusions were based on his gold-foil experiment.

8. In the planetary model, protons and neutrons are located in the nucleus, which is located at the center of the atom. The electrons are located in orbitals that revolve around the atom's nucleus. This theory was suggested by Danish physicist, Niels Bohr in 1913.

9. The formula for the maximum number of electrons in a single shell is: $2n^2$, where n is the shell number.

10. For an atom with 68 electrons, the total number of shells that are used would be: using the formula, there are 2 electrons in the $n = 1$ shell, 8 electrons in the $n = 2$ shell, 18 electrons in the $n = 3$ shell, 32 electrons in the $n = 4$ shell, and 50 electrons in the $n = 5$ shell. Counting all electrons in the $n = 1$ through the $n = 4$ shells would result in $2+8+18+32 = 60$ electrons. However, the element that we are looking at has 68 electrons. Since there are 50 electrons in the $n = 5$ shell, then this element would have four filled shells and 8 electrons left over in the unfilled $n = 5$ shell.

11. The electron distribution for an element that has 86 electrons would be:

$n = 1$	2 electrons
$n = 2$	8 electrons
$n = 3$	18 electrons
$n = 4$	32 electrons
$n = 5$	26 electrons

12. Isotopes are atoms that have the same number of protons, but they different in their number of neutrons.

13. Since the number of protons is the same, the identity of the element has not changed. However, with the change in the number of neutrons, the mass number also has a proportional change.

14. Mercury-202 has: 80 protons, 122 neutrons, and 80 electrons.

15.

Element	Z	A	#protons	#neutrons
Magnesium	12	24	12	12
Silver	47	107	47	60
Tin	50	118	50	68
Iodine	53	127	53	74

16. Find number of moles of Manganese (Mn).

$$3.642 \times 10^{33} \text{ atoms Mn} \times \frac{1 \text{ mole Mn}}{6.022 \times 10^{23} \text{ atoms Mn}} = \textbf{6.048} \times \textbf{10}^{\textbf{9}} \textbf{ moles Mn}$$

17. Find the number of atoms of Ar.

$$5.89 \text{ moles Ar} \times \frac{6.022 \times 10^{23} \text{ atoms Ar}}{1 \text{ mole Ar}} = \textbf{3.55} \times \textbf{10}^{\textbf{24}} \textbf{ atoms Ar}$$

18. Find number of moles of ozone (O^3).

$$8.99 \times 10^{26} \text{ atoms O}_3 \times \frac{1 \text{mole O}_3}{6.022 \times 10^{23} \text{ atoms O}_3} = \textbf{1.49} \times \textbf{10}^{\textbf{3}} \textbf{ moles O}_\textbf{3}$$

19. Find the number of bromine (Br2) molecules.

$$10.55 \text{ moles Br}_2 \times \frac{6.022 \times 10^{23} \text{ molecules Br}_2}{1 \text{mole Br}_2} = \textbf{6.353} \times \textbf{10}^{\textbf{24}} \textbf{ molecules Br}_\textbf{2}$$

$$6.353 \times 10^{24} \text{ molecules Br}_2 \times \frac{2 \text{ atoms Br}}{1 \text{ molecule Br}_2} = \textbf{1.271} \times \textbf{10}^{\textbf{25}} \textbf{ atoms Br}$$

The Periodic Table

HISTORICAL NOTE ON THE PERIODIC TABLE

In the chapter on matter and atoms, the nature of matter and the atomic structure were discussed as well as the names and origins of the chemical elements. So far no formal way of organizing these elements, besides in alphabetical order, has been used. Scientists have come up with different ways of organizing these elements so that the trends they display in their physical and chemical behavior could be easily accounted for in a visual way. By 1869 about 60 elements had been discovered, and new elements were being discovered on a yearly basis. Multiple systems existed for categorizing the elements, and chemists needed a uniform format for arranging all the elements. The system that would eventually be accepted was developed by the Russian chemist Dmitri Mendeleev (1834–1907) (Figure 3.1). Mendeleev arranged the elements in rows from increasing atomic mass, running from left to right. Doing this created columns that grouped elements with similar chemical and physical properties together. He called these groups families, whereas the rows are called periods. Another interesting outcome, from Mendeleev's arrangement of the elements, was that gaps existed between certain elements. Mendeleev predicted that these gaps would eventually be filled for yet-to-discover elements, even announcing the physical and chemical properties these elements would display.

Figure 3.1 Dmitri Mendeleev

Years later, several of the elements that Mendeleev had described were discovered and were found to exhibit many of the properties that Mendeleev predicted. It is because of his accurate predictions that Mendeleev is given credit for the development of the periodic table of elements. Since

Periodic Table of the Elements

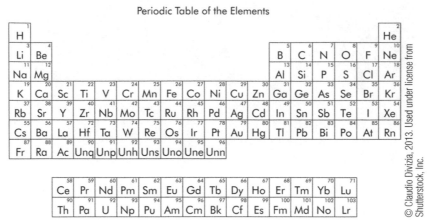

Figure 3.2 The periodic table

then the periodic table has been refined. It is not arranged by increasing atomic masses any longer but by increasing atomic number instead, as shown in Figure 3.2.

It is interesting to note that in the periodic table, the atomic numbers are written above the symbol of each element. However, the key to periodicity does not lie in the atomic number, but in a related component of the atom, electrons. The details of the structure of atoms will be covered in depth later. The periodicity observed in the periodic chart is due to the recurring number of the outermost electrons referred to as the valence shell. Every element in a group has the same number of outermost electrons in its atomic structure. The number of electrons in the outermost shell is represented by the group number, which determines the reactivity and periodicity of the elements. A fundamental aspect of this periodicity and the chemistry of the elements can be abbreviated as the Octet (8) Rule. This simple rule refers to the number of electrons an atom would need to be stable. That stability is seen clearly in the last group of elements, the noble gases. The structure of these atoms represents the most stable configuration of electrons. As we will see in this chapter, the periodic table is a very rich source of information for chemists.

Learning Check

1. In what order are elements arranged in the periodic table?

 Ans: Each element in the periodic table is arranged by increasing atomic number.

METALS, NON-METALS, METALLOIDS, AND THE PERIODIC TABLE

All elements fall into one of three major categories: metals, metalloids, and non-metals. Metals are often recognized by their shiny and metallic luster. Most metals tend to be malleable, meaning that they can be hammered into a shape, because they are able to deform without breaking. Also, some metals, especially the transition metals, can be easily spun into a wire, a physical property called *ductility*. These properties make metals a great substrate for jewelry or manuscript illumination. Indeed, in the Middle Ages, illuminated medieval manuscripts preserved the knowledge acquired during the antiquity so it could be passed on and rediscovered by the scholars of Western Europe. Thus, leading to the cultural revolution of the Renaissance, the illuminated manuscripts were a form of portable art, diffusing culture and taste. Medieval manuscripts were mainly produced using animal skin as a writing support, called parchment, which by the Middle Ages had largely replaced papyrus in Europe. Illumination comes from the Latin word *illuminare* and

means "to light up or illuminate." Once a manuscript is open, it seems to be illuminated from the glow created by the colors of the decorated letters and the illustrations, especially the ones using gold and silver (Figure 3.3).

Another physical property shared by most metals is that they are relatively non-brittle, making them convenient building materials. With the exception of mercury, all metals are solids at room temperature and have relatively high melting and boiling points. Also, metals are good conductors of heat and electricity.

In terms of chemical properties, metals can display a variety of reactivity with oxygen and water, ranging from highly reactive to no reactivity at all. The only generalization that can be made for the chemical properties of metals is that metals will react to form positive charged ions (cations). Metals constitute approximately 80% of all elements known and occupy the left side of the periodic table, i.e. left of the diagonal line formed by boron and polonium (Figure 3.4).

Figure 3.3 An illuminated manuscript

Non-metals are located on the righthand side of the periodic table. They have more varied physical properties than that of the metals. Several of the non-metals exist as gaseous at room temperature; examples are chlorine, argon, or helium. Bromine is a liquid at room temperature, and other non-metals, such as iodine or carbon, exist as solids at room temperature. The non-metals that do exist as solids tend to be brittle and lack a metallic luster. They do not conduct heat and electricity, and their chemical reactivity varies greatly. For example, the noble gases are almost completely non-reactive, while fluorine is considered to be one of the most reactive elements in the periodic table.

Finally, some elements exhibit some properties of both metals and non-metals and are called *metalloids*. Only a few of them exist (boron, silicon, germanium, arsenic, antimony, tellurium, and polonium), and they form a physical division on the periodic table between the metals on their left and the non-metals on their right. Of the three main categories, metalloids are the hardest to generalize because each metalloid exhibits its own specific set of properties. Physical properties such as boiling point, melting point, and hardness can vary greatly from one metalloid to the next. For example, silicon has a metallic luster as do most metals; however, silicon is brittle and is a relatively poor conductor similar to a non-metal. Because most metalloids can act as inefficient conductors, they are often used as semiconductors.

Learning Checks

1. If a compound exists in the gaseous state at room temperature and does not conduct electricity, is it likely to be a non-metal, metalloid, or metal?

 Ans: With the exception of mercury, all metals are in the solid state at room temperature, and none exist as a gas. So the compound could not be a metal. Metalloids have varying properties but none are a gas at room temperature. The compound would have to be a non-metal.

2. Group the following properties as a metal or a non-metal: high boiling point, gas at room temperature, solid at room temperature, good to excellent conductor of electricity, reacts with oxygen and water, high electronegativity, ductile, malleable, brittle, large variance in chemical reactivity, poor conductor of electricity, readily forms cations.

 Ans: Metals: high boiling point, solid at room temperature, good to excellent conductor of electricity, reacts with oxygen and water, ductile, malleable, readily forms cations. Non-metals: gas at room temperature, brittle, large variance in chemical reactivity, poor conductor of electricity.

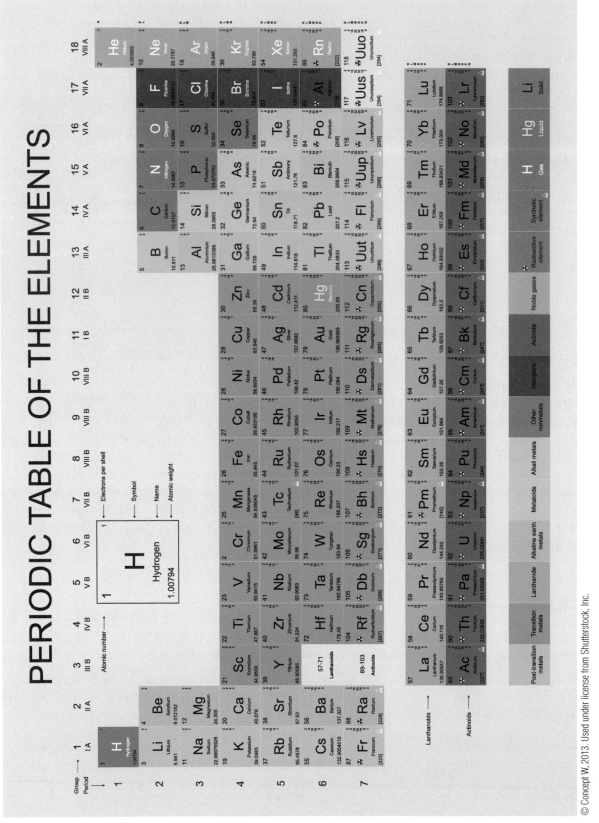

Figure 3.4 Metals are located on the left of the green diagonal shown on the periodic table

MORE ON GROUPS, FAMILIES, AND PERIODS

Each vertical column in the periodic table is called a *group* (or family) of elements; there are 18 of them. Recall the Octet Rule and numbering of the periodic chart that goes from 1 to 18, in some cases, and reflects on the number of electrons in the outermost shell. The size of atoms increase from top to bottom within a column. A group contains elements with similar chemical and physical properties and is identified by a group number at the top of the column. The representative elements, which are also called the main group elements, are assigned the following group numbers: 1A–8A. The transition elements use the letter "B" and they are all metals, i.e., the transition metals.

Each of the seven horizontal rows of the periodic table is called a *period* and is assigned a number starting with 1 on top to 7 for the bottom one (Figure 3.5). The atomic number increases by one going from left to right across the same period; however, there appears to be a drastic jump in atomic number for the sixth and seventh rows, which is explained by the fact that these rows are broken up. Indeed, what appear to be two separate rows at the bottom of the periodic table are actually part of rows 6 and 7; they are placed in this manner for space reasons. These two rows at the bottom are part of period 6 and 7 and are called respectively lanthanides and actinides, after the name of the element that is at their respective beginning: lanthanum and actinium. Actinides are very rare and are all radioactive. Atomic size decreases from left to right on a period as more protons, neutrons, and electrons are added to the atomic structure. The decrease in size is attributed to the increasing positive charge of the nucleus, which pulls the negative electron ever closer to the nucleus. However, we will find out in atomic structure that once you reach the end of a period, the next period that starts below is larger.

Group 1A: Alkali Metals

The group 1A elements are called the alkali metals, have silvery-grayish appearance, and are quite reactive. Alkali metals have only one valence electron, which they can easily lose to become positively charged, as in the case with potassium:

$$K \rightarrow K^+ + 1e^-$$

The alkali metals are increasingly reactive from top to bottom of the group, because that single valence electron is more loosely tied to the atom as the atom size increases from top to bottom.

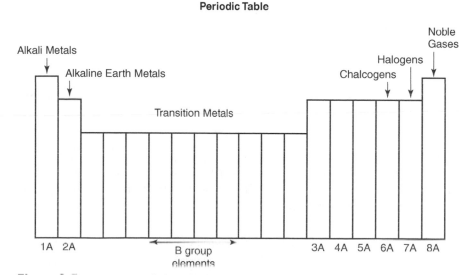

Figure 3.5 Names of the chemical groups of the periodic table

© Andraž Cerar, 2013. Used under license from Shutterstock, Inc.

Figure 3.6 Sodium that has been cut with a knife

Therefore, lithium is less reactive than sodium, which is less reactive than potassium and so forth. The last element in this group, francium, is rarely mentioned because it is a radioactive element. Alkali metals are classified as soft metals because they can easily be cut. For instance, sodium can be cut with a kitchen knife. Because alkali metals are so reactive, they are never found in their elemental state in nature. In Figure 3.6, a piece of sodium is shown after it has been cut with a knife. The inside is shiny as it has been freshly cut and has not had time to react with the moisture from the air. The outside white crust shows the product of the reaction between sodium metal and water from the air, which forms a caustic white compound, sodium hydroxide (NaOH), commonly referred to as lye, and a flammable gas commonly referred to as hydrogen (H_2).

The balanced chemical equation corresponding to this reaction can be written as:

$$2\,Na + 2\,H_2O \rightarrow 2\,NaOH + H_2$$

Learning Checks

1. In chemical reactions, how many electrons do group 1A metals lose?

 Ans: All group 1A elements lose one electron when reacting with other compounds. Lithium is a group 1A element and thus exists as the Li^+ cation.

2. How many valence electrons do group 1A elements have?

 Ans: All group 1A elements have one valence electron.

Group 2A: Alkaline Earth Metals

The group 2A, named the alkaline earth metals group, contains beryllium, magnesium, calcium, strontium, barium, and radium. Calcium and magnesium are abundant in the earth's crust and can be found in many types of mineral deposits; barium and radium are not as common, but can still be found in the earth's crust. Like alkali metals, alkaline earth metals cannot be found in a native state; instead they exist as compounds bonded to other elements. Like the alkali metals, their reactivity increases from the top of the group down. Alkaline earth metals have two valence electrons, which they can easily lose to become positively charged, as in the case with calcium:

$$Ca \rightarrow Ca^{2+} + 2e^-$$

Alkaline earth metals react with the water to produce a base and hydrogen gas in a similar way that the alkali metals do. For instance, calcium reacts with water, producing calcium hydroxide and hydrogen following this chemical equation:

$$Ca + 2\,H_2O \rightarrow Ca(OH)_2 + H_2$$

Learning Checks

1. How many valence electrons do group 2A elements have?

 Ans: Group 2A elements have 2 valence electrons.

2. How many electrons do group 2A elements have a tendency to lose?

 Ans: Group 2A elements have a tendency to lose 2 electrons, forming a 2+ cation.

3. What group does beryllium belong to? What can you determine about its number of valence electrons?

 Ans: Beryllium is in group 2A, the alkaline earth metals. It has two valence electrons that it can easily lose to form a +2 charged cation, Be^{2+}.

Group 3A: The Boron Family

Aluminum is the most common element of the boron family, although like all the other elements of this group, it is not found in its native state but as an oxide, Al_2O_3. In fact, aluminum is the third most abundant element in the Earth's crust. The boron family is not homogeneous, since boron is a metalloid and the other elements are metallic in nature. But they all have three valence electrons. Aluminum is the main element that would be of any interest here. As a metal with three valence electrons, it can easily lose them, producing a cation with a +3 charge, as shown in the following equation:

$$Al \rightarrow Al^{3+} + 3e^-$$

Learning Checks

1. How many valence electrons do group 3A elements have?

 Ans: Group 3A elements have 3 valence electrons.

2. Why does aluminum have a tendency to lose 3 electrons?

 Ans: Like all group 3A elements, aluminum has 3 valence electrons; by losing all 3 valence electrons, aluminum obtains a noble gas electronic configuration.

3. What group does strontium belong to? What can you determine about its number of valence electrons?

 Ans: Strontium is in group 2A, the alkaline earth metals; therefore, it has two valence electrons that can be easily lost to form a +2 charged cation, Sr^{2+}.

Group 4A: The Carbon Family

The carbon family contains non-metals, metalloids, and metals. Carbon is very important because it has a dominant role in the chemistry of life. The discipline that studies the chemistry of carbon is called organic chemistry and will be described in Chapter 8. Carbon has 4 valence electrons, and when

Figure 3.7 C_{60}, buckminsterfullerene

combined with hydrogen and other non-metals, it can form 4 bonds. Carbon is found free in nature in four allotropic (different) forms: amorphous like coal or soot; graphite, which is one of the softest known materials; and diamond, one of the hardest known materials. The fourth form of free carbon—C_{60}, called buckminsterfullerene—was discovered recently by Sir Harry Kroto.

Carbon has also been used as a pigment since prehistoric times, when fine soot was collected from incompletely burned carbon-containing materials. In that case, it was called lampblack. Tin and lead also have been used in art as pigments. Some examples are red lead (Pb_3O_4); lead tin yellow (Pb_2SnO_4); chrome yellow (chrome is French for chromium) ($PbCrO_4$); and lead white ($PbCO_3 \cdot Pb(OH)_2$).

Learning Checks

1. How many valence electrons do group 4A elements have?

 Ans: Group 4A elements have 4 valence electrons.

2. How many bonds does carbon prefer to form?

 Ans: Carbon is in main group 4 and has 4 valence electrons. Each electron can pair up with another electron, forming a total of 4 bonds.

Group 5A: The Nitrogen Family

Group 5A, also known as the nitrogen family, contains only two non-metals (nitrogen and phosphorus), two metalloids (arsenic and antimony), and one metal (bismuth). They all have 5 valence electrons. Arsenic, a highly toxic element, is known by artists as orpiment (As_2S_3), which is a yellow arsenic sulfide. It has been used since early Egyptian times, although it can fade quite easily with light, especially if mixed with other pigments that contain copper or lead. Early Egyptians knew of antimony as well, under the form of stibnite, which contains antimony sulfide (Sb_2S_3), a black compound used for eye makeup. Another antimony-based pigment, Naples yellow, also known as lead antimonate yellow, was also used in ancient Egypt. Finally, bismuth pigments were also used in cosmetics in these times. Bismuth oxychloride (BiOCl) and bismuth oxynitrate ($BiONO_3$), are both white pigments that have been found in what is called bismuth white or Spanish white and can have an iridescent aspect like the nacre of a pearl.

Nitrogen and phosphorus will be encountered later on in this book because of their ability to gain 3 electrons, forming an anion as shown for nitrogen in this equation:

$$N + 3e^- \rightarrow N^{3-}$$

Learning Checks

1. How many valence electrons to group 5A elements have?

 Ans: All group 5A elements have 5 valence electrons.

2. Give a possible explanation for why nitrogen prefers to gain 3 electrons.

 Ans: Nitrogen has 5 valence electrons and requires 3 more to have a complete octet.

Group 6A: The Oxygen Family

Group 6A, the oxygen family, is also known as the chalcogen family, meaning "copper-former" because they were often found associated with copper in ores. The elements in group 6A (oxygen, sulfur, selenium, tellurium, and polonium) all have 6 valence electrons and may occur in nature free or combined with other elements to form compounds. It is very common to find oxygen- and sulfur-containing pigments where these elements are associated with metals. Some examples are provided here, although the list is a very small representation of all the pigments that contain these two elements: titanium dioxide (white) (TiO_2), verdigris (green) ($Cu(CH_3COO)_2$), calcium carbonate ($CaCO_3$), cadmium yellow (CdS), cobalt violet (violet) ($Co_3(PO_4)_2$), and cobalt blue (CoO). Oxygen and sulfur are also present in dyes, which will be presented in Chapter 8.

Oxygen and sulfur can easily gain 2 electrons, forming an anion as shown for oxygen in this equation:

$$O + 2e^- \rightarrow O^{2-}$$

Learning Check

1. How many valence electrons do group 6A elements have?

 Ans: All main group 6A elements have 6 valence electrons.

Group 7A: The Halogen Family

The name of group 7A, halogens, has a Greek etymology that means "salt former." The elements in this group are quite reactive, with a reactivity decreasing from top to bottom, making fluorine the most reactive. All halogens have 7 valence electrons. Fluorine (F_2) is a highly reactive yellow gas and very corrosive, making it very difficult to store or work with. One of its compounds that may be known to artists is calcium fluoride (CaF_2), because it is used to etch glass. Chlorine (Cl_2) is also a gas and is green and toxic. Bromine (Br_2) is a red and reactive liquid, while iodine (I_2) is a violet solid that can undergo sublimation very easily (going from solid to gas phase). The last one is astatine, which is radioactive. Halogens are known for their ability to gain one electron, as shown for chlorine in this equation:

$$Cl + 1e^- \rightarrow Cl^-$$

Learning Checks

1. How many valence electrons do group 7A elements have?

 Ans: Many group 7A elements have 7 valence electrons.

2. List the halogens from increasing order of reactivity.

 Ans: For the halogen family, chemical reactivity decreases as you go down a column. The order is listed as follows: astatine, iodine, bromine, chlorine, fluorine

3. What group is chlorine in? How many valence electrons does it have? Will chlorine tend to lose or gain electron(s)?

 Ans: Chlorine is in group 7A, the halogens. It has seven valence electrons and therefore gains one electron to complete the octet, becoming Cl^-.

4. What group is iodine in? How many valence electrons does it have? Will iodine tend to lose or gain electron(s)?

Ans: Iodine is in group 7A, the halogens. It has seven valence electrons and therefore gains one electron to complete the octet, becoming I^-.

Group 8A: The Noble Gases Family

The last of group A is the noble gases family (group 8A), which used to be called the inert gases because of their very low reactivity. All of them, except for helium, which has 2, have 8 valence electrons, making them "unwilling" to gain any extra electrons or to lose any of their own electrons. This is why they do not react readily and are found in an uncombined form. They are, as their group name indicates, all gases: helium (He), neon (Ne), argon (Ar), krypton (Kr), Xenon (Xe), and the radioactive radon (Rn).

Learning Checks

1. In reference to the noble gases, what is meant by the word "noble"?

 Ans: All noble gases have a filled valence shell, implying that they do not wish to gain or lose any electrons. This makes the group 8A elements highly unreactive. Noble refers to the inert (unreactive) nature of all noble gases.

2. With the exception of helium, how many valence electrons do group 8A elements have?

 Ans: With the exception of helium, all group 8A element have 8 valence electrons.

Group B: The Transition Metals

The elements belonging to the groups 3 through 12 (or the B groups) of the periodic table are called the transition metals; as any metals, they will conduct electricity and heat, are shiny and have luster, are ductile and malleable, and have a tendency to lose electrons to become cations. The transition metals are otherwise quite heterogeneous in their properties. For instance, only iron (Fe), cobalt (Co), and nickel (Ni) can produce a magnetic field; mercury (Hg) is the only liquid metal at room temperature. In a very unique way for a transition metal, all of the known isotopes of technetium (Tc) are radioactive. However, almost all the transition metals share one characteristic: besides being metallic in nature, they can have more than one oxidation state, meaning they can exhibit different charges. Some common examples are iron with its two common oxidation states, +2 and +3, written as Fe^{2+} and Fe^{3+}, and a less common +6 oxidation state written as Fe^{6+}.

Some transition-metal based pigments have been widely used throughout the years by artists, and some of their common names might be familiar: Green Malachite ($CuCO_3 \cdot Cu(OH)_2$), Viridian (Cr_2O_3), Azurite ($CuCO_3 \cdot Cu(OH)_2$), Chinese white (ZnO), Vermilion (HgS), and Prussian blue ($[Fe_4[Fe(CN)_6]_3]$), which actually contains iron in both +2 and +3 oxidation states.

The inner transition metals, the lanthanides, or lanthanoids, and the actinides, or actinoids, are located at the bottom of the table and are also called the rare earth metals. These elements all have nearly identical chemical and physical properties, making them very difficult to identify and separate. As their names indicate, they are quite rare in nature, with China being a main producer, but

some can be synthesized in particle colliders by physicists for a very high cost. Some of them were produced over time by the radioactive decay of other elements. Although they have the reactivity of an alkali-metal, they are not very much used, except in high-tech electronics and military devices. Moreover, since all actinides are radioactive, they have little commercial significance but can be used in nuclear power plants or as weapons.

Learning Checks

1. Other than being metallic, what other characteristic do all transition metals have in common?

 Ans: Almost all transition metals have multiple oxidation states. This is vastly different from main group elements that usually have only one oxidation state.

2. What process is thought to be responsible for producing some of the rare earth metals?

 Ans: Several of the rare earth metals are thought to have formed through the radioactive decay of other elements.

COMBINING MOLE AND MASS: THE MOLAR MASS

The periodic table provides a lot of very useful information for a chemist. One of them is the atomic mass which is written under the symbol for each element. For instance, the atomic mass for one hydrogen atom, AW(H), is 1.00794 amu (atomic mass unit). The atomic mass is different from the mass number. Remember that the mass number is the number of protons and neutrons in the nucleus of an atom, whereas the atomic mass is the mass for one of the atoms. If one considers a mole of atoms, then the numerical value found in the periodic table does not change but the unit is now gram per mole instead of atomic mass unit. Therefore, the mass of one mole of hydrogen atoms, MW(H), is 1.00794 g/mol. The concept of mole has already been described in Chapter 2. If one chemical compound is made of several atoms, then its mass (molecular or molar) is the some of the masses of the individual atoms. An example is shown below:

The mass of one molecule of carbon dioxide CO_2 is:

$$AW(C) + 2\,AW(O) = 12.0107\ \text{amu} + 2 \times 15.9994\ \text{amu} = 44.0095\ \text{amu}$$

Because the numerical values for one molecule or one mole of molecules are the same, one mole of carbon dioxide molecules (6.022×10^{23} molecules) weighs 44.0095 g/mol. Another way of expressing this is by saying that the molar mass of CO_2 is 44.0095 g/mol.

Learning Checks

1. What is the atomic mass of oxygen? What is its molar mass? What is the molar mass of ozone, O_3?

 Ans: As written in the periodic table, one atom of oxygen weighs 15.9994 amu and one mole of oxygen atoms weighs 15.9994 g/mol. The molar mass of ozone is: 3×15.9994 g/mol = 47.9982 g/mol.

2. What is the molar mass of water H_2O?

 Ans: The molar mass for each atom has to be added up:

 $$2\,MW(H) + MW(O) - 2 \times 1.00794\ \text{g/mol} + 15.9994\ \text{g/mol} = 18.01528\ \text{g/mol}$$

Once one knows how to calculate the molar mass, it is easy to find the number of moles in a certain amount of compound, using this formula:

$$Mass = \# \, moles \times MW$$

The mass is given by the number of moles of molecules multiplied by the molar mass of each molecule.

Learning Checks

1. Assuming an egg weighs 71 grams. How much does a dozen eggs weigh? How much does a mole of eggs weigh?

 Ans: In order to get the mass of a dozen eggs, we simply multiply the mass of one egg by the quantity of eggs, 12 in this case.

 $$71 \, g \times 12 \, eggs = 852 \, g$$

 A dozen eggs weighs 852 grams.

 The word "mole" is similar to "dozen" in that it describes a specific number of items, although a very large number.

 $$71 \, g \times \left(6.02 \times 10^{23}\right) \, eggs = 4.27 \times 10^{23} \, g$$

 A mole of eggs weighs 4.27×10^{23} grams. If converted into tons, it would be equal to 4.70×10^{17} tons! For comparison, the Earth is estimated to weigh 6.58×10^{21} tons.

2. What is the mass of 3.5 moles of ozone, O_3?

 Ans: First the molar mass of ozone has to be calculated: $3 \times 15.9994 \, g/mol = 47.9982 \, g/mol$.

 Then, since there 3.5 moles, this molar mass has to be multiplied by 3.5.

 $$3.5 \, moles \times 47.9982 \, g/mol = 167.9937 \, g$$

 Note that the moles as a unit cancels out.

3. How many moles are present in 75.2 grams of ozone? How many molecules does that represent?

 Ans: The formula mass = # moles × MW can be rearranged to solve for number of moles:

 $$\# moles = \frac{mass}{MW}$$

 $$\# moles = \frac{75.2 \, g}{47.9982 \, g/mol} = 1.5667 \, moles$$

 There are 1.5667 moles of ozone in 75.2 grams of ozone. Since each mole contains Avogadro's number of molecules, the number of ozone molecules is as follows:

 $$1.5667 \, moles \times 6.022 \times 10^{23} \, molecules \, per \, mole = 9.4348 \times 10^{23} \, molecules$$

 There are 9.4348×10^{23} molecules of ozone in 75.2 grams of it. Note that the mole as a unit cancels out.

PROBLEMS

1. Why is Mendeleev considered to be the father of the periodic table?

2. The ordering of elements in a period is based on what atomic property?

3. Why would arranging the elements by mass cause issues?

4. For any element in the periodic table, the number above the elemental symbol is described as what? What about the number below the atomic symbol?

5. How is the modern periodic different from Mendeleev's version? In what ways are they similar?

6. List some general properties of metals, non-metals, and metalloids.

7. If an element is a poor conductor and exists as a liquid at room temperature, which of the three main categories is it likely to belong to?

8. Why is it often difficult to make generalizations about the properties of metalloids?

9. From the properties list, categorize the unknown element as a metal, non-metal, or metalloid: The compound is a poor conductor of electricity. It exists as a solid at room temperature. It has a high boiling point. It has a metallic luster.

10. List the order of reactivity for the alkali metals (main group 1A).

11. Why are metalloids used as semiconductors?

12. Although hydrogen is placed at the top of the first column, it is not considered to be an alkali metal. Why is this?

13. What kind of cations do alkaline earth metals form?

14. What charge does aluminum take?

15. How many allotropic forms can carbon exist as?

16. What was the last allotrope of carbon to be discovered?

17. How many non-metals, metals, and metalloids are found in group 5A?

18. What role did arsenic play in Egyptian art?

19. Why does nitrogen have a tendency to from three bonds?

20. Why are group 6A elements sometimes called the chalcogen family?

21. Based on the number of valence electrons oxygen has, why do you think oxygen has a tendency to form two bonds?

22. In reference to the halogens, what does the term "salt former" imply?

23. Why would a highly reactive material be stored in an environment saturated with argon or neon?

24. If an element produces a magnetic field, where in the periodic table will it be found?

25. Which transition metals produce a magnetic field?

26. Why can iron exist as both as Fe^{+2} and Fe^{+3}?

27. Why is it difficult to distinguish between different types of rare earth metals?

ANSWERS

1. Dmitri Mendeleev was a Russian chemist that arranged the elements into rows from increasing atomic mass (now we use atomic number instead), running from left to right. By doing this, he created columns of elements that possess similar chemical and physical properties. He called these columns, families of element. He is considered the father of the periodic table although he was not the only one to have arranged elements in a pattern, his pattern and his genius allowed to predict the existence of yet-to-be-discovered elements.

2. The ordering of elements in a period is based on the increasing atomic number Z from left to right.

3. The problem with trying to arrange the periodic table by mass is due to isotopes. Some elements have many isotopes that give the element an average mass.

4. The number above any element on the periodic table is the atomic number of the element. This is how the modern periodic table is organized. The number below the atomic symbol is the average mass of the element.

5. Mendeleev's periodic table the modern periodic table differ by the organization of the elements. Mendeleev organized by atomic mass. The modern periodic table is organized by atomic number. They are similar in the grouping of families. Both Mendeleev and the modern table group columns of atoms by chemical and physical properties. The modern periodic table does not have the blanks Mendeleev's has.

6. Metals are often identified by their shiny, metallic luster, malleability, and ductility (thermal and electrical). Metals are located on the middle and left side of the periodic table. Non-metals have the opposite physical properties of the metals. Non-metals mostly exist in a gaseous state at room temperature, lack metallic luster, have little to no ductility, and their chemical reactivity varies greatly. Finally, metalloids possess some properties of both metals and non-metals. Each metalloid exhibits its own specific set of properties.

7. If an element is a poor conductor and exists as a liquid at room temperature, then the element is most likely a non-metal.

8. Metalloids possess some properties of both metals and non-metals. Each metalloid exhibits its own specific set of properties. Metalloids are inefficient conductors; but some are used as semiconductors.

9. An element with poor conductance of electricity, exists as a solid at room temperature, possesses a high boiling point, and has a metallic luster would most likely be classified as a metalloid.

10. As the period number increases down the alkali metal group, the reactivity of the elements increases. For example: Rubidium is more reactive than sodium in general. Alkali metals react violently in water. This means that rubidium would react in a more violent manner than sodium would in the presence of water.

11. Metalloids are inefficient conductors of heat and electricity. This makes them great semiconductors.

12. Hydrogen is not considered an alkali metal because it does not possess the same physical or chemical properties as these metals. It is actually a non-metal and exists as diatomic a gas at room temperature. Hydrogen is placed on the left side of the periodic table because of its one valence electron. That is the only similarity that it shares with the alkali metals.

13. Alkaline earth metals form cations with a plus two charge. For example:
$$Sr \rightarrow Sr^{2+} + 2e^-.$$

14. When Aluminum becomes an ion, it loses three electrons and results in a plus three charge. For example: $Al \rightarrow Al^{3+} + 3e^-$.

15. Carbon is found in nature in four allotropic forms: amorphous (coal or soot), graphite, diamond, and free carbon C_{60}.

16. The last allotrope of carbon was recently discovered by Sir Harry Kroto and is named $C_{60,}$ buckminsterfullerene.

17. Group 5A contains six elements. Nitrogen and phosphorus are non-mentals, arsenic and antimony are metalloids, and bismuth and ununpentium are metals.

18. Arsenic was incorporated into Egyptian art in the form of yellow arsenic sulfide (As_2S_3). This substance fades easily in the presence of light, and it can also fade when mixed in the presence of lead or copper containing pigments.

19. Nitrogen has 5 valence electrons, 2 of them are locked in a non-bonding pair and 3 of them are free to form one bond each.

20. Group 6A elements are sometimes called chalcogens because they were often associated with copper ore. The word "chalcogens" literally means "copper-former."

21. Oxygen has 6 valence electrons, 4 of them are in non-bonding pairs and 2 of them are free to form one bond each.

22. The term "salt-former" refers to the chemical property of halogens that includes their highly reactive and corrosiveness with metals and storing containers.

23. Argon and neon are noble gases, which mean that they are not naturally reactive with other elements. Therefore, storing highly corrosive or reactive substances under argon or neon will eliminate the ability of moisture or other gaseous molecules from reacting with the stored substance or from disturbing the process (neon lamp).

24. If an element produces a magnetic field, then it will be located in the transition metals on the periodic table.

25. Elements, which include iron, cobalt, and nickel, produce magnetic fields.

26. Iron has two common oxidization states. Iron can oxidize to Fe^{2+} or Fe^{3+}. This is a common characteristic of transition metals.

27. Many of the rare earth metals have very similar chemical and physical properties. This means the separation and identification of these elements difficult.

Ionic Compounds

IONS

An ion is an atom that carries an electrical charge. Ions form when a neutral element either loses or gains an electron. The strength of the charge depends on how many electrons were gained or lost. In the periodic table, each element is represented in a neutral state, meaning that the element has an equal number of electrons and protons. If a neutral element loses an electron, it becomes positively charged and is called a cation. If it gains an electron, it becomes negatively charged and is called an anion. Another way of stating this is to say that for an element to become a cation and to have a positive charge, it must have fewer electrons than protons; for it to be negatively charged, it must have more electrons than protons. Furthermore, an element can only be described as neutral if and only if it has the same amount of protons and electrons. Non-metals tend to gain electrons to form negatively charged ions called anions while metals tend to lose electrons to form positively charged ions called cations.

Learning Check

1. Fill in the following table.

Element	Protons	Electrons	Formula
Zinc		28	
Iron		23	
			Fe^{2+}
			Br^{-}

Solution:

Element	Protons	Electrons	Formula
Zinc	30	28	Zn^{2+}
Iron	26	23	Fe^{3+}
Iron	26	24	Fe^{2+}
Bromine	35	36	Br^{-}

Zinc: Zinc has 30 protons, meaning 30 positive charges, and since there are only 28 electrons, meaning 28 negative charges, the charge is

$$30^{+} + 28^{-} = 2^{+}$$

The formula must be zinc with a +2 charge, Zn^{2+}.

Iron: Iron has 26 protons thus 26 positive charges. In this instance, it has 23 electrons thus 23 negative charges:

$$26^{+} + 23^{-} = 3^{+}$$

The formula must be iron with a +3 charge, Fe^{3+}.

Fe^{2+}: Iron has 26 protons that fact never changes. Remember that if the number of protons changes, the element changes as well. So we need to figure out how many electrons iron needs to have to form a +2 ion.

$$26^{+} + x^{-} = 2^{+}$$

The answer is 24 electrons will cause iron to have a +2 charge.

Br^{-}: Bromine has 35 protons. To make an ion that has a $^{-}1$ charge, there must be one more electron than there are protons, so 36 electrons.

FORMING AND NAMING IONS

In chemistry, like in all sciences, it is mandatory to use common naming rules that are recognized internationally. The International Union of Pure and Applied Chemistry (IUPAC) has established these rules. We have already briefly seen the name of a few simple ions in the periodic table chapter and now we will see more details.

Non-Metals

Non-metals have a tendency to become anions; therefore, the name of their ions is the name of the element with the end of the name replaced by the suffix –ide. As seen previously in Chapter 3, they will gain electrons based on their location in the periodic table. If they belong to group 5A, they will gain 3 electrons in order to reach a full shell, which consists of 8 electrons (it is called the octet rule for *oct–* meaning eight in Latin), if they belong to group 6A, they need to gain 2 electrons, and only 1 when they belong to group 7A. Common and useful examples of anions are listed in Table 4.1.

Case of Hydrogen

Hydrogen is a very unique element because it can either become positively or negatively charged. When hydrogen loses its unique valence electron, it becomes H^{+} and is called a hydrogen ion or proton. When it gains an electron, it is written H^{-} and is called ion hydride.

Table 4.1 Common and useful examples of anions

Name of element	Ionic form	Name of ion
Nitrogen	N^{3-}	Nitride
Phosphorus	P^{3-}	Phosphide
Arsenic	As^{3-}	Arsenide
Oxygen	O^{2-}	Oxide
Sulfur	S^{2-}	Sulfide
Fluorine	F^-	Fluoride
Chlorine	Cl^-	Chloride
Bromine	Br^-	Bromide
Iodine	I^-	Iodide

Metals of Group 1, 2, and 3A

The metals belonging to the groups 1, 2, and 3A all have a well-defined oxidation state when they lose electrons, meaning they have only one possible charge, which is determined by the number of valence electrons they have. For instance, group 1A metals all become M^+, group 2A M^{2+}, and group 3A M^{3+}. Consequently, there is no need to indicate the charge of that ion as it is understood from their location in the periodic table. Here are some examples: Na^+ is called sodium ion, Ca^{2+} is called calcium ion.

A table summarizing the relationship between the location in the periodic table for groups 1A, 2A, 3A, 5A, 6A and 7A is shown here (Table 4.2).

Metals of Group B and 4A

Transition metals are somewhat different from the group 1, 2 and 3A metals. Since they are metals, they still will lose electrons and become cations. However, because the electronic orbitals of these metals are pretty close in energy, it happens that they will lose not only their valence electrons but

Table 4.2 Relationship between group number and ionic charge for selected groups

Group Number	Number of Valence Electrons	Electron Change to Give an Octet	Ionic Charge	Examples
Metals				
1A	1	Lose 1	1+	Li^+, Na^+, K^+
2A	2	Lose 2	2+	Mg^{2+}, Ca^{2+}
3A	3	Lose 3	3+	Al^{3+}
Non metals				
5A	5	Gain 3	3-	N^{3-}, P^{3-}
6A	6	Gain 2	2-	O^{2-}, S^{2-}
7A	7	Gain 1	1-	F^-, Cl^-, Br^-, I^-

Table 4.3 Most important transition metal ions

Element	Possible Ions	Systematic Name	Older Name
Iron	Fe^{2+} Fe^{3+}	Iron (II) Iron(III)	Ferrous Ferric
Copper	Cu^+ Cu^{2+}	Copper(I) Copper(II)	Cuprous Cupric
Gold	Au^+ Au^{3+}	Gold(I) Gold(III)	Aurous Auric
Tin	Sn^{2+} Sn^{4+}	Tin(II) Tin(IV)	Stannous Stannic
Lead	Pb^{2+} Pb^{4+}	Lead(II) Lead(IV)	Plumbous Plumbic
Manganese	Mn^{2+} Mn^{3+}	Manganese(II) Manganese(III)	Manganous Manganic
Cobalt	Co^{2+} Co^{3+}	Cobalt(II) Cobalt(III)	Cobaltous Cobaltic
Chromium	Cr^{2+} Cr^{3+}	Chromium(II) Chromium(III)	Chromous Chromic
Nickel	Ni^{2+} Ni^{3+}	Nickel(II) Nickel(III)	Nickelous Nickelic

sometimes also an electron or more from another shell. The consequence of this unusual trait is that they may have different oxidation states, i.e., different charges. In order to account for this, a roman numeral is placed after the name of the ion to reflect that charge. Finally, some of these metals were named a long time ago, before the IUPAC agreed on the Roman numeral system, and have a suffix –ous for the smaller charge or –ic for the greater charge. For example, the ion Fe^{2+} is called iron (II) ion (IUPAC name) or ferrous ion (older name). Table 4.3 lists the most important ions of transition metals.

It is always a challenge to formulate rules for a large number of elements, and in some cases this creates some exemptions to the rule. Silver, zinc, and cadmium, although transition metals, do have a preferred charge, so for them there is no need to indicate the Roman numeral. So Zn^{2+} is called zinc ion, Ag^+ silver ion, and Cd^{2+} cadmium ion.

Polyatomic Ions

In some instances, ions may be composed of 2 or more atoms bonded together, forming polyatomic ions, mostly anions. When an element combines with oxygen to form two different polyatomic ions, the ion with the smallest number of oxygen atoms will be named with the suffix –ite and the other one with –ate, such as nitrite for NO_2^- and nitrate for NO_3^-. Moreover, one may have noticed that some ions have the suffixes -hypo or -hyper. This is the case when more than two ions of that element combined with oxygen are known; -hypo is attributed to the ion with the smallest number of oxygen atoms, whereas -hyper is placed before the name of the ions with the greatest number of oxygen atoms. A very common example is for the ions formed by combining chlorine and oxygen, since four possible ions may be formed: ClO^-, ClO_2^-, ClO_3^- and ClO_4^-, respectively named hypochlorite, chlorite, chlorate, and perchlorate. A list of the most important polyatomic ions is provided in Table 4.4 with their charge and names.

Table 4.4 Polyatomic atoms, Including Chemical Formula and Name

Nonmetal	Formula of ion	Name of ion
Hydrogen	OH^- H_3O^+	Hydroxide Hydronium
Nitrogen	NH_4^+ NO_3^- NO_2^-	Ammonium Nitrate Nitrite
Chlorine	ClO_4^- ClO_3^- ClO_2^- ClO^-	Perchlorate Chlorate Chlorite Hypochlorite
Carbon	CO_3^{2-} HCO_3^- CN^- $CH_3CO_2^-$	Carbonate Hydrogen carbonate (or bicarbonate) Cyanide Acetate
Sulfur	SO_4^{2-} HSO_4^- SO_3^{2-} HSO_3^-	Sulfate Hydrogen sulfate (or bisulfate) Sulfite Hydrogen sulfite (or bisulfite)
Phosphorus	PO_4^{3-} HPO_4^{2-} $H_2PO_4^-$ PO_3^{3-}	Phosphate Hydrogen phosphate Dihydrogen phosphate Phosphite
Oxygen	O_2^{2-}	Peroxide
Chromium	CrO_4^{2-} $Cr_2O_7^{2-}$	Chromate Dichromate
Manganese	MnO_4^-	Permanganate

FORMING AND NAMING IONIC COMPOUNDS

These ions cannot exist by themselves, so they have to combine with each other in order to create an ionic compound that has no charge, although it does contain charged entities. In order to achieve electrical neutrality, an anion (or two or three) has to combine with a cation (or two or three). There is electrostatic attraction between the cation and anion within the ionic compound, which makes this bond ionic. Electrostatic attraction takes place between entities of opposite charges in a similar way that magnetic attraction makes the negative pole of a magnet attracted to the positive pole of another magnet. The total number of positive charges must equal the total number of negative charges, and the parentheses with subscripts are used if there is more than one ion of a given type. The formula of the compound indicates the ratio of cations to anions, which is determined by the charges. Cations are always listed first and anions last. Some examples of colorful ionic compounds are shown in Figure 4.1.

Figure 4.1 Examples of ionic compounds containing metals and their colors in solution

How to find the formula of an ionic compound based on the charges of the elements that it is composed of? Here is an example: Na⁺ and Cl⁻, sodium ion and chloride ion, have each one charge so they combine to give NaCl, which is electrically neutral. The name of this compound is found by placing the name of the cation first and of the anion second: sodium chloride, also commonly known as table salt. Note that the formula does not show the charges of the ions in the compound. In cases where it is a little bit more complicated, one can use the cross-over method as follows:

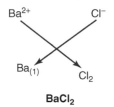

$$BaCl_2$$

Learning Checks

1. Find the formula and name for a compound made of magnesium and nitrogen.

 Ans: Magnesium is a group 2A metal and as such will lose 2 electrons while nitrogen is a 5A non-metal so it will gain 3 electrons, both becoming Mg^{2+} and N^{3-}. Using the cross-over method, it is easy to determine that the formula of the ionic compound is Mg_3N_2 and is called magnesium nitride.

2. Write out the formula for copper (II) cyanide.

 Ans: Copper is a transition metal and can exist in more than one ionic form. When naming ionic compounds that are capable of existing in more than one ionic form, Roman numerals are used to distinguish one species from another. The Roman numeral represents the magnitude of the positive charge. Hence, copper (II) is Cu^{2+}. Cyanide is a polyatomic anion, having the formula CN^-. Do not let polyatomic ions confuse you: The negative charge on the cyanide anion means that the entire structure is negatively charged, and in order for the net charge to be zero, two cyanides must be present for every one copper (II) ion. When two or more polyatomic ions are needed, the polyatomic ion is placed in parentheses with a subscript that represents the number of polyatomic ions needed: $Cu(CN)_2$

3. Sodium cyanide is a deadly poison. What is the formula for sodium cyanide?

 Ans: Looking at Table 4.4, the formula for cyanide is CN^-. It is an anion with a −1 charge. In Chapter 3, we learned that sodium, Na, has a +1 charge; therefore, one sodium will be enough for each cyanide and the formula is: NaCN.

4. Silver nitrate is used extensively in black and white film photography. What is the formula for silver nitrate?

 Ans: Silver forms a +1 ion. Nitrate has a −1 charge; therefore, the formula is $AgNO_3$

OLDER NAMES

Since some metallic ions have older names, which can also be used in naming ionic compounds. In such a case, the metal name with a Roman numeral is replaced by the root of its name and −ous is added at the end if it is the ion with the smallest oxidation state and −ic for the one with the larger oxidation state, just as was done earlier. A list of examples is provided in Table 4.5.

USE OF IONIC COMPOUNDS IN ART

Most pigments are made of ionic compounds; some examples have already been discussed in this text. Dyes, which are colorants obtained from organic molecules, will be described in another chapter. A list of pigments for each color showing not only the chemical and common names along with the chemical formula but also the chronological order by which they have been used throughout the ages is provided. Note that not all the pigments described in Table 4.6 are ionic and that the number of actual pigments is so large that the list is not meant to be a complete list of all pigments but just of some very common ones.

Table 4.5 Systematic and older names for ionic compounds containing transition metals

Compound	Systematic Name	Older Name
$FeCl_2$	Iron (II) chloride	Ferrous chloride
$FeCl_3$	Iron (III) chloride	Ferric chloride
Cu_2S	Copper (I) sulfide	Cuprous sulfide
$CuCl_2$	Copper (II) chloride	Cupric chloride
$SnCl_2$	Tin (II) chloride	Stannous chloride
$SnCl_4$	Tin (IV) chloride	Stannic chloride
$PbBr_2$	Lead(II) bromide	Plumbous bromide
$PbBr_4$	Lead (IV) bromide	Plumbic bromide

Table 4.6 List of selected pigments with their color, chemical formula and names and timeline

White						
Common name	Chalk	Gypsum	Lime white	Lead white	Zinc white	Titanium white
Chemical name	Calcium carbonate	Calcium sulfate	Calcium hydroxide	Lead (II) carbonate, lead (II) hydroxide	Zinc oxide	Titanium (IV) oxide
Chemical formula	$CaCO_3$	$CaSO_4$	$Ca(OH)_2$	$PbCO_3, Pb(OH)_2$	ZnO	TiO_2
Used since	Prehistory in cave painting	Prehistory in cave painting	Prehistory in cave painting	Antiquity	Sold in 1834 as Chinese white	1921

Blue			
Common name	Ultramarine	Azurite	Smalt, cobalt glass
Chemical name	Sodium alumino sulfosilicate	Copper (II) carbonate, copper (II) hydroxide	Cobalt potassium silicate
Chemical formula	May vary: $Na_{8–10}Al_6Si_6O_{24}S_{2–4}$	$CuCO_3, Cu(OH)_2$	$CoAsS, CoAs_2$
Used since	Obtained from Afghanistan mines as a precious stone (lapis lazuli) since antiquity, man-made since 1828	Antiquity, replaced by Prussian blue in the 18th century	Used from 15th to 18th century in Europe, but was known in Egypt in the antiquity

Blue			
Common name	Prussian blue	Cobalt blue	Cerulean blue
Chemical name	Iron (III) hexacyanoferrate (II)	Cobalt (II) oxide, aluminum oxide	Cobalt (II) oxide, tin (II) oxide
Chemical formula	$Fe[Fe^{3+}Fe^{2+}(CN)_6]_3$	CoO, Al_2O_3	CoO, SnO
Used since	1704	1803	1860

Green					
Common name	Malachite	Verdigris	Cobalt green	Emerald green	Viridian
Chemical name	Copper (II) carbonate, copper (II) hydroxide	Copper (II) acetate	Cobalt (II) oxide, zinc oxide	Copper (II) acetate, copper (II) arsenite	Chromium (III) oxide
Chemical formula	$CuCO_3.Cu(OH)_2$	$Cu(CH_3COO)_2$	CoO, ZnO	$Cu(CH_3COO)_2$ $Cu(AsO_2)_2$	Cr_2O_3
Used since	Antiquity	Antiquity	Late 18th century	Late 18th century	Late 18th century

Table 4.6 *(Continued)*

Yellow						
Common name	Orpiment	Litharge	Lead tin yellow	Naples yellow	Chrome yellow	Cadmium yellow
Chemical name	Arsenic sulfide	Lead (II) oxide	Lead (II) stannate	Lead (II) antimonate	Lead (II) chromate	Cadmium (II) sulfide
Chemical formula	As_2S_3	PbO	Pb_2SnO_4	$Pb_3(SbO_4)_2$	$PbCrO_4$	CdS
Used since	Antiquity	Antiquity	Renaissance	1758	Late 18th century	1829

Red				
Common name	Ochre	Red lead, Minium	Red vermilion	Cadmium red
Chemical name	Iron (III) oxide	Mix of lead (II) and (IV) oxide	Mercury (II) sulfide	Cadmiun (II) sulfide, cadmium (II) selenide
Chemical formula	Fe_2O_3	Pb_3O_4 (2 PbO .PbO_2)	HgS	CdS.CdSe
Used since	Prehistory in cave painting	Antiquity	Antiquity	1910

Other colors such as black can be produced by using carbon black obtained from burning wood or bone black obtained from burning bones. Both forms have been known since prehistory because they have been detected in cave paintings.

When a mixture of red and yellow was not used to create an orange color, it was obtained from an arsenic sulfide pigment, named Realgar As_4S_4, until it was made in a chemistry laboratory as chrome orange, a lead (II) chromate.

One of the colors that was probably the most elusive for artists was violet, until it was synthesized in the middle of the 19th century as cobalt violet, a cobalt (II) phosphate or cobalt (II) arsenate compound, $Co_3(PO_4)_2$ or $Co_3(AsO_4)_2$, which then was replaced by manganese violet, a manganese (III) ammonium pyrophosphate.

A WORD OR TWO ON CERAMICS

The origins

Neolithic men needed a way other than baskets and leather bags to protect food and liquids from the natural elements and animals. They also needed a means of transport for trading purposes, so they created vessels from clay, allowing them at the same time to cook and boil food in a new fashion. Pots were made either by pinching or by coiling pieces of clay together, sometimes using another pot as a mold. Pottery fragments dating from the Neolithic agricultural revolution have been found all over the Middle East. Soon the turntable was invented in Egypt around 5,000 BC to facilitate the potters' ability to work on all sides of the piece. Later when the wheel was invented for cart use in Mesopotamia, it was adapted to be used as a potter's wheel. The word ceramic has its root in the Greek word, *keramos*, which means "burnt earth", referring to the firing of the clay to become a true piece of ceramic. This word also gave its name to an area of Athens in Greece where

the potters could be found in the antiquity: *kerameikos*. The technique of pottery is only one aspect of ceramics making which also includes the making of figurines and other 3D-objects made from modeling and firing clay.

Clays

There are various types of clay depending on their composition: kaolin also known as china clay, ball clay, slip clay, fire clay, flint clay, pottery clay, shale, brick clay, vitrifying clay, and so forth. Clay minerals used to make ceramics belong to the realm of inorganic compounds that are nonmetallic crystalline solids and that have been formed during weathering of rocks. For instance, granite breaks down into quartz, feldspars, and mica, the two latter making the clay material. Basalt, in a similar way, breaks down into feldspars as well and other magnesium- and iron-based minerals. Feldspars, the most abundant mineral present on the surface of the earth, are indeed the major component of clay. They are anhydrous potassium aluminosilicates $KAlSi_3O_8$; however, they can also contain sodium and calcium ions in addition or replacement of the potassium ions. These aluminosilicates are made of negatively charged ions: tetrahedral silicates SiO_4^{4-} and octahedral aluminates AlO_6^{6-}. The ratio of silicates and aluminates gives different types of clay with different physical properties. Kaolinite has the following layers in this specific order: silicate, aluminate, water or cations, silicate, aluminate. Smectite (talc) or vermiculite both have this arrangement: silicate, aluminate, silicate, water or cations, silicate, aluminate, and silicate. Water acts as a lubricant during the molding process and evaporates during the drying stage. The amount and kind of impurities present in the clay will modify its physical properties, like color but more importantly the temperature of the fire at which the clay will be transformed into a ceramic. For instance, earthenware clays fuse at lower temperatures and therefore can never achieve a glassy translucent aspect, whereas stoneware or porcelain which require higher temperatures can. Because pure materials have a higher melting point than impure ones, compounds can be added to a clayin order to lower the melting point. The mixture thus obtained is called eutectic, literally meaning "easier to melt." Finding the right composition for a clay body is not a trivial affair and various chemicals can be added to lower or raise the melting temperature. Maturity or maturing point in ceramics is the point at which the clay has fused into a ceramic during firing. Flux compounds can be naturally present or added to the clay in order to lower the needed temperature, whereas refractory compounds elevate it. Ubiquitous earthenware clay, for instance, is rich in iron, a common flux so it could be fired at low temperatures in a simple fire or pit, making it a very ancient type of known ceramics, even before early kilns were created around 6,000 years BC in Mesopotamia.

Clay minerals look like flaky layers, which is due to the flat shape of platelets they are made of. These platelets are held together by hydrogen bonds and the space in between them can be filled with water or other minerals. That location of the water in wet clay is responsible for its lubricant effect making wet clay slippery and plastic. Plasticity refers to an object ability to be deformed into permanent shapes. Depending on their chemical compositions, clays have different levels of plasticity and the artist has to choose carefully since clays for casting require different physical properties as the ones for throwing on a potter's wheel, for instance.

Firing clays into ceramics

Once the clay has been made into the desired shape, the firing process will hardens it following these steps:

1. Air drying: The water from the clay evaporates on its own, shrinking the object. Clays that contain mainly fine particles, like porcelain, will shrink more than other types of clays but they will also lead to a denser and harder final object. In order to prevent the formation of cracks and other defects, especially in arid climates, this step should be done slowly and should be carefully monitored, moistening if necessary. At the end of this step, the object, called a greenware, is said to be leather hard although it still contains some water.

2. Low-temperature heating: Objects are placed in the kiln at a low temperature and heated slowly pass the boiling point of water (100°C). If the water is heated too fast, the object may burst since liquid water expands to a large volume when converted into steam. Temper, like sand, straw, or mica, make clay coarser and allow water to escape more easily during firing thus reducing bursting or cracking.

3. Dehydration: Some solids contain molecules of water as part of their structure, they are said to be hydrated salts. In this case, the molecules of water are included in the formula and the dehydration (removal of these water molecules) requires a higher temperature than boiling. A classic example is the blue solid compound copper (II) sulfate pentahydrate, $CuSO_4 \cdot 5H_2O$, which can be dehydrated to a white solid, anhydrous copper (II) sulfate, $CuSO_4$. A similar process takes place for the dehydration of clays at a temperature ranging from 300 to 550°C depending on the conditions and the clay itself. Because the complex chemical structure of the clay has been changed, it is not possible to revert this process and obtain the initial clay again, contrary to rehydration of an anhydrous salt yielding back the hydrated original salt. The ceramic is called at this stage a bisque. At the same time, burning off may occur. Clays, as all natural materials contain impurities which can be organic or inorganic. Most of these impurities can be burnt off at high temperatures. If an object is to be made more porous, then a compound that burns off during firing can be added, leaving gaps in the finished structure. It is important from a safety point of view to note that toxic gases may be released during this stage so working in a well-ventilated area and not inhaling the exhaust fumes (at any time of any stage) are crucial.

4. Glass transition or quartz inversion: Glass and quartz are both made of silicon dioxide so this transition or inversion is a common problem for glass makers and ceramic artists. When heating quartz containing materials like clays, a process called quartz inversion takes place at 573°C. Molecules can arrange themselves under various geometric forms, called crystalline structures, which may vary with temperatures. It is called the quartz inversion when it happens with quartz. Like a lot of other crystalline structures, quartz has different physical and chemical properties, including density, so this change in volume as a function of temperature makes the object expand and this is why they should not be too close to each other in the kiln.

5. Vitrification: The last step in the firing process is a partial fusion called vitrification, literally meaning "the making of glass," during which shrinkage occurs as molecules come closer to another. This step hardens and strengthens the structure by promoting upon cooling the formation of new crystals. The point at which the ceramics has the final desired physical properties is called the maturing point which temperature depends on the chemical composition of the clay. On the one hand, if the fire is not hot enough to reach vitrification, the clay body is said to be "open" and is still porous. On the other hand, if the firing is too hot, the temperature will be higher than the maturity point and total melting occurs, destroying the object. Pyrometric cones are placed in kilns and each bends at a specific temperature so the artists can visually check the inside of the kiln and obtain an idea of the temperature. As always, one should always follow the safety precautions set by the kiln manufacturer when doing so.

Glazes

In order to render the ceramic objects nonporous, ancient techniques rely on burnishing the object or covering it with a resin, or using a low-temperature glaze. A glaze, mainly composed of silica, is a glass-forming compound that can be applied inside or outside the object before firing and that will stick to it. The chemicals present in the glaze, silica, alumina and a flux, fuse together in the kiln, thus creating a glossy and glassy layer that adheres to the object: it is given the name of vitrification. The presence of the flux in the glaze is necessary since very high temperatures are required to fuse the silica (1,899 °C or 3,271°F), which would at the same time melt the clay. Glazes can also have a decorative effect if colorants are added. The oldest glazed ceramic tiles currently known date from

© val lawless, 2014. Used under license from Shutterstock, Inc.

Figure 4.2 Examples of ionic compounds used as colorants in pottery

9,000 years BC and were produced in Mesopotamia. Ionic compounds can be used as colorants in the process of making ceramics, when they are added to the clay or the glaze. Metal oxides and metal carbonates are widely used and the color they may produce depends on the condition of the firing. The most common colorants are iron (III) oxide which can lead to red and brown colors if used by themselves and to blue-green colors if used in combination with potassium, to yellow with barium or calcium. In a similar manner, cobalt carbonate or oxide provides blue and green colors and chromium and tin salts can give a pink color. Another versatile metallic salt used in ceramics is copper. Copper (II) carbonate can color the pieces green, turquoise, or blue and under the right reductive condition in the kiln, a red color can be obtained. Also opacity can be increased by adding a form of titanium dioxide called rutile TiO_2, or zirconium silicate and even tin (IV) oxide.

Some famous examples of ceramics in history

Black figure pottery developed in 7th century BC in Corinth, Greece. The object is naturally red from the clay being used and shows black designs. In order to produce these black figures, the object is completely covered witha slip that contains red iron (III) oxide, Fe_2O_3. First the object is placed in the kiln under normal conditions and the red clay reaches its maturity point. Then the vents of the kiln are closed, starving the fire from atmospheric oxygen, creating a reducing atmosphere. The fire has to extract the oxygen from the iron oxide slip to continue its combustion, which chemically reduces the iron (III) oxide into iron (II) oxide, which displays a strong black color, as shown in the reaction below.

$$Fe_2O_3 \rightarrow 2\ FeO + \frac{1}{2}\ O_2$$

The final stage for the artist is to scratch out the black slip in order to make the red color hidden underneath. The opposite technique, called red figures, used the same concepts but the slip is painted only around what will be after firing the red figures. This method is called reserve (Figure 4.3).

Another famous example of ceramics is terracotta army found in China. The empire of China was unified around the 3rd century BC by the emperors of the Quin dynasty. Its first emperor, Quin Shi Huang, was buried with an army of thousands of terra-cotta life size warriors and horses, making it the greatest collection of its kind (Figure 4.4).

Kaolin is also called China clay because the first deposits were discovered in China, during the ruling of the Tang dynasty from 617 to 906. When kaolin, a very pure white feldspar, is mixed with petuntze, a compound also found in China, a porcelain clay is obtained. Once fired at very high temperatures (around 1,300°C), the resulting ceramic is such a strong material that it can be spread into very thin layers that are almost translucent. This translucence is the reason why the Italian

Figure 4.3 Ancient Greek vases, left: black figure technique, right: red figure technique

Figure 4.4 The Terracotta Army buried next to Qin Shi Huang's tomb

merchants traveling on the silk road named this type of ceramics: porcellana, the Italian word for cowry shell (Figure 4.5). Indeed the strength of this type of material is so great that very thin layers can be made, creating what is now called a very fine China. Of course, this fabrication, like the making of paper or silk, was kept secret for as long as possible in China. Under the Ming, dynasty porcelain was decorated with the traditional white and blue colors, still very famous today (Figure 4.6).

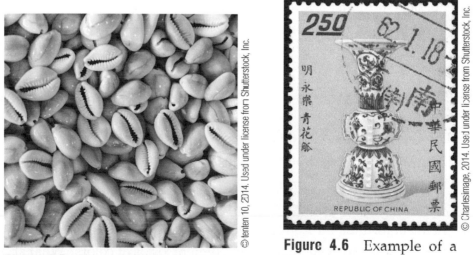

Figure 4.5 Cowry shell

Figure 4.6 Example of a Ming vase

A word on safety

Finally, it has already been mentioned that one should not inhale the fumes coming out of a kiln as they can be very toxic. Also, it is important to know that chronic exposure to some of the clay minerals can lead to lung inflammation or disease. These materials contain very fine particles, especially silicon dioxide. Silica dust, as it is commonly known, is responsible for silicosis, the miner's disease. Therefore, when working in the studio, one should never dry sweep and always try to remove dust with damp towels. Dust has to be kept at a minimum at all times whenever possible and proper ventilation or even a dust mask are all necessary steps to protect one's health.

PROBLEMS

1. Under what conditions does an element become negatively charged? Neutral? Positively charged?

2. What is the difference between a cation and an anion?

3. Fill in the table below.

Element	Protons	Electrons	Formula
Tin		48	
Mercury		78	
			Cu^{2+}
			O^{2-}
	6	6	
Aluminum		10	

4. Write the structural formula for potassium bromide.

5. Name the following ionic compound: MgO.

6. What is the structural formula for calcium sulfide?

7. What is the chemical formula for potassium permanganate?

8. Name the following compound: $FeCl_3$.

9. What is the chemical formula for lead (IV) sulfate?

10. What is the chemical formula for potassium dichromate?

11. If an ionic compound must contain 2 sulfur ions per every 1 copper ion, what is the charge of the copper ion?

12. What is the formula of sodium acetate?

13. What is the formula of tin (IV) carbonate?

14. Name the following compound: $Ni_3(PO_4)_2$.

15. What is the chemical formula of cobalt (II) iodide?

16. What is the chemical formula of barium sulfite?

17. What is the chemical formula of manganese (III) oxide?

18. What is the chemical formula for iron (III) perchlorate?

19. Lead-based compounds can create how many different kinds of colors? What about copper-based paints?

20. What color(s) would you expect a titanium-base paint to be?

21. An art dealer believes he may have been sold a fake painting. The painting was supposedly created in the 17th century. Upon chemical analysis, the painting is shown to contain trace amounts of titanium and cadmium. Is it likely that painting is from the 17th century?

ANSWERS

1. Ions are formed by the gaining or losing of electrons of neutral atoms. If an element gains a negatively charged electron, the elemental charge becomes more negative. If an element loses one of its negatively charged electrons, then the elemental charge becomes more positive. If an element does not gain or lose any electrons, then it remains a neutral atom with a net electrical charge of zero.

2. A cation is a positively charged ion. An anion is a negatively charged ion. Cations are formed by an element losing electron(s), and anions are formed by the gaining of electron(s).

3.

Element	Protons	Electrons	Formula
Tin	50	48	Sn^{2+}
Mercury	80	78	Hg^{2+}
Copper	29	27	Cu^{2+}
Oxygen	8	10	O^{2-}
Carbon	6	6	C
Aluminum	13	10	Al^{3+}

4. Find the chemical formula for potassium bromide.

Ions: K^+ and Br^- Formula: **KBr**

5. Name MgO.

Ions: Mg^{2+} and O^{2-} Name: Magnesium oxide

6. Find the chemical formula for calcium sulfide.

Ions: Ca^{2+} and S^{2-} Formula: **CaS**

7. Find the chemical formula for potassium permanganate.

Ions: K^+ and MnO_4^- Formula: **$KMnO_4$**

8. Name $FeCl_3$.

Ions: Fe^{3+} and Cl^- Name: **Iron (III) chloride**

9. Find the chemical formula of lead (IV) sulfate.

Ions: Pb^{4+} and SO_4^{2-} Formula: **$Pb(SO_4)_2$**

10. Find the chemical formula of potassium dichromate.

Ions: K^+ and $Cr_2O_7^{2-}$ Formula: **$K_2Cr_2O_7$**

11. If there one sulfide ion per every one copper ion, then:

Ions: $1(S^{2-}) + 1(Cu^{2+})$, then the charge of the copper ion is +2. Cu^{2+}

12. Find the chemical formula of sodium acetate.

Ions: Na^+ and CH_3COO^- Formula: **CH_3COONa**

13. Find the chemical formula for tin (IV) carbonate.

Ions: Sn^{4+} and CO_3^{2-} Formula: **$Sn(CO_3)_2$**

14. Name $Ni_3(PO_4)_2$.

Ions: Ni^{2+} and PO_4^{3-} Name: **Nickel (II) phosphate**

15. Find the chemical formula of cobalt (II) iodide.

 Ions: Co^{2+} and I^- Formula: **CoI_2**

16. Find chemical formula of barium sulfite.

 Ions: Ba^{2+} and SO_3^{2-} Formula: **$BaSO_3$**

17. Find chemical formula of manganese (III) oxide.

 Ions: Mn^{3+} and O^{2-} Formula: **Mn_2O_3**

18. Find chemical formula for iron (III) perchlorate.

 Ions: Fe^{3+} and ClO_4^- Formula: **$Fe(ClO_4)_3$**

19. Lead-based compounds can create different kinds of color, which include white, yellow, and red. Copper-based compounds can create colors of blue and green in paintings.

20. Titanium-based paint would include the color of white.

21. Since the painting contains trace amounts of cadmium and titanium, the painting is not from the 17th century. Titanium-based paint was used starting in 1921 under the name titanium white. Cadmium-based paints were used starting in 1910 as cadmium red. The earliest this painting could have been painted would be in the 1920s.

Oxidation Reduction Reactions

METAL ALLOYS

Metals are the most abundant elements on the periodic chart. What we will cover here is the properties of metals and in some cases their use. Their properties have proved to be a major factor in the scientific and artistic advancement of civilization. Be it a metallic sculpture, like The Thinker by French sculptor Auguste Rodin (Figure 5.1), or the vibrant color from a pigment, metals are an important component of art.

This piece is made of bronze, a mixture of copper and tin in the ratio of 88% copper and 12% tin. However, the composition can vary in this alloy, a solid mixture of two or more metals. The choice of metals for an alloy can be done by trial and error or by looking at the chemical nature of the metal. In general, for an alloy one looks for metals with similar characteristics, atomic size, and crystalline structure.

Gold is not used as a pure metal in jewelry because it is too soft, so it is sold as an alloy. Depending on the gold content and the nature of the other metals forming the alloy, different names are given. The unit for gold jewelry is the karat: symbol K, with 24K corresponding to 100% pure gold. Some examples of gold alloys used in jewelry are listed in Table 5.1.

METALLIC BOND

In looking at the ease of oxidation—i.e., ionization, or its ability to alloy with another metal—it is important to look at bonding in metals. Bonding in metals is based on the electron sea model. In this model, the outer electrons, the valence shell electrons, are considered to be delocalized from a particular nucleus; in other word, they are mobile. The delocalized electrons along with atomic size lead to the properties of metals, such as heat and electricity conductivity, malleability,

Figure 5.1 The Thinker (Rodin)

Table 5.1 Gold alloys

Alloy	Gold	Other Metals
18K yellow gold	75%	copper, silver, zinc, or cobalt
18K nickel white gold	75%	copper, nickel, zinc, or palladium, plated with rhodium
18K palladium white gold	75%	25% palladium
18K red gold	75%	25% copper
18K pink gold	75%	20% copper, 5% silver
18K green gold	75%	20% silver, 5% copper

ductility, strength, and density. The delocalized electrons are also responsible for the reactivity of the metals. As these electrons are shared over the metallic structure, they are not attached to a particular atom so they can move easily, transmit electricity, or be lost due to a reaction. The metals tend to easily lose these "electrons in the sea" and become oxidized. Metals can also easily share the "electrons in the sea" and form alloys when they are of similar size and have a similar crystal structure.

One of the chemical properties of metals is that they are easily oxidized. We will discuss oxidation in greater detail later. However, what is noted is that since metals undergo oxidation easily, they are generally found in the oxidized state. This led to their early adoption as a colorant, mineral pigment. That oxidized state can occur with oxygen or any of the non-metals on the periodic chart, especially group 6 and 7. This usually means we will find metals as metal oxides or metal halides, commonly referred to as salts. The oxidation of metals is caused by the need to be stable electronically. Electronic stability refers to the number of electrons that are around the nucleus and the tendency not to lose more. The most stable elements are those with 8 electrons in the outermost shell or a stable configuration consisting of filled or half-filled shell (more about this later). For most metals, in order to reach a stable electron configuration, they lose electrons and become positive. However, some metals, already quite stable, like gold, platinum or silver, do not easily lose electrons and are referred to as the noble metals. To reach a stable number of electrons in the outermost shell around an element we invoke the octet rule: Atoms prefer to have a filled valence shell containing eight (8) electrons like a noble gas valence shell, the exception being helium that only has 2 electrons in its outer shell. As stated, metals tend to lose electrons, whereas nonmetals tend to gain electrons. In gaining electrons, nonmetals are negatively charged and are called anions, whereas in losing electrons metals become oxidized and positive and are called cations. Because of electrostatic attraction between the cations and anions, ionic compounds are formed as we saw in Chapter 4.

OXIDATION REDUCTION REACTIONS

In many reactions the oxidation state of the elements, i.e., its charge, does not change. However, a number of important reactions occur in which there is a change in the oxidation state of the elements. When a change in the oxidation state of the elements occurs in a chemical reaction, that reaction is called an *oxidation-reduction reaction*, or *redox*. Oxidation is the loss of electrons by an element, whether as the free element, in a compound, or in a current ionic state. The loss of electrons leads to an increase in charge, i.e., more positive. For instance, if element A loses 2 electrons, it becomes A^{2+}, 3 electrons A^{3+}, and so forth. This is also valid for an ion, for instance if A^{2+} loses one electron by oxidation it becomes A^{3+}. An easy way to remember what happens during an oxidation process is to remember the acronym OIL: Oxidation Is Loss of electrons. Oxidation cannot occur by

itself; it is always accompanied by reduction, the gain of electrons by an element, which also can be remembered by an acronym: RIG: Reduction Is Gain of electrons. Indeed, the electrons lost have to be gained by another element.

Learning Check

1. Indicate whether the following redox reactions are oxidation or reduction reactions or both.

 1. $Mg^{2+}(aq) + 2\ e^- \rightarrow Mg\ (s)$
 2. $Al\ (s) \rightarrow Al^{3+}(aq) + 3\ e^-$
 3. $O_2(g) + 4\ e^- \rightarrow 2\ O^{2-}(aq)$

 Ans: In reactions 1 and 3 the electrons are on the reactant's side (left side) of the equation, this means that the Mg^{2+} (reaction 1) and the O_2 (reaction 3) are gaining electrons. Whenever an atom gains electrons, it becomes reduced, so reactions 1 and 3 are both reduction reactions.

 In reaction 2, electrons are on the products side of the reaction (right side), implying that the reaction produces free electrons. The electrons come from elemental aluminum; notice that the aluminum transitions form having a charge of 0 to a charge of 3^+. Electrons are negatively charged, so in order for the change in charge to occur, each aluminum atom must lose 3 electrons. Anytime a substance loses electrons, it becomes oxidized; therefore, reaction 2 is an oxidation reaction.

We see oxidation of materials around us all the time, iron rusting, wood burning (usually referred to as a combustion reaction), or in the early days of photography processing of film. Redox reactions are important to society in a number of ways: Development of batteries, corrosion problems, electrolytic plating, and various industrial and artistic processes rely heavily on redox. Redox reactions can release energy as heat or electrical energy, the latter being referred to as electrochemistry. Electrochemistry is the study of electrical energy within a chemical process. The energy can be derived from or used by the chemical reaction process.

A good example of a redox reaction is the reaction of zinc metal with copper ions.

$$Zn\ (s) + Cu^{2+}(aq) \rightarrow Cu(s) + Zn^{2+}_{(aq)}$$

In this reaction the zinc is being oxidized, losing 2 electrons, and the copper is being reduced, gaining these 2 electrons.

$$Zn\ (s) \rightarrow Zn^{2+}(aq) + 2e^-$$

$$Cu^{2+}(aq) + 2\ e^- \rightarrow Cu\ (s)$$

This particular redox reaction as an electrochemical reaction can release as much as 1.10 volts of electrical energy.

Learning Check

1. Consider the following equation: $Cu + 2\ AgNO_3 \rightarrow Cu(NO_3)_2 + 2Ag$

 What is oxidized? What is reduced?

 Ans: Copper metal has been oxidized by silver nitrate to give copper (II) nitrate. Silver nitrate has been reduced by copper metal to produce silver metal.

2. Consider the equation: $Sn^{2+} + Ca \rightarrow Sn + Ca^{2+}$

What is oxidized? What is reduced?

Ans: Tin gained two electrons to go from a +2 to a charge of 0 so tin is reduced. Calcium lost two electrons to go from a charge of 0 to a +2 charge and is oxidized.

BALANCING REDOX EQUATIONS

In balancing redox reactions, the concept is no different than balancing a regular chemical reaction with the exception that the numbers of electrons being lost and gained are just as important as balancing the number of atoms. Balancing redox reactions is usually accomplished using the half-equation method. This method relies on the identification of the oxidation reaction and the reduction reaction. Several important terms used include that of the *oxidizing agent*, the one being reduced or gaining electrons, and *reducing agent*, the one being oxidized or losing electrons.

For example, the overall redox reaction responsible for producing electrical energy in a car battery can be split into two distinct half-reactions.

$$\text{Overall reaction: } Pb_{(s)} + PbO_{2(s)} + 2\ H_2SO_{4(aq)} \rightarrow 2\ PbSO_{4(aq)} + 2\ H_2O_{(l)}$$

In this particular reaction the product of the reduction of Pb (IV) and oxidation of lead is Pb (II):

$$\text{Half-reaction the reduction of Pb (IV): } PbO_{2(s)} + 4H^+_{(aq)} + 2\ e^- \rightarrow Pb^{2+}_{(aq)} + 2\ H_2O_{(l)}$$
$$\text{Half-reaction for the oxidation of lead: } Pb_{(s)} \rightarrow Pb^{2+}_{(aq)} + 2e^-$$

Based on the two half-equations, one can see that there is a 2-electron loss in the oxidation reaction and 2-electron gain in the reduction reaction.

Learning Check

1. Identify which element is oxidized and which is reduced in the following equation and write the half-equations:

$$Fe^{2+}_{(aq)} + Co^{3+}_{(aq)} \rightarrow Co^{2+}_{(aq)} + Fe^{3+}_{(aq)}$$

Ans: The first step is to identify which substances experienced a change in charge. Iron transitioned from a charge of 2+ to 3+ and cobalt transitioned form a charge of 3+ to charge of 2+.

Next write the two half-reactions:

oxidation: $Fe^{2+}_{(aq)} \rightarrow Fe^{3+}_{(aq)} + 1e^-$
reduction: $Co^{3+}_{(aq)} + 1e^- \rightarrow Co^{2+}_{(aq)}$

2. Consider the following equation: $Cu + 2AgNO_3 \rightarrow Cu(NO_3)_2 + 2\ Ag$

What is oxidized? What is reduced?

Ans: One of the easiest ways to see what is happening is to break the equation down into half reactions, ignoring the nitrate which is a spectator polyatomic ion that is not involved in the oxidation–reduction process:

$$Cu \rightarrow Cu^{2+} + 2e^-$$

$$Ag^+ + 1e^- \rightarrow Ag$$

In this way, it can be seen that the copper loses electrons so it is oxidized and the silver gains an electron so it is reduced. One can also see that the number of electrons is not equal in each of the half reactions, so the second half reaction will need to be doubled.

$$Cu \rightarrow Cu^{2+} + 2e^-$$

$$2Ag^+ + 2e^- \rightarrow 2Ag$$

Now the number of electrons is equal for both half reactions.

COMPOUNDS OF METALS: ORES

Almost all metals are found in an oxidized state as their metal oxides. For instance, iron (III) oxide can be found as the mineral hematite, Fe_2O_3, which was used for centuries as a writing or tinting agent. It is considered to be one of the first mineral pigments used by man. Because this is the most oxidized state of iron, iron (III) will not undergo any additional oxidation reactions and will not lose its particular characteristics, thus providing long-term stability. This ore was and has found its way back into use in the production of jewelry items in the form of hematite beads. Other useful metals are copper, which is found as a copper (II) sulfide commonly referred to as chalcopyrite. Chalcopyrite is actually an intermixed copper and iron sulfide ore ($CuFeS_2$). Aluminum is found as the ore bauxite, an aluminum hydroxide-aluminum oxide ($Al(OH)_3$ and Al_2O_3) mixture with iron oxides and other metal oxides.

Corrosion is the layman's term for the redox reaction of metals. The most common oxidation reaction we know is the rusting of iron.

$$4\ Fe_{(s)} + 3\ O_{2(g)} \rightarrow 2\ Fe_2O_{3(s)}$$

This reaction is actually an oversimplification of a multistep process for the oxidation of iron:

$$Fe_{(s)} \rightarrow Fe^{2+}_{(aq)} + 2e^-$$

and the reduction of $O_{2(g)}$,

$$2\ H_2O_{(l)} + O_{2(g)} + 4e^- \rightarrow 4\ OH^-_{(aq)}$$

The second step in the process is the oxidation of Fe^{2+} to Fe^{3+} and reduction of more oxygen. The last step is the production of the product we know so well as rust. The primary way to stop the oxidation of iron is by utilizing a metal that will oxidize more easily as a sacrificial electrode material. The material of choice for this is usually zinc, aluminum, or magnesium. To explain this fully we need to consider another term used in discussing redox, the *galvanic cell*. The term is more easily discussed as a battery, or more specifically the term *electrochemistry*, the production of electrical energy from a chemical reaction. For every oxidation reduction reaction there is a certain amount of electrical energy that can be spontaneously produced, the cell potential. This potential is based on the oxidation reaction and the reduction reaction occurring. For example, the oxidation of iron to iron (III) and the reduction of O_2 produce an electrical output respectively shown here:

$$Fe_{(s)} \rightarrow Fe^{3+}_{(aq)} + 3\ e^- \qquad\qquad E^\circ_{oxid} = +0.04\ volts$$

$$O_{2(g)} + 2H_2O_{(l)} + 4\ e^- \rightarrow 4\ OH^-_{(aq)} \qquad\qquad E^\circ_{red} = +0.44\ volts$$

When the two reactions are added together, one obtains a reaction that shows the production of iron (III) hydroxide and 0.48 volts. To correctly add the two equations, one must acknowledge that

the electron loss equals electron gain in the two half reactions. To do so, we multiply the iron oxidation reaction by 4 and the oxygen reduction by 3, giving the following reaction:

$$4Fe(s) \rightarrow 4Fe^{3+}(aq) + 12e^- \quad .04 \text{ volts}$$

$$3O_2(g) + 6H_2O + 12\,e^- \rightarrow 12OH^-(aq) \quad 0.44 \text{ volts}$$

$$3O_2(g) + 6H_2O + 4Fe(s) \rightarrow 4Fe(OH)_3(aq) \quad +.48 \text{ volts}$$

As long as the potential voltage is positive, the reaction will occur spontaneously. The oxidation of zinc is more positive than that of iron, leading to the oxidation of zinc and not to the oxidation of iron.

$$Zn(s) \rightarrow Zn^{2+} + 2\,e^- \quad E^\circ_{oxid} = +0.764 \text{ volts}$$

This explains why zinc is used as a sacrificial electrode for protecting iron from rusting. The overall voltage for zinc oxidation is 1.104 volts (0.764 + 0.44), which is far greater than that for the oxidation of iron (0.48 volts).

Another commonly observed oxidation reaction is the tarnishing of silver. Sulfur compounds in the air will react with silver (Ag), producing silver (Ag_2S). Silver is used in the making of jewelry; however, it is too soft. Sterling silver is the choice when looking to use silver in jewelry. Sterling silver is an alloy containing no less 92.5% silver by mass, and 7.5% other metals by mass such as platinum. The choice of the second metal is for structural and reactive reasons. Platinum can impart strength and non-reactivity.

Learning Check

1. Calculate the total electric potential for the two half reactions and write the overall reaction. Indicate whether the overall reaction will occur spontaneously or non-spontaneously.

$$Cu_{(s)} \rightarrow Cu^{2+}_{(aq)} + 2e^- \quad E^\circ = -0.34 \text{ V}$$

$$Ag_{(s)} \rightarrow Ag^+_{(aq)} + e^- \quad E^\circ = -0.80 \text{ V}$$

Ans: The equations need to be combined in order for the total electric potential to be calculated. However, the equations need to be manipulated in order the get the reactants and products on the correct side. One of the reactions must be a reduction and the other an oxidation. If the second reaction is reversed:

$$Ag^+_{(aq)} + e^- \rightarrow Ag_{(s)} \quad E^\circ = +0.80 \text{ V}$$

The sign of the potential voltage is changed because the equation is reversed. It can be seen that in the copper half reaction there are two electrons and in the silver half reaction there is only one electron. The silver half reaction will have to be doubled, but its electric potential is left the same: one way to understand this is by remembering that the potential for water to fall from the top of a cliff down, does not change with the amount of water actually falling, that height, i.e., the potential, is the same regardless.

$$2Ag^+_{(aq)} + 2e^- \rightarrow 2Ag_{(s)} \quad E^\circ = +0.80 \text{ V}$$

$$\frac{Cu_{(s)} \rightarrow Cu^{2+}_{(aq)} + 2e^- \quad E^\circ = ^-0.34 \text{ V}}{2Ag_{(aq)} + Cu_{(s)} \rightarrow 2Ag_{(s)} + Cu^{2+} \quad E^\circ = +0.46 \text{ V}}$$

Because the total electric potential is positive ($E^\circ = +0.46$ V) for the cell, the reaction is spontaneous.

2. Is the reverse of the above reaction spontaneous? Explain.

> **Ans:** No. If the reaction is reversed, the electric potential sign would be changed from positive to negative, +0.46 to −0.46 V. Since the electric potential must be positive for a spontaneous reaction and since reversal causes it to be negative, the reaction will not be spontaneous and energy would need to be input to the system.

ELECTROLYSIS AND ELECTROPLATING

The previous discussion shows that electricity can be derived from a chemical reaction. This also provides evidence that electricity can drive a chemical reaction. The reverse reaction to producing electricity to using electricity to drive a chemical reaction is electrolysis. *Electrolysis* is the use of electricity to drive the reduction of a metal by applying a specific voltage. The basis for this is the use of electrons to drive the reverse reduction reaction as opposed to the spontaneous oxidation reaction. For instance, the electrolysis of molten sodium chloride yields sodium metal and chlorine gas as shown in Figure 5.2.

The negative electrode connected to the negative side of the battery is called the *cathode,* and it attracts the cations. The positive electrode connected to the positive side of the battery is called the *anode* and it attracts the anions.

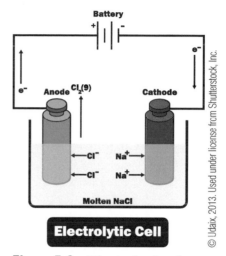

Figure 5.2 Electrolysis of molten sodium chloride yields sodium metal and chlorine gas

Electrolysis is used to purify certain materials or to coat various materials with a thin layer of a metal. Under electrolysis, the specified voltage is applied over a given time period to produce the desired effect. The amount of material that can be deposited can be determine using Coulomb's Law, where the amount deposited is related to the current applied in amps (coulombs per second), the time for the current flow (time in seconds), the number of electrons (1 mole of electrons = 96,485 coulombs), the number of electrons involved in the reduction or oxidation (mole ratio to the reductant or oxidant), and finally the molar mass of the reductant or oxidant.

$$mass = \frac{current \times time \times molar\,mass}{\#electrons \times Faraday's\,constant}$$

For example, if one wished to plate silver onto a particular metal, the metal would be lowered into a solution containing Ag^+ ion and connected to an external voltage source in which a silver electrode would serve as the anode and the metal would serve as the cathode. A voltage greater than 0.80 volts (reduction potential) would be applied and the current flow monitored. Based on the time the current is applied, one can determine the amount of silver that has been deposited. Such a methodology is applied on multiple occasions in the production of jewelry and also in the recovery of artifacts. In the recovery of artifacts, electrolysis is used to drive the reduction of the metal to prevent loss from the artifact. The use of electrolysis has been used drive the reduction of silver (I) sulfide to produce silver in the recovery of silver coins at a shipwreck. In this process the reaction below is driven by applying a voltage.

$$Ag_2S_{(s)} + 2e^- \rightarrow Ag_{(s)} + S^{2-}_{(aq)}$$

Learning Check

1. If you are trying to coat a strip with aluminum and you have a current of 15.0 A (amperes) running for two hours, what mass of Al is formed?

 Ans: Use the general formula and insert the known values:

$$\text{Mass} = \frac{\text{Current} \times \text{time} \times \text{molar mass}}{\text{\# of electrons} \times \text{Faraday's constant}}$$

$$\text{Mass} = \frac{15.0 \dfrac{\text{Coulombs}}{\text{s}} \times 7200\,\text{s} \times 27 \dfrac{\text{grams}}{\text{mole}}}{3\,\text{moles of electrons} \times 96,500\,\text{Coulombs}} = 10.1\,\text{grams Al}$$

2. How much current is needed to coat a strip with 8.2 grams of magnesium in three hours?

 Ans: First manipulate the equation to isolate current.

$$\text{Current} = \frac{\text{mass} \times \text{\# of electrons} \times \text{Faraday's constant}}{\text{time} \times \text{molar mass}}$$

$$\text{Current} = \frac{8.2\,\text{grams} \times 2\,\text{moles of electrons} \times 96,500\,\text{Coulombs}}{10,800\,\text{seconds} \times 24.3 \dfrac{\text{grams}}{\text{mole}}} = 6.0\,\text{Amperes}$$

PROBLEMS

1. Indicate whether the following redox reactions are oxidation or reduction reactions or both.

 $Fe^{3+}_{(aq)} + e^- \rightarrow Fe^{2+}_{(aq)}$

 $Cl_{2(g)} + e^- \rightarrow 2Cl^-_{(aq)}$

 $Cl_{2(g)} + Fe^{2+}_{(aq)} \rightarrow 2Cl^- + Fe^{3+}_{(aq)}$

 $2H^+_{(aq)} + 2e^- \rightarrow 2H_{2(g)}$

 $Cu_{(s)} \rightarrow Cu^{2+}_{(aq)} + 2e^-$

 $Zn_{(s)} \rightarrow Zn^{2+}_{(aq)} + 2e^-$

 $2\ Fe^{3+} + Sn^{2+} \rightarrow 2\ Fe^{2+} + Sn^{4+}$

2. Identify which element is oxidized and which is reduced in the following equations:

 $Tl^+_{(aq)} + 2Ce^{4+}_{(aq)} \rightarrow 2\ Ce^{3+}_{(aq)} + Tl^{3+}_{(aq)}$

 $Na^+_{(aq)} + Ar_{(g)} \rightarrow Na_{(s)} + Ar^+_{(aq)}$

 $2Mg_{(s)} + O_{2(g)} \rightarrow 2MgO_{(s)}$

3. In the chemical equation below identify what is being oxidized and what is being reduced.

 $$Hg^{2+}_{(aq)} + N_2O_4^-{}_{(aq)} \rightarrow NO_3^-{}_{(aq)} + Hg_2^{2+}{}_{(aq)}$$

4. Indicate which reaction occurs spontaneously and which occurs non-spontaneously.

 A. $K_{(s)} \rightarrow K^+_{(aq)} + e^- \ E^\circ = +2.93V$

 B. $Al_{(s)} \rightarrow Al^{3+}_{(aq)} + 3e^- \ E^\circ = +1.66V$

 C. $2I^-_{(aq)} \rightarrow I_{2(l)} + 2e^- \ E^\circ = -0.54V$

5. For the questions below calculate the total electric potential for the two half reactions and write the overall reaction. Indicate whether the overall reaction will occur spontaneously or non-spontaneously.

 $Fe^{2+} (aq) + 2e^- \rightarrow Fe\ (s),\ E^\circ = -0.44V$

 $Cd^{2+} (aq) + 2e^- \rightarrow Cd\ (s),\ E^\circ = -0.40V$

6. In a certain electrochemical cell 2.0 g of solid Mg is formed when a current of 5.0 A is produced by the cell. How long will it take for the cell to completely run out?

7. If you are trying to coat a strip with 5 g aluminum for one hour, how many coulombs of current will be produced per second?

ANSWERS

1. $Fe^{3+}_{(aq)} + e^- \rightarrow Fe^{2+}_{(aq)}$ **Reduction reaction**

 $Cl_{2(g)} + e^- \rightarrow 2Cl^-_{(aq)}$ **Reduction reaction**

 $Cl_{2(g)} + Fe^{2+}_{(aq)} \rightarrow 2\,Cl^-_{(aq)} + Fe^{3+}_{(aq)}$ **Both reduction and oxidation reactions**

 $2H^+_{(aq)} + 2e^- \rightarrow 2H_{2(g)}$ **Reduction reaction**

 $Cu_{(aq)} \rightarrow Cu^{2+}_{(aq)} + 2e^-$ **Oxidation reaction**

 $Zn_{(s)} \rightarrow Zn^{2+}_{(aq)} + 2e^-$ **Oxidation reaction**

 $2Fe^{3+} + Sn^{2+} \rightarrow 2Fe^{2+} + Sn^{4+}$ **Both reduction and oxidation reactions**

2. $Tl^+_{(aq)} + 2Ce^{4+}_{(aq)} \rightarrow 2Ce^{3+}_{(aq)} + Tl^{3+}_{(aq)}$ **Oxidized: Tl⁺** **Reduced: Ce⁴⁺**

 $Na^+_{(aq)} + Ag_{(g)} \rightarrow Na_{(s)} + Ag^+$ **Oxidized: Ag** **Reduced: Na⁺**

 $2Mg_{(s)} + O_{2(g)} \rightarrow 2MgO_{(s)}$ **Oxidized: Mg** **Reduced O₂**

3. $Hg^{2+}_{(aq)} + N_2O_4^-{}_{(aq)} \rightarrow NO_3^-{}_{(aq)} + Hg_2^{2+}{}_{(aq)}$ **Oxidized: N** **Reduced: Hg²⁺**

4. Reaction A: Potassium is oxidized to the potassium ion. $E^\circ = +2.93V$. This reaction occurs spontaneously.

 Reaction B: Aluminum is oxidized to the aluminum ion. $E^\circ = +1.66V$. This reaction occurs spontaneously.

 Reaction C: Iodide is reduced to iodine. $E^\circ = -0.54V$. This reaction occurs non-spontaneously.

5. $Fe^{2+}_{(aq)} + 2e^- \rightarrow Fe_{(s)}, E^\circ_{Red} = -0.44V$

 $Cd^{2+}_{(aq)} + 2e^- \rightarrow Cd_{(s)}, E^\circ_{Red} = -0.40V$

 One reaction must be a reduction, and the other must be an oxidation. Flip the second reaction around to yield: $Cd_{(s)} \rightarrow Cd^{2+}_{(aq)} + 2e^-, E^\circ_{Oxi} = +0.40\ V$.

 The total electric potential is $(-0.44\ V) + (+0.40\ V) = -0.04\ V$, which results in a non-spontaneous reaction.

6. Electrolysis – Coulomb's Law: $mass = \dfrac{(current)(time)(molar\,mass)}{(\#electrons)(Faraday's\,constant)}$

 Find the time. Rearrange the equation.

 $time = \dfrac{(mass)(\#electrons)(Faraday's\,constant)}{(current)(molar\,mass)}$

 $Time = \dfrac{(2.0g\,Mg)(2e^-)(96,500\,c)}{(5.0A)(24.31g/mol)} = \textbf{3.2} \times \textbf{10}^3 \textbf{ seconds} \sim \textbf{53 minutes.}$

7. Electroplating – Coulomb's Law: $mass = \dfrac{(current)(time)(molar\,mass)}{(\#electrons)(Faraday's\,constant)}$

 Find the time. Rearrange the equation.

 $current = \dfrac{(mass)(\#electrons)(Faraday's\,constant)}{(time)(molar\,mass)}$

 $Time = \dfrac{(5g\,Al)(3e^-)(96,500\,c)}{(3600s)(26.98g/mol)} = \textbf{15 Amps.}$

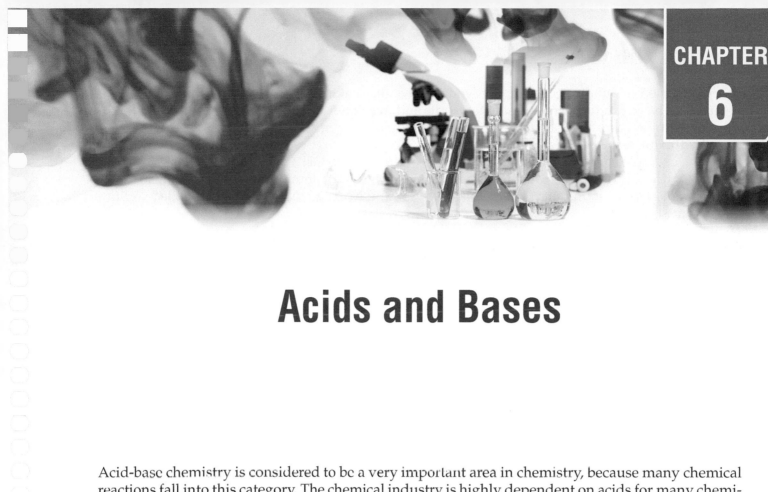

Acids and Bases

Acid-base chemistry is considered to be a very important area in chemistry, because many chemical reactions fall into this category. The chemical industry is highly dependent on acids for many chemical processes, making sulfuric acid one of the most important chemicals in this industry. Of course, acid-base chemistry is not limited to just industry, as many biological processes involve acid-base reactions and we, as individuals, are faced with acids and bases every day.

GENERAL PROPERTIES OF ACIDS AND BASES

All acids and all bases exhibit certain common properties—for instance, all acids taste sour while all bases taste bitter. Acids can be found in the stomach and some food. Citric acid is responsible for the sour flavor found in citrus fruits such as lemons and oranges (Figure 6.1); acetic acid is responsible for the smell and sour taste of vinegar.

Of course, the acids that we consume are very dilute and only make up a small percentage of the food being consumed. In higher concentrations acids can be extremely corrosive. For example, sulfuric acid is capable of turning bone into a gelatinous mixture in a matter of hours.

Here is a list of some important acids: sulfuric acid (H_2SO_4); hydrochloric acid (also known as muriatic acid in hardware stores) (HCl); hydrobromic acid (HBr); nitric acid (also known under its Latin name *Aqua Fortis*) (HNO_3); and acetic acid (found in vinegar) (CH_3COOH or CH_3CO_2H).

Like acids, bases also exhibit certain common properties: They all taste bitter and feel slippery or soapy to the touch. In fact, soap is a basic product made through a very old process called saponification, where animal fat was heated and stirred with ashes to yield a solid compound that has cleaning properties. Nowadays, soap is not made using this process any longer. Most household detergents and cleaning supplies, like window-cleaners and bleach, are basic as well but stronger, which makes them more harmful than soap.

Figure 6.1 Citrus fruits are acidic and taste sour because of the presence of citric acid

Bases can also be found in cooking; everyone knows that baking soda, baking powder and cream of tartar are basic products and are safe to handle and ingest. As a matter of fact, most antacid medicines are simple bases like calcium carbonate, sodium hydrogen carbonate (Figure 6.2), or magnesium hydroxide also known as milk of magnesia.

Some examples of common bases are sodium hydroxide (NaOH); potassium hydroxide (KOH); calcium hydroxide ($Ca(OH)_2$); magnesium hydroxide ($Mg(OH)_2$; ammonium hydroxide, also called ammonia (NH_4OH); sodium carbonate (Na_2CO_3); sodium hydrogenocarbonate, also called sodium bicarbonate ($NaHCO_3$).

CHEMICAL PROPERTIES OF ACIDS

The Swedish chemist Svante Arrhenius (1859–1927) conducted research on the properties of electrolytes in solutions, including their effects on colligative properties. For his research efforts he received the 1903 Nobel Prize in chemistry.

According to Arrhenius, it can be said that all acids (AH) release at least one proton H^+ when dissolved in water. In Figure 6.4, the structures of important acids are shown and the hydrogen that is released as a proton is circled.

That proton combines with a molecule of water to become a hydronium ion H_3O^+. The other part of the acid becomes an anion A^-, also called the conjugate base. The corresponding general chemical equation is:

$$AH + H_2O_{(l)} \rightarrow A^-_{(aq)} + H_3O^+_{(aq)}$$

Here are some examples for main acids:

$$\text{For hydrochloric acid: } HCl_{(g)} + H_2O_{(l)} \rightarrow Cl^-_{(aq)} + H_3O^+_{(aq)}$$

$$\text{For nitric acid: } HNO_{3(l)} + H_2O_{(l)} \rightarrow NO_3^-_{(aq)} + H_3O^+_{(aq)}$$

$$\text{For acetic acid: } CH_3COOH_{(l)} + H_2O_{(l)} \rightarrow CH_3COO^-_{(aq)} + H_3O^+_{(aq)}$$

Some acids are monoprotic acid, meaning they only have one acidic hydrogen ion per molecule, such as hydrochloric acid, HCl (aq), whereas a polyprotic acid is an acid that has two or more acidic protons per molecule, like phosphoric acid (H_3PO_4). Here is a worked–out example with sulfuric acid:

$$H_2SO_{4(aq)} + H_2O_{(l)} \rightarrow HSO_4^-_{(aq)} + H_3O^+_{(aq)}$$

The hydrogenosulfate generated, HSO_4^-, has the capability to lose another proton as follows:

$$HSO_4^-_{(aq)} + H_2O_{(l)} \rightarrow SO_4^{2-}_{(aq)} + H_3O^+_{(aq)}$$

Figure 6.2 Common name for sodium hydrogeno-carbonate

Figure 6.3 Svante Arrhenius

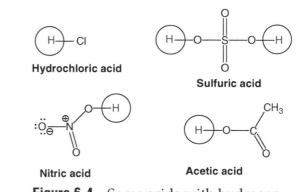

Hydrochloric acid

Sulfuric acid

Nitric acid

Acetic acid

Figure 6.4 Some acids with hydrogen released as proton shown

This shows the sulfuric acid is a diprotic acid since it could lose up to 2 protons. The overall equation showing the loss of the 2 protons can be written as:

$$H_2SO_{4(aq)} + 2\,H_2O_{(l)} \rightarrow SO_4^{\,2-}{}_{(aq)} + 2\,H_3O^+{}_{(aq)}$$

Learning Checks

1. A triprotic acid, like phosphoric acid, H_3PO_4 can lose up to 3 protons. Write the three equations for each step of the dissociation and the overall equation.

 Ans: Each dissociation reaction has to be written first independently:

 First dissociation: $\quad H_3PO_{4(l)} + H_2O_{(l)} \rightarrow H_2PO_4^-{}_{(aq)} + H_3O^+{}_{(aq)}$

 Second dissociation: $\quad H_2PO_4^-{}_{(aq)} + H_2O_{(l)} \rightarrow HPO_4^{\,2-}{}_{(aq)} + H_3O^+{}_{(aq)}$

 Third dissociation: $\quad HPO_4^{\,2-}{}_{(aq)} + H_2O_{(l)} \rightarrow PO_4^{\,3-}{}_{(aq)} + H_3O^+{}_{(aq)}$

 Overall equation: $\quad H_3PO_{4(l)} + 3\,H_2O_{(l)} \rightarrow PO_4^{\,3-}{}_{(aq)} + 3H_3O^+{}_{(aq)}$

2. Write the equation for the dissociation of hydrobromic acid.

 Ans: $HBr_{(g)} + H_2O_{(l)} \rightarrow Br^-{}_{(aq)} + H_3O^+{}_{(aq)}$

ACID STRENGTH

Not all acids behave the exact same way in aqueous solution. Some acids are strong and some are weak. The strength of an acid depends on how much it dissociates (ionizes) in water. If the dissociation is total, it is said to be a strong acid, otherwise it is a weak acid. Total dissociation or ionization means that no molecular form of the acid survives in water and the corresponding equation can be written with a single arrow as:

$$AH + H_2O_{(l)} \rightarrow A^-{}_{(aq)} + H_3O^+{}_{(aq)}$$

There are only a few strong acids: hydrochloric acid (HCl), nitric acid (HNO_3), sulfuric acid (H_2SO_4) (the first acidity only), hydrobromic acid (HBr), hydroiodic acid (HI), chloric acid ($HClO_3$) (unstable) and perchloric acid ($HClO_4$).

All other acids are weak and their dissociation water will not be complete, meaning that at any time, the acid exists as both an ion and a molecule. This is what is called an equilibrium noted with a double arrow:

$$AH + H_2O_{(l)} \rightleftharpoons A^-{}_{(aq)} + H_3O^+{}_{(aq)}$$

Learning Checks

1. Write the equation for the dissociation of perchloric acid.

 Ans: $HClO_{4(s)} + H_2O \rightarrow ClO_4^-{}_{(aq)} + H_3O^+{}_{(aq)}$

2. Write the equation for the dissociation of sulfuric acid.

 Ans: First dissociation:

 $$H_2SO_{4(l)} + H_2O_{(l)} \rightarrow HSO_4^-{}_{(aq)} + H_3O^+{}_{(aq)}$$

The first equation shows that sulfuric acid is a strong acid.

Second dissociation:

$$HSO_{4\ (aq)}^{-} + H_2O_{(l)} \rightleftharpoons SO_{4\ (aq)}^{2-} + H_3O_{\ (aq)}^{+} \quad Ka = 1.02 \times 10^{-2}$$

The second equation demonstrates that bisulfate is a weak acid.

The relative proportion between the ionic and the molecular forms is characterized by a constant, named the acid equilibrium constant K_a (sometimes called acidity constant) that can be calculated using the following formula:

$$k_a = \frac{[A^-] \times [H^+]}{[AH]}$$

[A⁻], [H⁺], and [AH] are respectively the concentration of the ionic form of the acid, called the conjugate base, of the protons and of the molecular form of the acid. The higher the value of the constant, the more acidic the acid is. Strong acids, by definition, do not have an acidity constant since the concentration of [AH] tends toward zero.

Table 6.1 contains the values of Ka for a few common acids.

Learning Checks

1. Based on the acidity constant value, which acid is stronger, acetic acid or nitrous acid?

 Ans: Acetic acid has a Ka of 1.8×10^{-5} while nitrous acid has a Ka of 4.5×10^{-4} the larger the Ka the stronger the acid. Of the two, nitrous acid has the largest Ka, making it the stronger acid.

2. Write the Ka expression for the dissociation of hypochlorous acid.

 Ans: First write the acid dissociation equation:

 $$HClO_{(l)} + H_2O_{(l)} \rightleftharpoons ClO_{\ (aq)}^{-} + H_3O_{\ (aq)}^{+}$$

 Second, write the concentration of products over the concentration of the reactants.

 $$k_a = \frac{[ClO^-] \times [H^+]}{[HClO]}$$

Table 6.1 Values of ka for a few common acids

Name	Acid Formula	Conjugate Base	Ka
Hydrofluoric	HF	F⁻	6.8×10^{-4}
Nitrous	HNO_2	NO_2^-	4.5×10^{-4}
Benzoic	$C_7H_5O_2H$	$C_7H_5O_2^-$	6.5×10^{-5}
Acetic	$C_2H_3O_2H$	$C_2H_3O_2^-$	1.8×10^{-5}
Hypochlorous	HClO	ClO⁻	3.0×10^{-8}
Hydrocyanic	HCN	CN⁻	4.9×10^{-10}
Phenol	C_6H_5OH	$C_6H_5O^-$	1.3×10^{-10}

ACIDS AND METALS

Another important chemical property of acids is that they can dissolve active metals, which produces hydrogen gas according to this general chemical equation:

$$AH_{(aq)} + M_{(s)} \rightarrow MA_{(aq)} + H_{2(g)}$$

Example: Write the chemical equation for the reaction between hydrochloric acid and zinc.
Answer: The formula for the zinc ion is Zn^{2+} since zinc always loses 2 electrons to become a cation, therefore 2 chloride ions are necessary to combine with a (1) zinc ion.

$$HCl_{(aq)} + Zn_{(s)} \rightarrow ZnCl_{2(aq)} + H_{2(g)}$$

This equation needs to be balanced as follows:

$$2\,HCl_{(aq)} + Zn_{(s)} \rightarrow ZnCl_{2(aq)} + H_{2(g)}$$

Learning Checks

1. Write the balance equation for the reaction between hydrobromic acid and sodium.

 Ans: Sodium is a group 1A metal and, therefore, always loses one electron, forming a +1 cation. The balanced chemical equation is written below:

 $$2\,HBr_{(aq)} + 2\,Na_{(s)} \rightarrow 2\,NaBr_{(aq)} + H_{2(g)}$$

2. Write the balanced equation for the reaction between iron and hydrochloric acid.

 Ans: Iron has many oxidized forms; however, the two most common are the 2+ and 3+. Experimentally, it has been demonstrated that the Fe^{2+} cation is formed. With this information the balanced chemical equation can be written as:

 $$2\,HCl_{(aq)} + Fe_{(s)} \rightarrow FeCl_{2(aq)} + H_{2(g)}$$

Not all metals can react with any acid, there is a difference in the reactivity of metals with acids as was already suggested in the chapter on the periodic table. As one goes down the periodic table in a column, the metals tend to be more reactive, so, for instance, potassium is more reactive than lithium. Also across the periodic table, all group 1A and some 2A metals (Ca, Sr, Ba) are so reactive that they react with oxygen and water from the air and have to be kept in mineral oil to preserve them. Magnesium will require an acid to react, just like aluminum, zinc, and manganese do, which explains why these metals can be used as construction material. Other metals like iron, lead, and tin will react only with strong acids, while copper will only react with acids that are also oxidizers like nitric acid. Finally, some metals are very resistant to acidic attack, thus do not corrode easily and can be used in jewelry or coin making and dentistry. They include silver, gold, platinum, and mercury. Table 6.2 provides an exhaustive list of metals and their reaction under various conditions.

Since gold is resistant to acid attack, it was used during the 19th-century California gold rush to distinguish between gold (Figure 6.5) and other metals that will dissolve in nitric acid. This was known as the "acid test."

Aqua regia, which means royal water in Latin, is a 1:3 mixture of HNO_3 and HCl capable of reacting with noble metals such as gold, platinum, and palladium that cannot be attacked by a single acid.

Figure 6.5 Gold

© Tiff, 2013. Used under license from Shutterstock, Inc.

Table 6.2 Metals, their chemical activity and corresponding chemical equations

Reactivity	Metal	Symbol	Reactivity
React with cold water, steam and acids. $M + AH \rightarrow H_2 + MOH$	Lithium	Li	$2\,Li_{(s)} + 2\,H_2O_{(l)} \rightarrow 2\,LiOH_{(aq)} + H_{2(g)}$ $2\,Li_{(s)} + 2\,H_2O_{(l)} \rightarrow 2\,LiOH_{(aq)} + H_{2(g)}$ $2\,Li_{(s)} + 2\,HA_{(aq)} \rightarrow 2\,LiA_{(aq)} + H_{2(g)}$
	Potassium	K	$2\,K_{(s)} + 2\,H_2O_{(l)} \rightarrow 2\,KOH_{(aq)} + H_{2(g)}$ $2\,K_{(s)} + 2\,H_2O_{(l)} \rightarrow 2\,KOH_{(aq)} + H_{2(g)}$ $2\,K_{(s)} + 2\,HA_{(aq)} \rightarrow 2\,KA_{(aq)} + H_{2(g)}$
	Calcium	Ca	$Ca_{(s)} + 2\,H_2O_{(l)} \rightarrow Ca(OH)_{2(aq)} + H_{2(g)}$ $Ca_{(s)} + 2\,H_2O_{(l)} \rightarrow Ca(OH)_{2(aq)} + H_{2(g)}$ $Ca_{(s)} + 2\,HA_{(aq)} \rightarrow CaA_{2(aq)} + H_{2(g)}$
	Sodium	Na	$2\,Na_{(s)} + 2\,H_2O_{(l)} \rightarrow 2\,NaOH_{(aq)} + H_{2(g)}$ $2\,Na_{(s)} + 2\,H_2O_{(l)} \rightarrow 2\,NaOH_{(aq)} + H_{2(g)}$ $2\,Na_{(s)} + 2\,HA_{(aq)} \rightarrow 2\,NaA_{(aq)} + H_{2(g)}$
React with steam and acids. $M + HA \rightarrow H_2 + MOH$	Magnesium	Mg	$Mg_{(s)} + 2\,HA_{(aq)} \rightarrow MgA_{2(aq)} + H_{2(g)}$ $Mg_{(s)} + 2\,H_2O_{(l)} \rightarrow Mg(OH)_{2(aq)} + H_{2(g)}$
	Aluminum	Al	$2\,Al_{(s)} + 6\,HA_{(aq)} \rightarrow 2\,AlA_{3(aq)} + 3\,H_{2(g)}$ $2\,Al_{(s)} + 6\,H_2O_{(l)} \rightarrow 2\,Al(OH)_{3(aq)} + 3\,H_{2(g)}$
	Zinc	Zn	$Zn_{(s)} + 2\,HA_{(aq)} \rightarrow ZnA_{2(aq)} + H_{2(g)}$ $Zn_{(s)} + 2\,H_2O_{(l)} \rightarrow Zn(OH)_{2(aq)} + H_{2(g)}$
	Chromium	Cr	$Cr_{(s)} + 2\,HA_{(aq)} \rightarrow CrA_{2(aq)} + H_{2(g)}$ $Cr_{(s)} + 2\,H_2O_{(l)} \rightarrow Cr(OH)_{2(aq)} + H_{2(g)}$
React with acids. $M + HA \rightarrow H_2 + MOH$	Iron	Fe	$Fe_{(s)} + 2\,HA_{(aq)} \rightarrow FeA_{2(aq)} + H_{2(g)}$
	Cobalt	Co	$Co_{(s)} + 2\,HA_{(aq)} \rightarrow CoA_{2(aq)} + H_{2(g)}$
	Nickel	Ni	$Ni_{(s)} + 2\,HA_{(aq)} \rightarrow NiA_{2(aq)} + H_{2(g)}$
	Tin	Sn	$Sn_{(s)} + 2\,HA_{(aq)} \rightarrow SnA_{2(aq)} + H_{2(g)}$
	Lead	Pb	$Pb_{(s)} + 2\,HA_{(aq)} \rightarrow PbA_{2(aq)} + H_{2(g)}$
React with nitric acid, an oxidizer	Copper	Cu	In concentrated nitric acid: $Cu_{(s)} + 4\,HNO_{3(aq)} \rightarrow Cu(NO_3)_{2(aq)} + 2\,NO_{2(g)} + 2H_2O_{(l)}$ Or in dilute nitric acid: $3\,Cu_{(s)} + 8\,HNO_{3(aq)} \rightarrow 3\,Cu(NO_3)_{2(aq)} + 2\,NO_{(g)} + 4\,H_2O_{(l)}$
	Silver	Ag	In concentrated nitric acid: $Ag_{(s)} + 2\,HNO_{3(aq)} \rightarrow AgNO_{3(aq)} + NO_{2(g)} + H_2O_{(l)}$ Or in dilute nitric acid: $2\,Ag_{(s)} + 3\,HNO_{3(aq)} \rightarrow 2\,AgNO_{3(aq)} + 2\,HNO_{2(aq)} + H_2O_{(l)}$
Do not react with acids	Platinum	Pt	Not applicable
	Gold	Au	

Gold is corroded by aqua regia, because the nitric acid is also an oxidizer. Oxidation and reduction reactions are studied in Chapter 5. The overall chemical equation for the corrosion of gold with aqua regia can be written as:

$$Au_{(s)} + HNO_{3\,(aq)} + 4\,HCl_{(aq)} \rightarrow H^+_{(aq)} + AuCl_4^-{}_{(aq)} + NO_{(g)} + 2\,H_2O_{(l)}$$

CHEMICAL PROPERTIES OF BASES

Arrhenius defined a base as a compound able to increase the concentration of hydroxide ion, OH^-, when dissolved in water. Also another definition of a base is that it is a substance capable of gaining a proton. Of course, it appears immediately that all metal hydroxides will be basic as long as they can dissolve in water. In Table 6.3, the formula, name and solubility of important bases are shown.

Once dissolved in water the dissociation occurs as follows:

$$MOH_{(s)} + H_2O_{(l)} \rightarrow M^+_{(aq)} + OH^-_{(aq)}$$

Here are some examples for some metal hydroxides:

$$NaOH_{(s)} + H_2O_{(l)} \rightarrow Na^+_{(aq)} + OH^-_{(aq)}$$
$$KOH_{(s)} + H_2O_{(l)} \rightarrow K^+_{(aq)} + OH^-_{(aq)}$$
$$Ba(OH)_{2(s)} + H_2O_{(l)} \rightarrow Ba^{2+}_{(aq)} + 2OH^-_{(aq)}$$
$$LiOH(s) + H_2O_{(l)} \rightarrow Li^+_{(aq)} + OH^-_{(aq)}$$

Learning Check

1. Write the chemical equation for the dissociation of strontium hydroxide.

 Ans: $Sr(OH)_{2(s)} + H_2O_{(l)} \rightarrow Sr^{2+}_{(aq)} + 2\,OH^-_{(aq)}$

What about ammonia (NH_3)? What about sodium carbonate (Na_2CO_3)? Ammonia, sodium carbonate, and related compounds are also classified as bases; although it seems they do not contain a hydroxide part to be released in water. When dissolved, they actually increase the concentration of hydroxide ions in water as shown here:

$$\text{Ammonia: } NH_{3(g)} + H_2O_{(l)} \rightarrow NH_4^+{}_{(aq)} + OH^-_{(aq)}$$
$$\text{Sodium carbonate: } Na_2CO_{3(s)} + 2\,H_2O_{(l)} \rightarrow 2Na^+_{(aq)} + 2\,OH^-_{(aq)} + H_2CO_{3(aq)}$$

Table 6.3 Important Bases

Solubility	Name	Chemical formula
Soluble	Lithium hydroxide	LiOH
Soluble	Sodium hydroxide	NaOH
Soluble	Potassium hydroxide	KOH
Soluble	Rubidium hydroxide	RbOH
Soluble	Cesium hydroxide	CsOH
Slightly soluble	Magnesium hydroxide	$Mg(OH)_2$
Slightly soluble	Strontium hydroxide	$Sr(OH)_2$
Slightly soluble	Barium hydroxide	$Ba(OH)_2$

Learning Check

1. Write the chemical equation demonstrating the basic behavior of potassium bicarbonate.

Ans: $KHCO_{3(s)} + H_2O_{(l)} \rightarrow K^+_{(aq)} + H_2CO_{3(aq)} + OH^-_{(aq)}$

BASE STRENGTH

Just like the acids, not all bases have the same strength. First, a potentially basic compound has to be able to dissolve in water to be an efficient base. For instance, calcium carbonate, although it contains a carbonate that has the potential to increase the concentration of hydroxide ions in water, is not an efficient base because it does not dissolve in water. As a matter of fact, calcium carbonate is the compound from which seashells are made (Figure 6.6), so it is indeed very insoluble.

Second, for a base to be strong, it has to dissociate completely in water. Here is a list of the strong bases: lithium hydroxide (LiOH), sodium hydroxide (NaOH), potassium hydroxide (KOH), calcium hydroxide (Ca(OH)$_2$), strontium hydroxide (Sr(OH)$_2$), and barium hydroxide (Ba(OH)$_2$). Ammonia and other carbonates are all weak bases, meaning that they do not fully dissociate in water but are in an equilibrium reaction:

$$Base + H_2O \rightleftharpoons B^+_{(aq)} + OH^-_{(aq)}$$

The equilibrium for ammonia is given here as an example.

$$NH_{3(aq)} + H_2O \rightleftharpoons NH_4^+{}_{(aq)} + OH^-_{(aq)}$$

Just like acids, bases will be assigned a constant that quantifies their strength and their ability to dissociate and ionize in water. This constant, named the base equilibrium constant K_b, can be calculated using the following formula:

$$k_b = \frac{[OH^-] \times [B^+]}{[Base]}$$

[OH$^-$], [B$^+$], and [base] are respectively the concentration of the hydroxide ions, the ionic form of the base, and of the molecular form of the base. The higher the value of the constant, the more basic the base is. Strong bases, by definition, do not have such a constant since the concentration of the molecular form tends toward zero.

Example: Write the basic equilibrium constant for the dissociation of ammonia in water:

$$NH_{3(aq)} + H_2O_{(l)} \rightleftharpoons NH_4^+{}_{(aq)} + OH^-_{(aq)}$$

Solution:

$$K_b = \frac{[OH^-] \times [NH_4^+]}{[NH_3]}$$

© Triff, 2013. Used under license from Shutterstock, Inc.

Figure 6.6 Calcium carbonate is found in sea shells

Table 6.4 Values of Kb for Important Bases

Name	Formula	Conjugate acid	K_b
Ammonia	NH_3	NH_4^+	1.8×10^{-5}
Methylamine	CH_3NH_2	$CH_3NH_3^+$	4.38×10^{-4}
Ethylamine	$C_2H_5NH_2$	$C_2H_5NH_3^+$	5.6×10^{-4}
Diethylamine	$(C_2H_5)_2NH$	$(C_2H_5)_2NH_2^+$	1.3×10^{-3}
Aniline	$C_6H_5NH_2$	$C_6H_5NH_3^+$	3.8×10^{-10}
Pyridine	C_5H_5N	$C_5H_5NH^+$	1.7×10^{-9}
Hydrogen sulfide ion	HS^-	H_2S	1.0×10^{-7}

Learning Check

1. Write the K_b expression for the dissociation of ethylamine in water:

$$C_2H_5NH_{2(aq)} + H_2O_{(l)} \rightleftharpoons C_2H_5NH_3^+{}_{(aq)} + OH^-{}_{(aq)}$$

Ans:
$$K_b = \frac{[OH^-] \times [C_2H_5NH_3]}{[C_2H_5NH_2]}$$

Table 6.4 contains the values of Kb for important bases is provided below.

The strength of an acid or a base is inversely related to the strength of its conjugate base or acid. The stronger the acid, the weaker the conjugate base properties; the stronger the base, the weaker the conjugate acid properties.

MORE ON CONJUGATE ACID-BASE PAIRS

As described above, conjugate acids and bases are related since they are compounds that differ only by one proton. For example, hydrochloric acid (HCl) can lose a proton to become the chloride ion, so HCl/Cl⁻ is a conjugate pair. All bases have a conjugate acid, and all acids have a conjugate base. Some substances can act as both a base and an acid and are called amphiprotic or amphoteric. This is the case of the hydrogenocarbonate ion (HCO_3^-): It can lose a proton to become a carbonate (HCO_3^-) and as such it is an acid, or it can gain a proton to become carbonic acid (H_2CO_3) and as such is a base, as illustrated below.

$$HCO_3^- + H^+ \rightleftharpoons H_2CO_3$$

$$HCO_3^- \rightleftharpoons CO_3^{2-} + H^+$$

Learning Check

1. Would sulfuric acid and sulfate be considered a conjugate acid/base pair?

Ans: Sulfuric acid dissociates into hydronium and bisulfate:

$$H_2SO_{4(l)} + H_2O_{(l)} \rightarrow HSO_4{}^-{}_{(aq)} + H_3O^+{}_{(aq)}$$

Sulfate will act as a weak base in water:

$$SO_4{}^{2-}{}_{(aq)} + H_2O_{(l)} \rightleftharpoons HSO_4{}^-{}_{(aq)} + OH^-{}_{(aq)}$$

Sulfuric acid and sulfate are related through the hydrogenosulfate ion, but they do not form a conjugate pair because they are 2 protons apart from each other.

THE pH SCALE

The pH scale was developed to easily quantify the acidity or basicity of an aqueous solution. It is based on the fact that hydronium and hydroxide ions are always present in water and that the product of their respective concentrations, called K_w, is a constant at constant temperature.

$$H_3O^+ + OH^- \rightleftharpoons 2\,H_2O \text{ and } K_w = [H_3O^+] \times [OH^-], \text{ at } 25°C, K_w = 10^{-14}$$

The pH is defined as the negative logarithm of the concentration of hydronium ions in solution:

$$pH = -\log [H_3O^+]$$

and since $[H_3O^+]$ and $[OH^-]$ are related to each other, it can also be written as:

$$pH = -\log \frac{KW}{[OH^-]}$$

Another way of expressing the acidity and basicity is to use the less common scale pOH, which is defined as:

$$pOH = -\log [OH^-]$$

The relationship between the two scales is: $pH + pOH = 14$, so it easy to go from one to another.

Learning Checks

1. What is the pH of a solution whose $[H_3O^+]$ is 0.5M?

 Ans: Use the following equation:

 $$pH = -\log [H_3O^+]$$

 $$pH = -\log[0.5] = 0.3$$

2. What is the pOH of a solution that has a hydroxide concentration of 2.6×10^{-7} M?

 Ans: The pOH can be found by using the following equation:

 $$pOH = -\log [OH^-]$$

 $$pOH = -\log [2.6 \times 10^{-7}] = 6.6$$

3. What is the pH of a solution that has a hydroxide concentration of 3.4×10^{-6} M?

 Ans: There are two ways to solve this problem.

First method:

 Use the following equation to solve for the concentration of hydronium:

$$K_w = [H_3O^+] \times [OH^-]$$

Table 6.5 pH of Common Products

Product	pH
Liquid drain cleaner	14
Oven cleaner	13
Soap	12
Window cleaner	11
Milk of magnesia	10
Toothpaste	9
Baking soda	8
Water	7
Milk	6
Black coffee	5
Tomato juice	4
Sodas and orange juice	3
Lemon juice	2
Hydrochloric acid in stomach	1
Battery acid	0

$$\frac{k_w}{[OH^-]}=[H_3O^+]$$

$$\frac{1.0 \times 10^{-14}}{3.4 \times 10^{-6}} = [H_3O^+] = 2.9 \times 10^{-9}$$

Then insert into the pH equation:

$$pH = \quad \log [H_3O^+]$$

$$pH = -\log [2.9 \times 10^{-9}] = 8.5$$

Second method:

Find the pOH using the following equation:

$$pOH --\log [OH^-]$$

$$pOH = -\log [3.4 \times 10^{-6}] = 5.5$$

Then use the following equation to find the pH:

$$pH + pOH = 14$$

$$pH + 14 = pOH$$

$$pH = 14 \ -5.5 = 8.5$$

The pH scale goes from 0 to 14. From 0 to 7, the solution is said to be acidic, and from 7 to 14, to be basic. The neutral pH, nor acidic, neither basic, is 7. The acidity of the solution increases as pH decreases and the basicity of a solution increases the pH increases. Table 6.5 provides with the pH of common products.

MEASURING pH

Knowing the acidity of a solution is very important color indicator, since many physical and biological properties are affected by it. For instance, proteins denature if the pH is not held constant, metals will corrode in an acidic environment, and as will be discussed later on in this chapter, works of art can also be deteriorated by acids and bases and have to be stored in a controlled environment. The pH can be determined quite easily in three major ways.

First, some organic molecules (which will be studied in Chapter 8)— that is, molecules containing carbon atoms—may display different colors depending on the pH. Such molecules belong to an acid base conjugate pair and are called color indicators, with HIn representing their acidic form and In⁻ their basic form, as shown in the chemical equation below:

$$HIn \rightleftharpoons H^+ + In^-$$

For example, the color indicator named bromocresol green has a yellow acidic form HIn, a blue basic form In⁻, and a green color when the pH is close to the limit between the two forms. By adding several drops of this indicator to a solution, an idea of the pH can be obtained. Many indicators display only two or three colors but a few of them can give more precise information because they display many more colors as a function of pH. A very famous experiment related to this and that can be done safely at home is to extract the juice of a red cabbage and see what color it becomes with several household products known to be acidic or basic. The color of the red cabbage juice changes and encompasses a variety of colors: red, purple, green, yellow, blue, and pink. Many flowers, fruits, and vegetables contain this type of dye that can act as a color indicator (Figure 6.7). These were used as indicators before the advances in organic chemistry in the 19th century that allowed for the synthesis of a plethora of chemicals in the laboratory.

A list of common color indicators with their color changes is provided in Table 6.6.

Second, a paper strip that has been dipped in color indicator solution can also be used. Depending on the kind, it is called pH paper or litmus paper. One places a drop of the solution to be tested on the strip of paper, observes the color change, and then compares the color to a scale provided with the pH paper to determine the pH of the solution. Such pH paper with the scale shown on the box and the piece that has been wetted with a solution is shown in Figure 6.8.

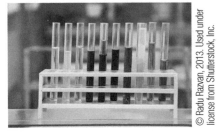

Figure 6.7 Examples of color indicators

Figure 6.8 pH paper with wetted piece on top

Figure 6.9 pH meter

Table 6.6 Color indicators and their changes

Color Indicator	pH Range	Acid Form Color	Basic Form Color
Thymol blue	1.2–2.8	red	yellow
Methyl orange	3.1–4.4	red	orange
Methyl red	4.2–6.2	red	yellow
Bromothymol blue	6.0–7.8	yellow	blue
Phenophthalein	8.3–10.0	colorless	red

Third, the way to determine very precisely the pH as required in many chemistry and biology laboratories is to use a pH meter such as the one in Figure 6.9. It consists of an electrode that is placed in the solution where the pH needs to be measured and a digital recorder that provides a digital reading of the pH, usually with at least one or two decimal points.

Learning Check

1. If a solution is at a pH of 6.1, what color would the methyl red indicator be?

 Ans: Methyl red turns from yellow to red as the pH increases. The color change occurs from a pH of 4.2 to 6.2, so at a pH of 6.1 the solution should have a red color.

 In order to make sure that the pH of a solution does not fluctuate very much, buffers can be used. Buffers are made of equal amounts of a weak acid and its conjugate weak base and are added to solutions whose pH needs to be controlled. Many biological samples in a laboratory as well as living organisms are examples of this. For instance, our blood has a pH of approximately 7.4, and it needs to be close to that number in order to avoid any major health problems. The most important buffer in the blood is the carbonic-acid-hydrogenocarbonate buffer, which can absorb excess base or acid according to this set of equilibrium reactions:

$$HCO_{3\ (aq)}^{-} + H^{+}_{(aq)} \rightleftharpoons H_2CO_{3(aq)} \rightleftharpoons CO_{2(g)} + H_2O_{(l)}$$

2. Phenophthalein is a very important indicator in chemistry. At what pH will the first pink color appear?

 Ans: The faint pink will first appear when the pH reaches 8.3. As the pH rises above that the color will intensify.

ACID AND BASE REACTIONS

Acids and bases react together, producing an ionic compound, also formerly called salt and sometimes water. Some examples of acid-base reactions are given below:

First example:

$$NH_{3(aq)} + HCl_{(aq)} \rightarrow NH_4Cl_{(aq)}$$

In this molecular equation above, ammonia reacts with hydrochloric acid to give ammonium chloride and water. The reaction can also be written as an ionic equation:

$$NH_{3(aq)} + H^{+}_{(aq)} + Cl^{-}_{(aq)} \rightarrow NH_4^{+}_{(aq)} + Cl^{-}_{(aq)}$$

In this case, the chloride ion is present on both sides of the equation unchanged, and it is said to be a spectator ion. Since it does not intervene in the chemical reaction, it can be eliminated from the equation to provide what is called the net ionic equation shown below:

$$NH_{3(aq)} + H^{+}_{(aq)} \rightarrow NH_4^{+}_{(aq)}$$

Second example:

$$NaOH_{(aq)} + HBr_{(aq)} \rightarrow NaBr_{(aq)} + H_2O_{(l)}$$

An aqueous solution of sodium hydroxide reacts with an aqueous solution of hydrobromic acid to give sodium bromide and water. The total ionic equation and the net ionic equation are worked out below:

$$Na^{+}_{(aq)} + OH^{-}_{(aq)} + H^{+}_{(aq)} + Br^{-}_{(aq)} \rightarrow Na^{+}_{(aq)} + Br^{-}_{(aq)} + H_2O_{(l)}$$

Once again, it can be seen that the sodium and bromide ions are spectator ions in this total ionic equation and can be removed to yield the net ionic equation:

$$OH^{-}_{(aq)} + H^{+}_{(aq)} \rightarrow H_2O_{(l)}$$

Third example:

$$Na_2CO_{3(aq)} + 2\ HCl_{(aq)} \rightarrow 2\ NaCl_{(aq)} + H_2CO_{3(aq)}$$

In this example, two molecules of HCl are needed to balance the reaction. It should also be noted that carbonic acid (H_2CO_3) is unstable and will readily decompose into water and carbon dioxide as follows:

$$Na_2CO_{3(aq)} + 2\ HCl_{(aq)} \rightarrow 2\ NaCl_{(aq)} + H_2O_{(l)} + CO_{2(g)}$$

The production of carbon dioxide, a gas, explains the effervescence created when a carbonate such as in baking soda reacts with an acid such as acetic acid in vinegar. The total and net ionic equations for this reaction, where sodium and chloride ions are spectator ions, are respectively:

$$2\ Na^+_{(aq)} + CO_3^{2-}{}_{(aq)} + 2\ H^+_{(aq)} + 2\ Cl^-_{(aq)} \rightarrow 2\ Na^+_{(aq)} + 2\ Cl^-_{(aq)} + H_2O_{(l)} + CO_{2(g)}$$

$$CO_3^{2-}{}_{(aq)} + 2\ H^+_{(aq)} \rightarrow H_2O_{(l)} + CO_{2(g)}$$

TITRATION

Discussing acid and base titrations and the calculations involved is not our scope, so only a simple but conceptual explanation is provided. In some cases a chemist needs to know the concentration of an acid and has at his or her disposition a base of known concentration or vice versa. He or she will use the known solution to determine the concentration of the unknown solution. An experiment of this type is represented in Figure 6.10.

The Erlenmeyer flask contains the unknown solution and a color indicator, here most likely phenolphthalein, easily recognizable by its strong pink color. The solution of known concentration is in the burette, clamped to a stand. By carefully adding the known solution to the unknown solution until the color indicator changes color, one can calculate the concentration of the unknown solution.

Figure 6.10 Setup for an acid-base titration

© Zern Liew, 2013. Used under license from Shutterstock, Inc.

ACIDS AND BASES IN ART

The aqueous solutions of various color indicators can be used as watercolors; however, with time the paper used as support will decompose because of the acidity or basicity of the solutions. This lack of permanence makes this technique quite useless, but it is an interesting experiment for the chemistry laboratory.

Metal etching is the process of using strong acid to create design in the metal, usually copper, sometimes zinc, and more rarely steel. The metal is protected by acid–resistant wax, which is removed only on the parts of the metal that need to be dissolved. The acid is poured onto the metal and only the naked parts are attacked, leaving a carved–out design. This process that creates metallic plates that then can be inked and used in printmaking is called intaglio. Stamps and the dollar bill, for instance, are prepared that way as shown by the fine lines observed under magnification as shown in Figure 6.11.

Among the great artists, Durer, Holbien, Rembrandt, Goya, and Picasso all mastered the art of etching and engraving. Rembrandt, for example, created hundreds of plates to be used that way.

When a frosted look on a piece of glass is desired now, one may use a sandblasting process or an etching cream that may contain a mixture that will etch the glass to give it a rough and desired appearance. However, an older technique that is now obsolete because of the immense safety risks associated with it was to use

Figure 6.11 Closeup of George Washington on a dollar bill—an example of etching

© Fliegenwulf, 2013. Used under license from Shutterstock, Inc.

hydrofluoric acid (HF). This acid can dissolve silicon dioxide from the glass, forming hydrofluorosilicic acid (H_2SiF_6) according to the following reaction:

$$SiO_{2(aq)} + 6\ HF_{(aq)} \rightarrow H_2SiF_{6(aq)} + 2\ H_2O_{(l)}$$

Of course, this implies that HF cannot be stored in a glass container since it would dissolve it. Although this process provides the desired frosted appearance, hydrofluoric acid can also react with calcium, dissolving the bones it comes in contact with and leaving the person with soft bones forever. The only way to stop such an attack is to inject a solution containing calcium ions directly where the acid has contaminated the person. The acid will then react with this injected calcium solution instead of the calcium from the bone; however, if the bone has already been damaged, it is irreversible.

An issue of acids in art conservation and in everyday life as well is the yellowing and deterioration of wood pulp paper over time. Now paper can be made using cotton fibers (sometimes called rag paper) or wood fibers. Paper made from plant fibers was invented in China by Ts'ai Lun in the year 105 C.E. (although recent archeological discoveries may change this date to an earlier date), and it was kept secret until through commercial exchanges it made its way to the Middle East in the 8th century and eventually to Europe via Italy in the 12th century. It was not until the industrial revolution in the 19th century and the access to chemicals that could bleach wood pulp that cheaper paper was manufactured from wood fibers, which are naturally yellow, instead of the whiter cotton fibers. The reduced cost of papermaking had a positive outcome since books were more affordable and helped propagate knowledge. However, the process had a paradoxical effect: It bleaches and whitens the wood pulp but leaves the paper acidic at the same time, which damages these fibers that in turn are more susceptible to yellowing and darkening. Now paper manufacturers can produce a more expensive but acid–free paper with a reduced amount of additives or with another chemical treatment that neutralizes the acid present in the paper. Finally, cotton paper is still available, although more expensive, but it does not require an extensive chemical treatment. It is used for bank notes and official documents that need to be archived for a long time because it can last many centuries if properly stored.

The technique of painting on fresh wet plaster is called *fresco*, which means fresh in Italian. This technique was already known in the early Greek period, around 1700 B.C.E. as can be seen in the ruins of the Minoan palace in Crete. Other famous frescoes include the frescoes in Pompeii and Herculaneum, the two Italian cities near Naples in the south of Italy that were destroyed by the volcanic eruption of the Mount Vesuvius in 79 C.E. The images in Figure 6.12 show from left to right the unearthed town of Pompeii with the Mount Vesuvius in the background, the remains of a person who died protecting his or her face from the toxic gases during the eruption, and a well-preserved fresco inside a house with the famous Pompeian red pigment. During the eruption, lethal gases and hot ashes killed the population, who did not have time to flee, burying the city and the bodies under a deep layer of pumice and volcanic ashes that will end up being a protective layer. The city was rediscovered in the 18th century. The bodies had decomposed, leaving a hollow shape in the ground that, once filled with plaster, could be excavated and provide historical evidence of the fact that the people were surprised and trapped during his eruption.

Figure 6.12 Images from Pompeii

© Vlad G, 2013. Used under license from Shutterstock, Inc.

Figure 6.13 Ceiling of the Sistine Chapel, The Vatican, Rome

Finally, a more recent and famous fresco is the one in the Sistine Chapel in the Vatican, shown in Figure 6.13, painted between 1508 and 1512 by Michelangelo Buonarroti (1475–1564). It was recently cleaned and restored in order to remove centuries of dust and dirt, exposing bright colors that remain controversial although no evidence of damage to the fresco has been found.

So fresco painting involves the use of wet lime-plaster on a prepared surface on which the artist paints with a paste made of pigments and water. Slaked lime is the old name for hydrated calcium hydroxide $Ca(OH)_2$. Because of the very basic nature of slaked lime, the pigments have to be resistant to a basic environment. As the plaster dries, it absorbs carbon dioxide from the air and becomes calcium carbonate, releasing water that will evaporate. The pigment is thus entrapped in the fresco as the following chemical reaction occurs:

$$Ca(OH)_{2(aq)} + CO_{2(g)} \rightarrow CaCO_{3(s)} + H_2O_{(l)}$$

Because of the basic nature of frescoes, they can be damaged by acids. The air contains traces of acids that are the result of burning fossil fuels. The burning of fossil fuels releases sulfur dioxide and nitrogen dioxide, which can react with oxygen and water in the air to produce sulfuric and nitric acids as described below:

$$SO_{2(g)} + O_{2(g)} \rightarrow SO_{3(g)}$$

$$SO_{3(g)} + H_2O_{(l)} \rightarrow H_2SO_{4(l)}$$

$$NO_{(g)} + H_2O_{(l)} \rightarrow HNO_{3(l)}$$

These acids will then react with the calcium carbonate converting it into calcium sulfate, $CaSO_4$, also called gypsum, which flakes off.

$$CaCO_{3(s)} + H_2SO_{4(l)} \rightarrow CaSO_{4(s)} + H_2O_{(l)} + CO_{2(g)}$$

One way to reverse this damage is to clean the fresco with ammonium carbonate, which reacts with the gypsum to regenerate calcium carbonate, as follows:

$$CaSO_4 \cdot 2H_2O_{(s)} + (NH_4)_2CO_{3(aq)} \rightarrow (NH_4)_2SO_{4(aq)} + CaCO_{3(s)} + 2H_2O_{(l)}$$

Then, barium hydroxide $Ba(OH)_2$, is applied using a swab, converting any remaining gypsum to barium sulfate $BaSO_4$:

$$(NH_4)_2SO_{4(aq)} + Ba(OH)_{2(aq)} \rightarrow BaSO_{4(s)} + 2NH_{3(aq)} + 2H_2O_{(l)}$$

Finally, the excess barium hydroxide migrates toward the inside of the fresco, reacting with any other sulfate present or if not with carbon dioxide, thus consolidating the fresco.

$$Ba(OH)_{2(aq)} + CO_{2(g)} \rightarrow BaCO_{3(s)} + H_2O_{(l)}$$

This series of treatment was developed in Florence, Italy, in 1966 and is known as the barium method.

PROBLEMS

1. Describe the physical and chemical properties of an acid.

2. Describe the physical and chemical properties of a base.

3. For the following acid/base reactions decide if the compound is an Arrhenius acid or base.

$$NaOH_{(S)} \rightarrow Na^+_{(aq)} + OH^-_{(aq)}$$

$$HI_{(S)} \rightarrow H^+_{(aq)} + I^-_{(aq)}$$

4. Write an equation for the dissociation of nitric acid (HNO_3).

5. Write the equation for the dissociation of perchloric acid ($HClO_4$).

6. Write the equation for the dissociation of hydrobromic acid (HBr).

7. Categorize the following as either an acid or base.

$$HCl, NaOH, KOH, H_2SO_3$$

8. Write the chemical equation for the dissociation of sodium hydroxide.

9. Write the chemical equation for the dissociation of barium hydroxide.

10. Write out the reaction of HCl with NaOH.

11. Write an equation of the dissociation of potassium hydroxide (KOH).

12. Write the chemical equation for the reaction that occurs when sodium hydride is dissolved in water.

13. In the reaction of bicarbonate with water identify the proton acceptor and the proton donor.

$$HCO^-_3 + H_2O \rightleftharpoons H_2CO_3 + OH^-$$

14. Why are acids, such as sulfuric (H_2SO_4) and carbonic (H_2CO_3) sometimes called diprotic acids?

15. Which of the following acids would be considered polyprotic?

$$HBr, HClO_4, H_2SO_4 \text{ and } CH_3CO_2H$$

16. When referring to acid/base chemistry, what does the term *neutralization* mean?

17. What is the difference between strong acids and weak acids?

18. When discussing strong acids and strong bases, why is no equilibrium considered to exist?

19. Acetic acid is a weak acid; write the equation for the dissociation of acetic acid in water.

20. Benzoic acid (C_6H_5COOH) is a weak acid. Write the equation for the dissociation of benzoic acid.

21. From K_b table decide if pyridine is a stronger base than methylamine.

22. Write the K_b expression for the dissociation of the hydrogen sulfide ion HS$^-$.

23. Write the balanced chemical equation for the reaction between magnesium and perchloric acid.

24. Write the balanced chemical equation for the reaction of aluminum and sulfuric acid.

25. In the presence of an acid, which would be more reactive, potassium or cesium?

26. What would be the conjugate acid of PO_4^{3-}?

27. Write two separate reactions in which water acts as a base in one and an acid in the other.

28. Write a set of chemical equations demonstrating that $H_2PO_4^-$ can act as both a base and an acid.

29. Identify the conjugate acid/base pairs for the following reaction:

$$HNO_2 + ClO_2^- \rightleftharpoons NO_2^- + HClO_2$$

30. Write chemical equations demonstrating how sodium bicarbonate can act as both an acid and a base.

31. For the following acid/base reaction identify the conjugate pairs:

$$SO_4^{2-}{}_{(aq)} + H_2O_{(l)} \rightleftharpoons HSO_4^-{}_{(aq)} + OH^-{}_{(aq)}$$

32. Would phosphoric acid and phosphate be considered a conjugate acid/base pair?

33. What is the relationship between the concentration of hydroxide ions and hydronium ions?

34. What is the pH of a solution that has a hydroxide concentration of $8.9 \times 10^{-4} M$?

35. Find the pOH of solution that has a hydroxide concentration of $2.1 \times 10^{-5} M$.

36. What is the hydronium concentration of a pH 6.3 solution?

37. If a pH–sensitive experiment must be conducted under a pH range of 8.0 to 9.5, which indicator should be used?

38. Write the net ionic equation for the reaction of hydrochloric acid and sodium hydroxide.

39. For the following equation label all spectator ions and write the net ionic equation:

$$H_3O^+{}_{(aq)} + ClO_4^-{}_{(aq)} + K^+{}_{(aq)} + CH_3CH_2COO^-{}_{(aq)} \rightarrow CH_3CH_2COOH_{(aq)} + K^+{}_{(aq)} + ClO_4^-{}_{(aq)} + H_2O_{(l)}$$

ANSWERS

1. All acids taste sour. All acids release protons when dissolved into water (Arrhenius). The protons that are release into water, react with water molecules to form hydronium. The conjugate base that the proton detached from becomes an anion. Some acids can donate more than one proton in solution. These acids are referred to as polyprotic acids.

2. All bases taste bitter and feel slippery, soapy to touch. Arrhenius bases are able to increase the concentration of hydroxide when dissolved in water. Another way to think about a base is that once dissolved in solution, it becomes a proton acceptor.

3. $NaOH_{(s)} \rightarrow Na^+_{(aq)} + OH^-_{(aq)}$ Sodium hydroxide increases the concentration of hydroxide in solution. Therefore, it is an Arrhenius Base.

 $HI_{(s)} \rightarrow H^+_{(aq)} + I^-_{(aq)}$ Hydroiodic acid increases the concentration of the hydronium ion in solution by donating a proton. Therefore, it is an Arrhenius acid.

4. Dissociation of nitric acid (HNO_3).
$$HNO_{3\,(l)} \rightarrow H^+_{(aq)} + NO_3^-_{(aq)}$$

5. Dissociation of perchloric acid ($HClO_4$).
$$HClO_{4\,(l)} \rightarrow H^+_{(aq)} + ClO_4^-_{(aq)}$$

6. Dissociation of hydrobromic acid (HBr).
$$HBr_{(l)} \rightarrow H^+_{(aq)} + Br^-_{(aq)}$$

7. Acid: **HCl and H_2SO_4** Base: **NaOH and KOH**

8. Dissociation of sodium hydroxide.
$$NaOH_{(s)} \rightarrow Na^+_{(aq)} + OH^-_{(aq)}$$

9. Dissociation of barium hydroxide.
$$Ba(OH)_{2\,(s)} \rightarrow Ba^+_{(aq)} + 2OH^-_{(aq)}$$

10. Reaction of hydrochloric acid and sodium hydroxide.
$$HCl_{(aq)} + NaOH_{(aq)} \rightarrow NaCl_{(aq)} + H_2O_{(l)}$$

11. Dissociation of potassium hydroxide.
$$KOH_{(s)} \rightarrow K^+_{(aq)} + OH^-_{(aq)}$$

12. Reaction of sodium hydroxide dissolving in water.
$$NaOH_{(s)} + H_2O_{(l)} \rightarrow Na^+_{(aq)} + OH^-_{(aq)}$$

13. $HCO_3^- + H_2O \rightleftharpoons H_2CO_3 + OH-$

 HCO_3^- is the proton acceptor. H_2O is the proton donor.

14. Sulfuric acid (H_2SO_4) and carbonic acid (H_2CO_3) are both diprotic acids because they have two available protons that can be donated to solution. Hydrochloric acid (HCl) is a monoprotic acid because it only has one proton to donate.

15. Monoprotic acid: HBr, $HClO_4$, and CH_3COH

 Polyprotic acid: H_2SO_4 (diprotic)

16. The term, neutralization, describes the process of an acid and a base reacting together to yield a neutral solution. When a strong acid neutralizes a strong base, the result is water and an aqueous salt.

17. A strong acid completely dissociates into solution, which makes it a strong electrolyte. A weak acid partially dissociates which makes it a weak electrolyte.

18. Since strong acids and bases are strong electrolytes and completely dissociate, the reverse reaction can be neglected. There is no reverse reaction as required in an equilibrium.

19. Dissociation of acetic acid (CH_3COH) in water.

$$CH_3COOH_{(l)} + H_2O_{(l)} \rightleftharpoons CH_3COO^-_{(aq)} + H_3O^+_{(aq)}$$

20. Dissociation of benzoic acid (C_6H_5COOH) in water.

$$C_6H_5COOH_{(l)} + H_2O_{(l)} \rightleftharpoons C_6H_5COO^-_{(aq)} + H_3O^+_{(aq)}$$

21. The K_b for pyridine is 1.7×10^{-9}. The K_b for methylamine is 4.38×10^{-4}. Since the K_b for methylamine is larger than the K_b of pyridine, methylamine is a stronger base.

22. K_b expression for Dissociation of the hydrogen sulfide ion, HS^-.

$$HS^-_{(aq)} + H_2O_{(l)} \rightleftharpoons H_2S_{(aq)} + OH^-_{(aq)}, \qquad K_b = \frac{[H_2S][OH^-]}{[HS^-]}$$

23. Balanced chemical equation for reaction of magnesium and perchloric acid.

$$Mg_{(s)} + 2HClO_{4(aq)} \rightarrow Mg(ClO_4)_{2(aq)} + H_{2(g)}$$

24. Balanced chemical equation for reaction of aluminum and sulfuric acid.

$$2Al_{(s)} + 3H_2SO_{4(aq)} \rightarrow Al_2(SO_4)_{3(aq)} + 3H_{2(g)}$$

25. In the presence of acid, cesium would be more reactive than potassium due to the trend of increasing reactivity as you travel down a column on the periodic table.

26. Conjugate acid of PO_4^{3-}. **Conjugate acid: HPO_4^{2-}**

27. $NaOH_{(s)} + H_2O_{(l)} \rightarrow Na^+_{(aq)} + OH^-_{(aq)}$ **(Water acts as an acid)**

 $HBr_{(l)} + H_2O_{(l)} \rightarrow H_3O^+_{(aq)} + Br^-_{(aq)}$ **(Water acts as a base)**

28. $HPO_4^{2-} + H_2O_{(l)} \rightleftharpoons H_2PO_4^-{}_{(aq)} + OH^-_{(aq)}$ **(HPO_4^{2-} acts as a base)**

 $HPO_4^{2-} + H_2O_{(l)} \rightleftharpoons PO_4^{3-}{}_{(aq)} + H_3O^+_{(aq)}$ **(HPO_4^{2-} acts as an base)**

29. Conjugate acid/base pairs:

 $HNO_{2(aq)} + ClO_2^-{}_{(aq)} \rightleftharpoons NO_2^-{}_{(aq)} + HClO_2{}_{(aq)}$

 Acid: HNO_2, conjugate base: NO_2^-

 Base: ClO_2^-, conjugate acid: $HClO_2$

30. Chemical equation for sodium bicarbonate as both acid and base.

 $NaHCO_3^-{}_{(aq)} + H_2O_{(l)} \rightleftharpoons H_2CO_3{}_{(aq)} + NaOH_{(aq)}$ **(HCO_3^- acts as a base)**

 $NaHCO_3^-{}_{(aq)} + H_2O_{(l)} \rightleftharpoons CO_3^{2-}{}_{(aq)} + Na^+_{(aq)} + H_3O^+_{(aq)}$ **(HCO_3^- acts as an acid)**

31. Conjugate acid/base pairs:

 $SO_4^{2-} + H_2O_{(l)} \rightleftharpoons HSO_4^-{}_{(aq)} + OH^-_{(aq)}$

 Acid: $H_2O_{(l)}$, conjugate base: $OH^-_{(aq)}$

 Base: SO_4^{2-}, conjugate acid: $HSO_4^-{}_{(aq)}$

32. Phosphoric acid and the phosphate ion would not be a conjugate acid/base pair because too many protons separate them. In order to be a conjugate acid/base pair, both species need to be a single proton lost/gained from becoming one another. Phosphoric acid had three available protons that it can donate to solution. It cannot take on any more protons. Therefore, it will have to lose a proton to the solution to become dihydrogen phosphate. Likewise, the phosphate ion does not possess any protons that it can donate to solution. Therefore, the

phosphate ion can only accept a proton from solution. When it accepts a proton, it becomes hydrogen phosphate. The conclusion is that these two species are not a single proton lost/gain from one another, which means they are not a conjugate pair.

33. The relationship between the total hydroxide and hydronium concentrations in solution determines the basic and acidic nature of a solution. The relationship is visually seen on the pH scale. If there are more hydroxide ions (fewer hydronium ions) in solution, then the solution is said to be basic. The opposite is true making it an acidic solution.

34. Find the pH of the solution:

 Given: $[OH^-] = 8.9 \times 10^{-4}$ M, pH $= 14 -$ pOH, pOH $= -\log([OH^-])$

 pOH $= -\log(8.9 \times 10^{-4}M) = 3.1$, pH $= 14 - 3.1 = \mathbf{10.9 = pH}$

35. Find the pOH of the solution:

 Given: $[OH^-] = 2.1 \times 10^{-5}$ M, pOH $= -\log([OH^-])$

 pOH $= -\log(2.1 \times 10^{-5}$ M$) = 4.7$, **pOH = 4.7**

36. Find $[H_3O^+]$.

 Given: pH $= 6.3$, $[H_3O^+] = 10^{-pH}$

 $[H_3O^+] = 10^{-6.3} = \mathbf{5.0 \times 10^{-7}}$ **M**

37. If an experiment takes place between the pH ranges of 8.0 and 9.5, the proper indicator is phenolphthalein. Phenolphthalein's pH range for color indication is 8.3–10.0.

38. Find the net ionic equation.

 $$HCl_{(aq)} + NaOH_{(aq)} \rightarrow NaCl_{(aq)} + H_2O_{(l)}$$
 $$H^+_{(aq)} + Cl^-_{(aq)} + Na^+_{(aq)} + OH^-_{(aq)} \rightarrow Na^+_{(aq)} + Cl^-_{(aq)} + H_2O_{(l)}$$

 From the total ionic equation above, the spectator ions are removed. Therefore, $Cl^-_{(aq)}$ and $Na^+_{(aq)}$ are cancelled out, leaving:

 $$H^+_{(aq)} + OH^-_{(aq)} \rightarrow H_2O_{(l)}$$ **This is the net ionic equation.**

39. Label the spectator ions in the following total ionic equation.

 $$H_3O^+_{(aq)} + ClO_4{}^-_{(aq)} + K^+_{(aq)} + CH_3COO^-_{(aq)} \rightarrow CH_3COOH_{(aq)} + K^+_{(aq)} + ClO_4{}^-_{(aq)} + H_2O_{(l)}$$

 Spectator ions: $ClO_4{}_{(aq)}$ and $K^+_{(aq)}$

Nuclear Chemistry

Except for hydrogen, which contains only one proton, all atoms have protons and neutrons in their nuclei. In some cases, atoms undergo a transformation in the nucleus that changes their identities from one isotope to another or from one element to another one. These transformations are called *nuclear reactions* and may involve great amounts of energy. The emission of radiation or particles from the nucleus is called *radioactivity*, and it can occur naturally if a naturally occurring isotope is radioactive or artificially if an isotope is made radioactive. A group of French scientists, Henri Becquerel, Pierre Curie and his wife Marie Curie, received the physics Nobel Prize in 1903 (Figure 7.1) for the discovery of natural radioactivity, while Irene Joliot-Curie, Pierre and Marie's daughter and her husband Frederic Joliot received the chemistry Nobel Prize in 1935 for the discovery of artificial radioactivity. In 1911 Marie received a second Nobel Prize, this time by herself in chemistry for the discovery of two new elements: polonium, named after her country of origin—Poland—and radium.

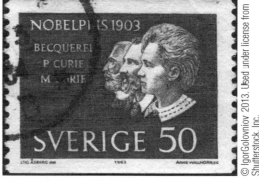

Figure 7.1 1903 Nobel Prize winners for Physics

The elements that are always radioactive are all the actinides plus polonium, astatine, radon, francium, radium, and technetium.

NUCLEAR FORCE AND NUCLEAR STABILITY

The nucleus is made up of protons and neutrons, but protons are positively charged. So why do the protons not repel each other? If only the electrostatic interactions between the positively charged protons were taken into account, the protons would repel each other, but another force is at play. Both neutrons and protons exert an attractive force on each other, this force is known as the strong nuclear force. The strength of the attractive interactions is heavily dependent on distance. As two particles in the nucleus (nucleons) become further and further apart, the strong nuclear force rapidly diminishes; however, as two nucleons approach each other, the strong nuclear force increase rapidly. The strong nuclear force is crucial to the structure of the atom; without it, the protons would spread out just as electrons do.

The two forces that decide the stability of a nucleus are the attractive strong nuclear force between nucleons and the repulsive electrical force between the positively charged protons. Because neutrons have no charge, the only force they exert is the attractive strong nuclear force, while the protons exert both an attractive strong nuclear force and a repulsive electrical force. Hence, it is thought that neutrons serve as a buffer between the protons, attracting the surrounding nucleons, while simultaneously limiting the electrostatic interactions between adjacent protons. For this reason, neutrons play a larger role in holding the nucleus together than the protons. The ratio of neutrons to protons also plays a crucial role in stabilizing an atom. For lighter atoms the ratio of neutrons to protons is approximately one to one, but as the atomic number increases, the ratio of neutrons to protons begins to increase. This means that repulsion from electrostatic interactions between protons increases steadily with increasing atomic numbers, while the stability gained by adding another neutron stays relatively constant. Eventually, a point is reached in which stability cannot be obtained, meaning that all elements with atomic numbers greater than 83 (bismuth) have unstable nuclei and are, thus, radioactive. Unstable nuclei attempt to reach stability through a process known as radioactive decay. *Radioactive decay* is a spontaneous process that involves the nucleus releasing a radiation with or without one or more particles. Almost all nuclear reactions are accompanied by the release of gamma rays, which are extremely high energy electromagnetic radiation.

Learning Checks

1. What role, if any, do neutrons play in stabilizing an atoms nucleus?

 Ans: Neutrons by definition are electrically neutral, meaning that they do not exert an electrical force; however, neutrons can and do exert an attractive strong nuclear force. It is the strong nuclear force that holds a nucleus together, counteracting the repulsive interactions between the positively charged protons. Hence, neutrons are crucial for the stability of the nucleus.

2. How does distance affect the strong nuclear force? Is the effect similar for the electrical force?

 Ans: As the distance between nucleons increases, the strength of the strong nuclear force rapidly dies off, and thus, for larger atoms the strong nuclear force felt between nucleons is dependent on proximity. However, the electrical force continually builds as the number of protons increases and does not depend on proximity.

3. Over 99% of all naturally occurring hydrogen has no neutrons. Why does hydrogen not require neutrons for stability?

 Ans: Hydrogen has an atomic number of 1, meaning that hydrogen only has one proton, so unlike all other atomic nuclei, the hydrogen nucleus does not require any neutrons because the single proton is not experiencing any repulsive interactions from adjacent protons.

NUCLEAR RADIATION AND SAFETY ISSUES

A radioactive isotope—i.e., an unstable isotope—has an unstable nucleus and emits radiation in order to modify the nucleus and become more stable. An element can have both stable and unstable isotopes. For instance, magnesium-24 is stable, while magnesium-23 and magnesium-27 are not. In some other cases, all isotopes of an element can be unstable; this is the case for all the actinides elements, such as uranium or plutonium.

A nuclear reaction refers to a change in composition of an atom's nucleus. There are three types of nuclear reactions, which will be discussed in this chapter: alpha, beta, and gamma. Alpha- and

beta-type nuclear reactions involve the emission of particles; gamma involves the emission of pure energy in the form of radiation.

Figure 7.2 Safety equipment for radiation

The penetrating ability of the particles and rays are proportional to their energies. Alpha particles are much heavier than beta particles and thus slower moving. Beta particles can damage skin and other soft tissues but do not damage internal organs because they do not penetrate far enough. Of course, if the beta-emitter is ingested, the damage to internal organs will be done from within. The heavy, slow-moving alpha particles have an even lower penetrating ability and are not even capable of damaging skin unless placed directly on it. Gamma rays are the opposite because they are only a highly energetic radiation not associated with any particle. They have an amazing penetrating strength and can damage both skin and internal organs. Exposure to radiation is decreased by limiting the amount of time spent near a radioactive source and also by increasing the distance from the source. There is an inverse square relationship between the distance from the radioactive source, meaning that doubling the distance from the source decreases the intensity by a factor of four, or that tripling the distance decreases the intensity by a factor of 9. In order to protect oneself from alpha particles, something as simple as paper and clothing is sufficient, whereas heavier clothing (Figure 7.2), gloves, or wood can be enough for a beta emitter. However, because of its high energy and penetrating ability only thick layers of concrete or lead shields can stop gamma rays.

RADIOACTIVE MATERIALS AND ART

One might think there is no relationship between art and radioactive materials, but there is, besides the determination of the age of an object, as we will see later in this chapter. Shortly after uranium was first identified by German chemist Martin Heinrich in 1789, it has been used in glass making because of its ability to make it glow a bright yellow-lime color. In the 1930s, influenced by the Art Deco style, the kitchenware company Fiesta tableware produced solid-color pieces of ceramics, using for the orange-red color a uranium oxide glaze. Radium was also used in paint in order to make objects, such as hands on a clock or light switches, glow in the dark. Because these objects can now be found in museums, it can be a safety hazard that art conservators solve by not exhibiting the object to the public or in appropriate cases by encasing it in a leaded-glass window and placing at the back of the display since distance matters with radioactivity. It is only fair to mention and recognize here all the workers, virtually all women, who suffered from exposure to radium paint in the early 20th century while working in these factories as they were placing the paintbrushes in their mouths in order to keep the bristles together.

Finally, these three types of radiation are sometimes called *ionizing radiation* because they produce a trail of ions throughout the material that they penetrate. This ionizing ability is sometimes used to destroy living micro-organisms on food, thus eliminating foodborne pathogens and extending the shelf life on these products without making the food itself radioactive.

ALPHA RADIATION OR ALPHA DECAY

Alpha radiation or alpha decay is the emission of an alpha particle from an unstable nucleus, resulting in a new nucleus. The symbol for an alpha particle is:

$$_{2}^{4}He \text{ or } _{2}^{4}\alpha \text{ or simply } \alpha$$

An alpha particle is a helium atom with no electrons; thus it has a +2 charge, making it an ionizing particle, because it can grab electrons from other atoms. The effect of undergoing alpha decay is

that the daughter isotope's atomic number is two less than the parent isotope, and the mass number of the new nucleus is 4 less than that of the initial nucleus.

Nuclear equations are very different from chemical equations since the identity of the element may be changed. The way to balance a nuclear equation is by accounting for all the subatomic particles: neutrons and protons. An example is provided below.

$$^{238}_{92}U \rightarrow {}^{234}_{90}Th + {}^{4}_{2}He$$

This equation reads as follows: "Uranium-238 undergoes alpha decay to produce Thorium-90." In this equation, there are 92 protons and 238 nucleons on the both sides of the arrow. In other words, in a balanced nuclear equation, the sum of the mass numbers and the sum of the atomic numbers for the nuclei of the reactant and of the products must be equal.

Learning Checks

1. List the following radioactive emissions from greatest to least penetrating: alpha, beta, gamma.

 Ans: Alpha particles are the heaviest of the three emissions and are, thus, slowest and least penetrating. Beta particles are lighter than alpha particles, giving them greater penetrating ability. However, gamma rays are pure energy and have no mass, making them by far the most penetrating. So from greatest to least penetrating the order is: gamma, beta, alpha.

2. Plutonium-238 is known to emit alpha particles. Write out the nuclear reaction that occurs when an atom of plutonium-238 undergoes an alpha decay.

 Ans: An alpha particle has an atomic number of 2 and a mass number of 4. To find the identity of the daughter nucleus, subtract 2 protons from the atomic number of the parent nucleus (plutonium-238): $92 - 2 = 90$. Then, look at the periodic table and find the element that has the new atomic number. For this problem we are a looking for the element with the atomic number 90, which is uranium. The last step is to subtract 4 from the mass number of the parent nucleus: $238 - 4 = 234$. The reaction can then be written as:

 $$^{238}_{92} \xrightarrow{\text{alpha decay}} {}^{234}_{90}U + {}^{4}_{2}He$$

Beta Radiation or Beta Decay

A beta particle is an electron, so in beta decay an electron is emitted from the nucleus, thus converting a neutron in to a proton at the same time. It is absolutely crucial to understand that this electron comes from the makeup of a neutron in the nucleus and NOT from the electron cloud. The symbol for a beta particle is:

$$^{0}_{-1}e \text{ or } {}^{0}_{-1}\beta \text{ or simply } \beta$$

An example of beta emission is provided below.

$$^{14}_{6}C \rightarrow {}^{14}_{7}N + {}^{0}_{-1}e$$

This equation reads as follows: "Carbon-14 undergoes beta decay to produce nitrogen-14." It is important to notice here that the atomic number of the element produced (daughter element) is one unit higher than the mother element since a neutron became a proton in the process. This example is especially important since it allows scientists to perform carbon dating, as we will see later in this chapter.

Learning Checks

1. Why would a radioisotope undergo beta decay?

 Ans: Beta decay decreases the neutron-to-proton ratio, so radioisotopes that have too many neutrons (too high of a neutron-to-proton ratio) are likely to undergo beta decay.

2. Write the nuclear equation for the beta decay of Co-60.

 Ans: For beta decays, the identity of the daughter isotope can be found by adding 1 to the atomic number of the parent isotope and leaving the mass number alone. So for the beta decay of cobalt-60, the atomic number of the daughter isotope is: 27 + 1 = 28 and the mass number is the same (60) as the parent isotopes mass number: mass number (A) of parent isotope = mass number (A) of the daughter isotope. The nuclear reaction can then be written as:

$$^{60}_{27}Co \xrightarrow{\ beta\ decay\ } {}^{60}_{28}Ni + {}^{0}_{-1}e$$

GAMMA RADIATION

Gamma radiation is an energy loss by an unstable nucleus, indicated by the letter m above its symbol in order to represent metastability. In a nuclear equation for gamma emission, the mass number and the atomic number are unchanged as shown below.

$$^{99m}_{43}Tc \rightarrow {}^{99}_{43}Tc + \gamma$$

Learning Check

1. Write out an equation for the gamma decay of Ni-60.

 Ans: Remember that in gamma decay neither the mass number nor the atomic number changes. So the reaction can be written as:

$$^{60m}_{28}Ni \xrightarrow{\ gamma\ decay\ } {}^{60}_{28}Ni + \gamma$$

RADIATION DETECTION

There are different ways of measuring the level of radiation. The most commonly known is the Geiger counter shown in Figure 7.3, which measures the electrical current created by the ionization of the particles submitted to the radiation. Most models can only detect beta and gamma radiations.

People who work in places where there is a risk of exposure to radiation may wear a film badge, which contains a piece of film that is sensitive to radiation exposure. It will change color as a function of the sum of all the radiation exposures over time. The film may have up to three layers: one that all three types of radiation can penetrate, one that beta and gamma radiations can penetrate and one that only gamma radiation can get to.

There are many units to measure radiation levels and they are summarized in Table 7.1.

Figure 7.3 Geiger counter

Table 7.1 Radiation levels

	Common Unit	Official Unit	Equivalence
Activity	curie (Ci)	becquerel (Bq): disintegration per second	$1\ Ci = 3.7 \times 10^{10}\ Bq$
Dose	rad	gray (Gy)	$1\ Gy = 100\ rad$
Biological Damage	rem	sievert (Sv)	$1\ Sv = 100\ rem$

BACKGROUND RADIATION

A person is exposed to radiation from naturally occurring radioisotopes and also from medical X-rays. Depending on where a person lives and works and what kind of activities he or she is involved in, different levels of radiation may be received. According to the United States Nuclear Regulatory Commission (USNCR), the average dose received by an individual in the United States is about 620 mrem. People living on granite ground, for example, or at higher altitudes may be subject to higher radiation levels than someone who does not. Also, as if smoking was not bad enough from the tar that is deposited in the lungs, cigarette smoke contains an alpha emitter: polonium that is breathed in. The air we breathe, the food we eat, the TV we watch—all expose us to radioactive materials. Of course, special events, like medical X-rays may add to this natural background.

HALF-LIFE

Since radionuclides have different stabilities, they decay at different rates. Some decay completely within a few seconds or less, others require millions of years to fully decay. For all radioactive materials, the rate of decay is independent of temperature and is proportional, k, to the sample concentration C.

$$rate = k[c]$$

After appropriate mathematical transformations, this rate equation yields the following integrated equation, where C_0 is the initial concentration, C the concentration at the time t considered, and k the rate constant.

$$In\left(\frac{Co}{C}\right) = kt$$

The rate constant k is different for each radionuclide and is related to the half-life of that isotope. The half-life ($t_{1/2}$) is the time for the radiation level to decrease to one-half of the original value or for half of the amount of radioactive material to decay. The relationship between the half-life and the rate constant is:

$$t_{\frac{1}{2}} = \frac{In2}{k} = \frac{.693}{k}$$

Some examples of radioisotopes, their type of radiation, and their half-lives are provided in Table 7.2.

Table 7.2 Radioisotopes, Type of Radiation, and Half-Lives

Element	Symbol	Half-Life ($t_{1/2}$)	Radiation
Naturally Occurring Isotopes			
Carbon	^{14}C	5730 years	β
Potassium	^{40}K	1.3×10^9 years	β and γ
Uranium	^{238}U	4.5×10^9 years	α and γ
Some isotopes used in medicine			
Iodine	^{131}I	8 days	β and γ
Iodine	^{125}I	60 days	γ
Iron	^{59}Fe	46 days	β and γ
Phosphorus	^{32}P	14 days	β
Technetium	^{99m}Tc	64 days	γ

CALCULATIONS WITH HALF-LIFE

Calculating the amount remaining in a radioactive sample is quite easy when the number of half-lives that have elapsed is a whole number. If one considers the definition of a half-life, it is then easy to realize that when starting with a 100-mg sample for instance, every time one half-life has passed, half of the content is lost. Imagine four half-lives have passed, and then the sample contains only 6.25 mg as shown in the graph plotted below.

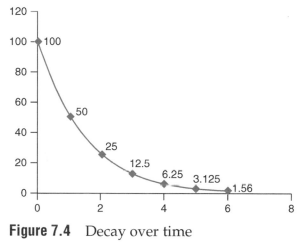

Figure 7.4 Decay over time

Learning Checks

1. A 40-gram sample of radioactive carbon-11 ($t_{1/2}$ = 20 minutes) is used. What amount is left after 100 minutes?

 Ans: 100 minutes represents 5 half-lives, therefore the amount after that period of time has been divided by half 5 times as follows:

 $$40\,grams \times \frac{1}{2} \times \frac{1}{2} \times \frac{1}{2} \times \frac{1}{2} \times \frac{1}{2} = 40\,grams \times \frac{1}{2^5} = \frac{40\,grams}{32} = 1.25\,grams$$

 There is 1.25 gram left of carbon-11 after 100 minutes.

2. If after 16 days, a sample of iodine-131 contains only 25 grams of this radioisotope ($t_{1/2}$ = 8 days), how much was present at the beginning?

Ans: 16 days represent 2 half-lives, so over that period of time, the amount was divided by half twice.

$$25\,grams \times 2 \times 2 = 100\,grams$$

So the amount of starting material was 100 grams of iodine-131.

MEDICAL APPLICATIONS

Radioisotopes with short half-lives can be used as tracers for medical diagnosis purposes (Figure 7.5). They react, chemically speaking, in the same way as their non-radioactive counterparts. Because of their short half-lives, they will be eliminated from the body rather quickly. As another consequence of this short half-life, they deliver concentrated bursts of radiation that can be recorded on a photographic plate to provide an image of an internal organ. For instance, iodine-131 and iodine-125 can be used for studying the thyroid gland that accumulates iodine; technetium-99 can be used in the diagnosis of bone damages and xenon-133, a gas, can be inhaled to provide a scan of the pulmonary system.

Figure 7.5 Radioactive isotopes are used in medicine

Another kind of medical applications is the use of radioactivity for cancer therapy using gamma radiation, which is highly energetic and as such can damage biological tissues such as tumors. Because tumor cells reproduce faster than normal ones, they are preferentially killed off during the process. Both cobalt-60 and cesium-137 are used for this purpose.

APPLICATION FOR DETERMINING AGE OF CARBON-CONTAINING SAMPLES

It is possible to estimate the age of an object that is made of material that was once alive. This is called *radiocarbon dating*, and it is done through the measurement of the isotopic ratios of carbon-14 (radioactive isotope) over carbon-12 (non-radioactive isotope). Carbon-14 is produced naturally in our atmosphere when a neutron ($_0^1n$) emitted from the sun gets absorbed by a nitrogen-14 atom, releasing a proton according to the following nuclear equation:

$$_7^{14}N + _0^1n \rightarrow _6^{14}C + _1^1H$$

Every living system takes up carbon, regardless of the isotope; plants do so by breathing carbon dioxide and incorporating these elements in their plant material, and animals do so by integrating in their tissues the carbon obtained from the food. As long as the plant or animal is alive, it keeps on taking in both isotopes of carbon. Therefore, the ratio carbon-14 over carbon-12 is pretty constant. However, once it dies, this intake, stops and the carbon-14 amount decreases over time because it is an unstable isotope, whereas carbon-12 is not. The nuclear equation representing the decay of carbon-14 is as follows, coincidentally regenerating nitrogen-14:

$$_6^{14}C \rightarrow _7^{14}N + _{-1}^0e$$

As a result, the ratio carbon-14 over carbon-12 decreases over time and its measurement can provide an estimate of the amount of time spent since the plant or animal has died. Probably the most

Figure 7.6 The shroud of Turin

famous case in the history of carbon dating is the one of the shroud of Turin because of the controversy surrounding it. The shroud of Turin (Figure 7.6) is a centuries-old cloth made of linen that shows the image of a thorn-crowned man and for which historical records go back to at least 1357 when it was first exposed in the South of France before making its way to Italy. Because of the image impressed on it, it is believed to be the shroud that covered Jesus Christ's body when he was entombed.

In 1988, three laboratories working independently (one in Oxford, one in Arizona, and one in Zurich), using a technique called *mass spectrometry*, which will be discussed in chapter 10, analyzed samples of the shroud. The shroud was made of linen, a material that came from a plant; therefore, the fabric was once alive and absorbing carbon, making it a great candidate for carbon dating. The three laboratories were each given four samples so they would not know which one came from the shroud of Turin. These control samples were either medieval or from the early second century c.e. Thorough cleaning was done on all samples to eliminate any trace of potential contamination that occurred over the years and leave only the actual linen fiber. The carbon-14/carbon-12 ratio was then obtained on each sample with a great accuracy on the control ones. The actual piece from the shroud of Turin was found to date from the period ranging 1260–1390 with at least 95% confidence. This entire study was published in the journal *Nature* in 1989.

It is quite rare that the number of half-lives is a whole number, so a slightly different calculation is required compared to what has been done earlier in the half-life paragraph. Let's consider a wooden statue found at an archeological site in Egypt. After analysis, it is found that the sample still displays a radioactivity of 9.8 Bq. Knowing that a recently cut piece of wood has an activity of 16.0 Bq and that the half-life of carbon-14 is 5730 years, how old is that wooden statue?

The formula to use here is: $\ln\left(\dfrac{A_t}{A_0}\right) = -\dfrac{0.693}{t_{1/2}}\, t$, where A_t is the current activity, A_0 is the activity at time 0, when the piece of wood was just cut and "t" the number of years that have elapsed since it was cut.

$$\ln\left(\frac{9.8}{16.0}\right) = -\frac{0.693}{5730}\, t$$

$$t = \ln\left(\frac{9.8}{16.0}\right) \times \left(\frac{-5730}{0.693}\right)$$

After calculations, it is found that the age of the statue is 4053 years old.

Learning Check

1. A species of tree that was commonly used in the manufacture of a medieval period sword has gone extinct. This makes it difficult for scientist to carbon date swords that were made with the extinct wood. A scientist decides to use a sword whose exact date of manufacture is known to come up with an estimate of the activity of a fresh piece of wood. If the sword is exactly 800 years old (t = 800 years) and the activity of a piece of wood taken from the handle was found to be $A_t = 12.0$ Bq. What is the activity of the fresh piece of wood ($t_{1/2} = 5730$ years)?

 Ans: The half-life equation: $\ln\left(\frac{A_t}{A_o}\right) = -\frac{0.693}{t_{1/2}}t$, can be rearranged as:

 $$A_0 = \frac{A_t}{e^{-\frac{0.693}{t_{1/2}}t}}$$

 $$A_0 = \frac{12.0}{e^{-\frac{0.693}{5730}800}}$$

 After calculation, A_0 is found to equal 13.2 Bq.

APPLICATION IN DETERMINING THE AGE OF ROCKS

What if there is no carbon-14 in the sample? Archeological, artistic, and historical objects may not come from a source that was once alive. In that case, measuring the potassium/argon ratio or the uranium/lead ratio is called for. In the case of potassium/argon dating, it is potassium-40, the only radioactive potassium isotope, that is measured against argon-40. Potassium-40 undergoes beta decay with a half-life of 1.25 billion years becoming argon-40, a gas that is then trapped inside the rock.

Another isotopic ratio that can be used to date minerals is the uranium-lead one. Uranium-238, after a sequence of many decays, eventually becomes lead-206, which accumulates in the sample and can be measured to give an age estimate.

Learning Checks

1. Let's consider a rock that contains 2.500×10^9 atoms of lead-206 and 3.300×10^{11} atoms of uranium-238. Assuming that the lead present only comes from the decay of uranium-238 ($t_{1/2} = 4.5 \times 10^9$ years), how old is the rock?

 Ans: We will need to use this formula: $\ln\left(\frac{N_t}{N_0}\right) = -\frac{0.693}{t_{1/2}}t$, where N stands for the number of atoms

 of considered element at the time. The amount of lead only helps us determine how many uranium atoms were present at the beginning (N_0), since all the lead came from the uranium:

 $N_0 =$ current lead atoms + current uranium atoms

 $N_0 = 2.500 \times 10^9 + 3.300 \times 10^{11}$

 $N_0 = 3.325 \times 10^{11}$ atoms of uranium

 So now, we can solve the equation: $\ln\left(\frac{N_t}{N_0}\right) = -\frac{0.693}{t_{1/2}}t$

$$\ln\left(\frac{3.300 \times 10^{11}}{3.325 \times 10^{11}}\right) = -\frac{0.693}{t_{1/2}} t$$

$$t = \ln\left(\frac{3.300 \times 10^{11}}{3.325 \times 10^{11}}\right) \times \left(\frac{-4.5 \times 10^9}{0.693}\right)$$

$$t = 4.9 \times 10^7 \ years$$

According to the data, the rock is 4.9×10^7 years old.

2. If a sample of rock form a mineral deposit has 6.500×10^{12} atoms of potassium-40 and 4.300×10^{10} atoms of argon-40, how old is the mineral deposit?

 Ans: Assuming that all the argon-40 came from the radioactive decay of potassium, the initial concentration of potassium-40 can be found by adding the two quantities together:

$$N_0 = 6.500 \times 10^{12} + 4.300 \times 10^{10} = 6.543 \times 10^{12}$$

The half-life of potassium-40 is 1.250×10^9 years and $N_t = 6.500 \times 10^{12}$. The problem is then solved as shown below:

$$t = -\ln\left(\frac{N_t}{N_0}\right)\frac{t_{1/2}}{.693}$$

$$t = -\ln\left(\frac{6.500 \times 10^{12}}{6.543 \times 10^{12}}\right)\frac{1.25 \times 10^9}{.693} = 1.189 \times 10^7 \ years$$

Therefore, the mineral deposit is 1.189×10^7 years old.

PROBLEMS

1. What is radioactivity?

2. What is the difference between natural and artificial radioactivity?

3. In your own words, describe the interaction occurring between neutrons and protons. Tell which are repulsive and which are attractive and the role of each interaction in either stabilizing or destabilizing the nucleus.

4. Why do unstable isotopes emit radiation?

5. Describe the inverse square relationship between distance and the intensity of radiation.

6. Gamma rays are extremely harmful. Why?

7. What precautions should be taken to limit exposure to radiation?

8. What criteria must a nuclear equation meet for it to be considered balanced?

9. For any radioisotope undergoing an alpha decay by what amount will the parent isotopes mass number decrease? What about the atomic number?

10. Write the nuclear equation for the alpha decay of curium-250.

11. From the following nuclear equation decide the identity of the parent isotope:

$$^?_?? \xrightarrow{\text{alpha decay}} {}^{165}_{68}Er + {}^4_2He$$

12. What affect does beta decay have on the atomic number of the daughter isotope in comparison to the parent isotope?

13. Write out the nuclear equation for the beta decay of palladium-103.

14. Why does the symbol for a beta particle have -1 subscript? Would the nuclear equation still be balance if the -1 subscript was left out?

15. Identify the following reactions as either alpha decays or beta decays:

$$^{132}_{56}Ba \xrightarrow{\text{yields}} {}^{132}_{57}La$$

$$^{226}_{88}Ra \xrightarrow{\text{yields}} {}^{222}_{86}Rn$$

16. What would be the identity of the final daughter isotope if uramium-238 underwent alpha decay followed by beta decay?

17. Write out the nuclear equation for the gamma decay of zinc-65.

18. If a 300-gram sample of iodine-131 is stored for 64 days, how many grams will be left? (The half of iodine-131 is 8 days)

19. If a sample of sodium-24, upon undergoing 6 half-lives, is found to have a final mass of 6.0 g what was the initial mass of the sodium-24 sample?

20. Californium has a half-life of approximately 2.7 years, if 100.0 g of californium is stored as radioactive waste for an unknown time and only 12.5 g californium is left, for how many years has the californium been in storage?

21. How many half-lives must a 600-gram sample of iron-59 undergo in order to obtain a final mass of 18.75 grams?

22. Describe how carbon dating is used and the importance of the carbon-14 to carbon-12 ratio.

23. When doing carbon dating, why is it important to thoroughly clean the sample?

24. If a bamboo spear was estimated to be 700 years old and the activity of fresh bamboo is 19 Bq, what is the intensity of the bamboo spear?

25. A historian examines a piece of Indian-made fabric; she believes that the fabric is from the late Vedic period (400–500 b.c.e.). She uses carbon dating to verify her assumption. The fabric is made out of cotton that is indigenous to southern Indian. The activity for freshly harvested cotton is found to be 17.0 Bq. The activity of a sample of cotton from the fabric is 15.2 Bq. Using this data decide if the historian's assumption was correct.

26. What assumptions are made about the sources of argon-40 and lead-206 when doing geological dating?

27. A sample of rock contains 7.80×10^{14} atoms of lead-206 and 9.50×10^{17} atoms of uranium-238, how old is the sample of rock?

28. A geologist believes that a local rock formation has been wrongly dated to the Miocene period (from 23 to 5 million years ago). He thinks that the rock formation is much older probably dating back to the Eocene period (56 to 35 million years ago). A sample of the rock contains 3.32×10^{15} atoms of uranium-238 and 8.70×10^{12} atoms of lead-206. Using the given data decide if the geologist assumptions are correct.

29. A 50.0 g sample of rock contains an unknown amount of potassium-40 and an unknown amount of argon-40. Previous testing showed samples of rock from similar deposits were around 15 million years old and had an initial amount of 8.90×10^{13} potassium- 40 atoms per 100 grams. Find the amount of potassium-40 atoms and argon-40 atoms in the 50.0 g sample.

ANSWERS

1. Radioactivity describes the particles that are emitted from unstable elemental nuclei. Some elements have radioactive isotopes that emit radiation in order to modify the nucleus to become more stable.

2. Natural radioactivity is when certain isotopes of an element undergo natural radioactivity to stabilize their nucleus without the aid an outside force. Artificial radioactivity occurs when certain isotopes are probed to undergo radioactive activity by an external force.

3. It is true that electrostatic forces between protons should repulse each other. Then, why do protons stay in the nucleus or close to one another? The reason is because electrostatic forces are not the only stabilizing/destabilizing forces at play in the nucleus. Protons and neutrons also exert a force on one another known as strong nuclear force. This force is more than enough to stabilize a nucleus with positively charged protons and neutrally charged neutrons collecting together. As nucleons become further and further apart, the strong nuclear force rapidly diminishes. As two nucleons approach one another, the nuclear force increases rapidly. This is what keeps the structure of the atom together. Protons possess both strong nuclear force attractions and electrostatic repulsions. Neutrons only possess strong nuclear force attractions since they are neutral.

4. When an atom becomes unstable, the primary process that the atom undergoes to reach stability again is to become radioactive. By emitting radiation from the nucleus, an atom can become stable.

5. The inverse square relationship explains the relationship between radiation absorbed and distance from the radiation source. As one increases their distance from the radiation source, their amount of radiation exposure starts to exponentially decrease.

6. Gamma rays are extremely harmful because they are highly energetic. Gamma rays can penetrate various substances, including skin, bones, and organs of a human being. Lead or concrete can stop gamma rays.

7. A concrete or lead shield has to be used to be protected against gamma rays. Wearing clothing or holding paper are enough to ensure protection from alpha particles. However, to block beta particle radiation, thicker clothing, gloves, or wood insulation are necessary.

8. To balance nuclear equations, one has to keep track of the number of particles on each side of the equation.

9. If a parent radioisotope undergoes alpha decay, then its mass number will decrease by four, and its atomic number will decrease by two.

10. Find the alpha decay of Curium-250.

$$\frac{250}{96}\text{Cm} \rightarrow \frac{246}{94}\text{Pu} + \frac{4}{2}\text{He}$$

11. Find the parent radioisotope that yields Erbium-165 through alpha decay.

$$\frac{169}{70}\text{Yb} \rightarrow \frac{165}{68}\text{Er} + \frac{4}{2}\text{He}$$

12. During the process of beta decay, an electron is emitted from the nucleus of a radioisotope, thus converting a neutron into a proton. The resulting atom now contains one more proton than the parent radioisotope.

13. Find beta decay of Palladium-103.

$$\frac{103}{46}\text{Pd} \rightarrow \frac{103}{47}\text{Ag} + \frac{0}{-1}e$$

14. Beta decay (β-) usually occurs when the neutron-to-proton ratio is high in an atom's nucleus. When the radioactive nucleus undergoes beta decay, a neutron is converted into a proton, while the mass number does not change. The −1 sign informs the reader that an electron has been emitted, however, using the β symbol is also an acceptable notation for beta decay, since its meaning is understood with or without a −1 subscript.

15. Identify the nuclear equations as beta or alpha decay.

 $\frac{132}{56}$ Ba → $\frac{132}{57}$ La **No change in mass number. The daughter atom contains 1 greater proton than the parent atom. Therefore, this is beta decay.**

 $\frac{226}{88}$ Ba → $\frac{222}{86}$ La **The mass number has decreased by four units and the atomic number by two units from the parent atom to the daughter atom. Therefore, this is alpha decay.**

16. Uranium-238 undergoes alpha decay. Then it undergoes beta decay.

 $\frac{238}{92}$ U → $\frac{234}{90}$ Th → $\frac{234}{91}$ Pa

17. Find gamma decay for Zinc-65.

 $\frac{65m}{30}$ Zn → $\frac{65}{30}$ Zn + γ

18. Find the number of grams of Iodine-131 after 64 days.

 Given: time (t) = 64 days, half-life of $\frac{131}{53}$ I = 8 days, sample mass = 300 grams.

 64 days/8 days = 8 half-lives. (300 grams of $\frac{131}{53}$ I) × $(1/2)^8$ = **1.17 grams of** $\frac{131}{53}$ **I**

19. Find the initial mass of sodium-24.

 Given: 6 half-lives have passed, final mass = 6.0 grams of $\frac{24}{11}$ Na,

 Original $\frac{24}{11}$ Na mass = (6.0 grams of $\frac{24}{11}$ Na)/$[(1/2)^6]$ = 384 grams = **380 grams of** $\frac{24}{11}$ **Na**

20. Find the number of years that the Californium-252 has been in storage.

 Given: $t_{1/2}$ = 2.7 years, original $\frac{252}{98}$Cf mass = 100.0 grams, final $\frac{252}{98}$ Cf mass = 12.5 grams

 (12.5 grams $\frac{252}{98}$ Cf)/(100.0 grams $\frac{252}{98}$ Cf) = 0.125 = 1/8 = (1/2) (1/2) (1/2) = 3 half-lives.

 (3 half-lives) (2.7 years) = **8.1 years in storage**

21. Find the number of half-lives that iron-59 undergoes.

 Given: $\frac{59}{26}$ Fe original mass = 600 grams, $\frac{59}{26}$ Fe final mass = 18.75 grams.

 (18.75 grams $\frac{59}{26}$ Fe)/(600 grams $\frac{59}{26}$ Fe) = 0.03125 = 1/32 = (1/2)(1/2)(1/2)(1/2)(1/2) =

 5 half-lives.

22. Carbon-12 occurs in the universe at 98.9%. Carbon-14 is a radioactive isotope that is naturally generated when nitrogen atoms in the earth's atmosphere absorbs a neutron, emitted by the sun. The process creates carbon-14 and H-1. All living organisms contain carbon atoms. As long as the organism is living, it will keep taking in carbon atoms from its surrounding (food for animals, CO_2 in air for plants), meaning that there is a consistent carbon-14 to carbon-12 ratio in any living organism.When an organism dies, it does not take in any more carbon-14 and the carbon-14 amount in the organism starts to decrease over time. Mathematical formulas can be used to find out when the living organism stopped taking in carbon-14, thus dating its death.

23. It is very important to clean a sample that one wishes to analyze via carbon dating so that only the original material is dated, not any new contaminant.

24. Find the intensity of the bamboo spear.

Given: estimated bamboo age: 700 years, fresh bamboo activity = 19 Bq.

$t_{1/2}$ of $\frac{14}{6}$C = 5730 years, Formula: $\ln(A_t/A_o) = -(\ln(2)/t_{1/2})$ t, where A_t is the final activity, A_o is the initial activity, and t is the estimated time.

Solve for $A_t = \ln(A_t/19\ Bq) = -(0.693/5730\ years)(700\ years)$ =

$A_t = (19Bq)\ (e^{-0.0847}) = 17.45\ Bq = \mathbf{17Bq = A_t}$.

25. Calculate the age of a piece of Indian-made fabric and agree or disagree with the historian's findings.

Given: $A_0 = 17.0\ Bq$, $A_t = 15.2\ Bq$, $t_{1/2}$ of $\frac{14}{6}$C = 5730 years.

Formula: $\ln(A_t/A_o) = -(\ln(2)/t_{1/2})t$, Solve for t:

t = [ln(15.2 Bq/17.0 Bq)]/–(0.693/5730 years) = 925 years, which means that this piece of Indian-made fabric is estimated to have been roughly made around 1085 A.D. Therefore, the historian's estimate is incorrect and off by roughly 1500 years.

26. When trying to date the age of rocks, the radioactive isotopes chosen are potassium-40 and uranium-238. Potassium-40 undergoes beta decay, which has a half-life of 1.25 billion years, giving gaseous argon-40 that remains trapped in the rock. Uranium-238 undergoes a sequence of many decays, which eventually leads to lead-206. Lead-206 accumulates into the sample and can be measured. The major assumptions are that all the generated argon is trapped in the rock and that all the lead found in the rock came from the decay of uranium.

27. Find the age of a sample of rock.

Given: sample = $7.80 \times 10^{14}\ \frac{206}{82}$ Pb atoms, $9.50 \times 10^{17}\ \frac{238}{92}$ U atoms

$t_{1/2}$ of $\frac{238}{92}$U = 4.5×10^9 years.

Formula: $\ln\ (N_t/N_o) = -(\ln(2)/t_{1/2})t$, N_t = # of $\frac{238}{92}$U atoms final, and N_o = # of $\frac{238}{92}$U atoms initially. Solve for t.

$t = [\ln\ (9.50 \times 10^{17}/(9.5 \times 10^{17} + 7.80 \times 10^{14}))]/[\times(0.693/4.5 \times 10^9\ years)]$ =

$\mathbf{t = 5.33 \times 10^6}$ **years or 5.33 millions years ago.**

28. Use the data provided to validate the geologist's findings.

Given: sample = $8.70 \times 10^{12}\ \frac{206}{82}$ Pb atoms, $3.32 \times 10^{15}\ \frac{238}{92}$ U atoms.

$t_{1/2}$ of $\frac{238}{92}$U = 4.5×10^9 years. Formula: $\ln\ (N_\tau/N_o) = -(\ln(2)/t_{1/2})$ t.

Solve for t.

$t = [\ln\ (3.32 \times 10^{15}/(3.32 \times 10^{15} + 8.70 \times 10^{12}))]/[-(0.693/4.5 \times 10^9\ years)]$ =

$\mathbf{t = 1.70 \times 10^7}$ **years old. The rock is placed roughly around 17 million BCE. Therefore, the rock is located in the Miocene period.**

29. Find the amount of potassium-40 atoms and argon-40 atoms in the 50.0 grams sample of rock.

Given: sample A mass = 50.0 grams, sample B mass = 100.0 grams,

sample B # $\frac{40}{19}$ K atoms = 8.90×10^{13}

$t_{1/2}$ of $\frac{40}{19}$ K $= 1.250 \times 10^9$ years. Formula: $\ln (N_t/N_o) = -(\ln(2)/t_{1/2})t$. where $N_t = $ # of K-40 atoms, and $N_o = $ (# of K-40 atoms + # of Ar-40 atoms)

Since the # of Ar-40 atoms are unknown, variable x will be substituted.

Modified formula: $\ln[N_t/(N_t + x)] = -(\ln(2)/t_{1/2})t$. Solve for x.

$\ln[(8.90 \times 10^{13})/(8.90 \times 10^{13} + x)] = -(0.693/1.250 \times 10^9) (1.5 \times 10^7)$

$x = [(1.008352)(8.9 \times 10^{13})] - 8.9 \ x \ 10^{13} = 7.43 \times 10^{11} \ \frac{40}{18}$ Ar atoms.

Since sample A is have the mass of sample B, and both samples are from the same rock deposit, the number of K-40 and Ar-40 atoms in sample A would be expected to be half of the atoms found in sample B. Therefore,

sample A $\frac{40}{19}$ K atoms $= 4.45 \times 10^{13}$ and sample A $\frac{40}{18}$ Ar atoms $= 3.72 \times 10^{11}$

Organic Chemistry and Functional Groups

Paints are composed of pigments and a binder, whose nature determines the type of paint. Additives can be added to modify the physical and optical properties of the paint, or add bulk to lower the price. Solvents are also present to thin the paint before it evaporates after the paint has been applied. Modern acrylic paints use water as a solvent because it is the greener available option, evaporates quite readily in addition to being available and inexpensive. However, it is not always feasible to use water as a solvent, and organic solvents often have to be used. This chapter describes the molecular formulas and characteristics of the main functional groups present in organic molecules, as some of them can be used as solvents. Before looking into the chemistry of organic compounds, let's review the history of paint binders.

TIMELINE OF PAINT BINDERS

Very early on, humans understood the necessity to mix a pigment with a binder. In prehistoric cave paintings, pigments easily available, like a piece of burnt wood or ground rocks, were used, either in their natural form or mixed with saliva or animal fats. Later on, ancient Egyptians used mainly beeswax to paint burial portraits that were bound at the place of the head of the mummified body. Because the wax has to be melted prior to being applied on wood or less often linen, the technique is called *encaustic*, which means to burn in. The region of Fayum in Egypt is famous for its encaustic burial portraits.

Ancient civilizations, including Egyptians, suspended pigments in water, making watercolors. In order to thicken the paint, they would add different types of gum, the most common gum being gum Arabic, the substance obtained from the acacia tree. This gum belongs to the family of carbohydrates that will be studied in Chapter 9. The favorite medieval binder was egg tempera. Now, when school children use tempera paint, it usually does not contain egg product. The traditional egg tempera paint was made with the egg yolk extracted from its membrane, diluted with water and mixed with the pigments. Of course, there will be exceptions where the egg white is also added or used as is called in that case: egg-white medium. The yellow color of the egg disappears quickly as the paint is drying so it is of no concern for the artist. Egg tempera is a medium that if done properly does not provide cracks over time. It also does not yellow like oil paintings do. However, it has a dry chalky effect that may be unappreciated. This is probably why it was replaced in the 15th–16th century by oil paint, which

Figure 8.1 Examples of oil paints in tubes

provides richer and more saturated hues. Oil paint can take up to 18 months to fully dry, as will be discussed in chapter 9. Linseed oil, poppy seed oil, and walnut oil are the most common oils used for painting. They are said to be drying oils. Other vegetable oils, like olive oil or canola oil, could not be used as they lack this drying property. When linseed oil was produced on a large scale by the 18th century, it became even more prevalent as a painting medium. In the 19th century, two painters, William Winsor and Henry Newton, who also happened to be chemists, added glycerin to their watercolors, making them spreadable and easy to use. This discovery, combined with the invention at the same time of the metal tube and the screw cap, allowed for what now seems ordinary: the paint tube. The new invention made paint easily portable, and at a time when photography was replacing portrait painting, it allowed artists to leave the studio and paint outside, capturing the effect of light on the landscapes, contributing to the development of new movements like impressionism.

Finally, modern organic and polymer chemistry made acrylic paints available in the 20th century. This binder polymerizes, trapping the pigment in its web structure, as will be discussed in another part of the text. The main advantage of acrylic paint is that since the solvent is water, its versatility as an additive can make the result look more like a watercolor or an oil paint, it dries fast, and contrary to oil paint, it does not yellow over time.

ORGANIC CHEMISTRY

Organic chemistry is the branch of chemistry that studies compounds that contain carbon, although carbon dioxide and carbonates are not included in organic chemistry. Chemical drawings representing a large variety of organic molecules are presented in Figure 8.2.

The term *organic chemistry* was first coined because the organic molecules seem to all come from living organisms or their remains. It was actually believed that these molecules could not be made in a laboratory and that a vital force had to be present in order to synthesize them. However, in 1828, Friedrich Wöhler performed an experiment in the laboratory using inorganic molecules, ammonium cyanate (NH_4CNO), and quite unexpectedly, synthesized urea, a molecule present in animal urine, therefore an organic molecule.

This discovery revolutionized the field of chemistry since it became obvious no vital force was needed to create organic molecules: Modern organic chemistry, the study and synthesis of carbon-containing molecules, was born.

Organic molecules are classified according to their common features, called *functional groups*. Compounds having a specific functional group react in the same way, making organic synthesis quite predictable. These groups are listed below in the order they will be described in this chapter later on: alkane,

Figure 8.2 Examples of organic molecules

Figure 8.3 Friedrich Wöhler and Erlenmeyer flask containing drawings of organic molecules as a metaphor of his legacy . . .

alkene, alkyne, aromatic compounds, haloalkane, alcohol, ether, aldehyde, ketone, carboxylic acid, esters, amine, and amide. But first, an explanation of the nature of the type of chemical bonds found in organic compounds and the way they are represented is needed.

COVALENT BONDS

Organic molecules are covalent molecules, which means that the bonds between the atoms are *covalent*, the opposite of ionic. In an ionic bond, as seen previously, the anion is negatively charged and the cation positively

Figure 8.4 Linus Pauling

charged, and they interact through an electrostatic attraction. In a covalent bond, there is no ion as the electrons are shared between the atoms. Sometimes the electrons are not equally shared, depending on the electronegativity of the elements involved. The electronegativity defined by Linus Pauling is the ability of an atom engaged in a bond to attract electrons towards itself. The American chemist Linus Pauling (1901–1994) received the Nobel prize in chemistry in 1954 for his research into the nature of the chemical bond and the Nobel peace prize in 1964 for his relentless anti-nuclear advocacy during the cold war (Figure 8.4).

The unitless scale of electronegativity has a value range from 0.7 to 4.0, with the highest value 4.0 attributed to fluorine and the lowest value to francium (0.7). However, francium is radioactive and is not used widely, so cesium is considered the least electronegative (0.8). Electronegativity increases across the periodic table from bottom to top and from left to right. A covalent bond occurs between two elements if the difference between their electronegativity is less than 1.5; otherwise, the bond will be ionic. Within the covalent bonds, also depending on the difference in electronegativity, the bond is said to be nonpolar (0 < difference < 0.2) or polar (0.2 < difference < 1.5). Polarity, as found with a magnet, will create a positive and a negative pole, representing respectively the less and the more electronegative atoms, each assigned a respective symbol: $\delta+$ and $\delta-$.

Learning Check

1. Define the nature of the bond formed between a carbon atom and an oxygen atom.

 Ans: The bond formed between a carbon atom and an oxygen atom is a polar covalent bond. Polar covalent bonds are formed when the difference in electronegativity between the two atoms is large. Because oxygen has a greater electronegativity than carbon, the shared electrons in the covalent bond are more localized on the oxygen than on the carbon. Therefore, a partial positive ($\delta+$) is placed beside the carbon and a partial negative ($\delta-$) is placed beside the oxygen as shown in Figure 8.5.

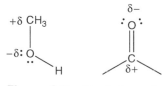

Figure 8.5 Partial positive and negative charges indicated by $\delta+$ and $\delta-$

DRAWING ORGANIC MOLECULES

There are many ways to draw organic molecules. One can show all the atoms involved or omit showing the carbon and hydrogen atoms. An example for the molecule of ethanol, also called grain alcohol is shown in Figure 8.6.

Molecular formula	Condensed structural formula	Expanded structural formula	Line formula or skeleton formula
C_2H_6O	CH_3CH_2OH		
$C_2H_5NH_2$	$CH_3CH_2NH_2$		

Figure 8.6 Examples of organic molecules

ALKANES, ALKENES, AND ALKYNES

Alkanes, alkenes, and alkynes are hydrocarbons, meaning that they contain only carbon and hydrogen. They are flammable, not dense, and insoluble in water. In the family of alkanes, hexane is a very common solvent; methane, propane, and butane are gases used for fuels. Carbon atoms can have at most 4 bonds, which can be single, double, or triple. Alkanes have only single bonds; alkenes have at least one double bond; and alkynes at least one triple bond as shown in Table 8.1.

Learning Check

1. Would the following structure be classified as an alkene, alkyne, or alkane? How many carbon atoms does it have? How many hydrogen atoms does it have?

Ans: The structure has one double and would therefore be classified as an alkene. It has 5 carbon atoms and 10 hydrogen atoms.

Table 8.1 Examples of alkane, alkene and alkyne

Functional group	Alkane	Alkene	Alkyne
Feature	$C - C$	$C = C$	$C \equiv C$
Example	$CH_3 - CH_3$	$CH_2 = CH_2$	$HC \equiv CH$

2. Is this an alkane, alkene, or an alkyne? How many carbon atoms does it have? How many hydrogen atoms does it have?

Ans: Since there are only single bonds are present, this is an alkane. There are 6 carbons and 14 hydrogens. The molecule has been redrawn below to show every atom.

3. Is this an alkane, alkene, or an alkyne? How many carbon atoms does it have? How many hydrogen atoms does it have?

Ans: There is a triple bond present making this an alkyne (Note the 180° for an alkyne, making the triple bond flat). There are five carbons and eight hydrogens.

The name of organic molecules is based on the roots listed in Table 8.2, which depend on the number of carbon atoms present. The scope of this text is limited to simple molecules, so extensive explanations on nomenclature will not be discussed here.

The location of the double or triple bond is also indicated by a number that is the smallest number possible when numbering the carbon chain from one end to the next, as shown below:

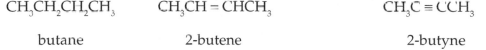

$CH_3CH_2CH_2CH_3$ $CH_3CH = CHCH_3$ $CH_3C \equiv CCH_3$

butane 2-butene 2-butyne

Table 8.2 Roots Used for Organic Molecules

# Carbon	Root	Alkane name	Alkene name	Alkyne name
1	Meth	Methane	Methene	Methyne
2	Eth	Ethane	Ethene	Ethyne
3	Prop	Propane	Propene	Propyne
4	But	Butane	Butene	Butyne
5	Pent	Pentane	Pentene	Pentyne
6	Hex	Hexane	Hexene	Hexyne
7	Hept	Heptane	Heptene	Heptyne
8	Oct	Octane	Octene	Octyne
9	Non	Nonane	Nonene	Nonyne
10	Dec	Decane	Decene	Decyne

Learning Check

1. Draw the expanded structure of 3-octyne.

 Ans: The root oct- means 8 carbons, -yne means that a triple bond exists between two of the carbons, and the 3- tells where the triple bond is—more specifically, the 3 means that the triple bond is between the carbon atoms #3 and #4.

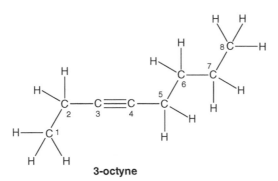

3-octyne

2. Could 3-octyne also be called 5-octyne?

 Ans: No, always use the lowest number possible when describing organic molecules.

3. Draw the line formula structure for 1-butyne and 2-butyne.

 Ans:

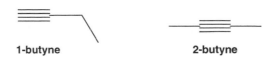

1-butyne 2-butyne

4. Draw the expanded structure of hexane.

 Ans:

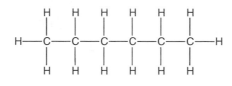

AROMATIC COMPOUNDS

A different class of hydrocarbons is the aromatic family, whose chief molecule is benzene. They are said to be aromatic because of their recognizable odor. Non-aromatic hydrocarbons (alkanes, alkenes, alkynes) are said to be aliphatic, the opposite of aromatic. The molecule of benzene has 6 carbon atoms, 6 hydrogen atoms, is cyclic, and has 3 double bonds. Remember that the carbon and hydrogen atoms do not have to be drawn and can be simply implied.

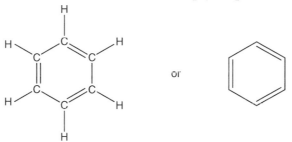

Because of the specific nature of aromatic compounds, the electrons involved in the double bonds are not localized at a fixed position and can move around the cyclic structure. This explains why the molecule of benzene can sometimes be represented with a circle in its center. These electrons are said to be delocalized.

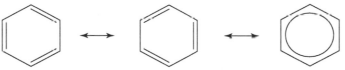

Benzene is a nonpolar solvent, meaning it will dissolve nonpolar molecules. However, it is highly toxic because it is a known carcinogen (can cause cancer) and is therefore very limited in its use and availability. Toluene and xylene are also non-polar aromatic solvents, and since their toxicity is less than benzene, they can be found in art restoration laboratories or the printmaking shop and so on. Xylene comes as a mixture of isomers (same molecular formula but different arrangements of the components of the molecule) and can be sold as "xylenes" or "xylol."

Toluene Ortho-xylene Meta-xylene Para-xylene

A SPECIAL CASE OF ALKENES: TERPENES AND TERPENOIDS

Terpenes and terpenoids are molecules obtained from plants and animals, with the terpenoids being the oxygenated version of the terpenes. They all derived from the isoprene molecule.

Pinene

Figure 8.7 Pinene is one of the molecules found in pine trees and turpentine

Isoprene

Terpenes dissolve fats, making them good nonpolar solvents and as such useful as paint or varnish thinners. For instance, the most common one in the artist's studio is probably turpentine, also known as spirit of turpentine, oil of turpentine, or wood turpentine. It is obtained by distilling resins or saps obtained from pine trees, which provides the characteristic odor, as one would smell in a pine forest. Turpentine is different from pine oil, which is obtained from the distillation of the pine needles, contains mostly terpenoids, and is used in aromatherapy or in household cleaning products. Turpentine is not quite a pure compound; it is a mixture of different molecules, all terpenes, with the most abundant (>90%) being the pinene molecule (Figure 8.7).

Turpentine undergoes a chemical reaction, called *polymerization*, that will be discussed in another chapter 9. This reaction occurs upon aging by the action of light, oxygen, and moisture and makes the solution more viscous and less volatile. It is recognizable by the gummy residue present around the mouth of an old bottle of turpentine, which should be discarded so as to not pollute the rest of the contents of the bottle. However, it is not a problem for the paint since the turpentine evaporates fast from the paint, long before it has a chance to be changed.

Sometimes there is confusion between turpentine and balsam. Both of them come from pine trees; however, turpentine should be used only for the terpene-containing exudate, while balsam should be used only for the cinnamic- and benzoic-acid-containing exudate. Balsams are also known as oleoresins.

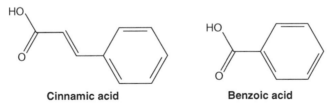

Cinnamic acid **Benzoic acid**

Finally, molecules containing hundreds or thousands of isoprene units form very long chains, called polyterpenes. The most famous representative of this family of macromolecules is the famous natural rubber or caoutchouc obtained by tapping the rubber tree (Figure 8.8).

HALOALKANES

Carbon tetrachloride (CCl_4), chloroform ($CHCl_3$), and methylene chloride (CH_2Cl_2) belong to the family of halogenated solvents, more precisely chlorinated. The former is very toxic and should not be used, whereas chloroform and dichloromethane, although still toxic, are used as solvents, because like the hydrocarbons they are pretty nonpolar and can thus dissolve fatty molecules, like oil-based stains. Some of these haloalkanes are known to be carcinogens and teratogens (can create malformations to the embryo or the fetus).

Figure 8.8 Caoutchouc is obtained by tapping the rubber tree

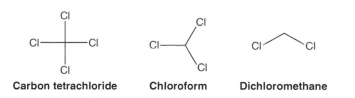

Carbon tetrachloride Chloroform Dichloromethane

Halogenated molecules have been used as solvents in industry and also for commercial purposes in dry cleaning. Dichloromethane is found in paint removers and thinners for instance. For health reasons, many of these solvents are not used anymore, and if the less toxic ones are still in use, they should be handled with precaution.

ALCOHOLS AND ETHERS

The family of alcohols has a hydroxyl group as a common feature, as shown in this drawing of important alcohols:

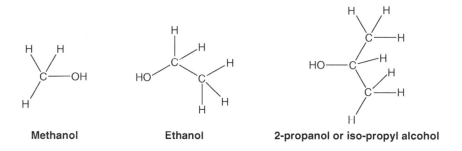

Methanol Ethanol 2-propanol or iso-propyl alcohol

Methanol is also known as wood alcohol, because it can be obtained by distillation of wood products, is toxic, and can lead to liver damage and blindness if ingested. Ethanol, also known as ethyl alcohol or grain alcohol, is the molecule found in liquors, while 2-propanol is sold in pharmacies under the name rubbing alcohol. All these molecules are polar and can be used as a polar solvent. Aromatic alcohols are called phenols, and carbolic acid (phenol itself) has been used for a long time as a disinfectant.

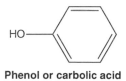

Phenol or carbolic acid

Ethers contain an oxygen atom between two carbon atoms. They can also be used as solvents, although they might become explosive over time unless they contain a stabilizer. Even with such a stabilizer, ethers have to be checked periodically for the presence of these explosive compounds, called organic peroxides. The chemical structure of the two most common ethers, diethyl ether and t-butyl methyl ether, are shown here.

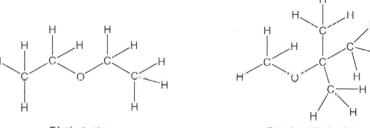

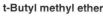

Diethyl ether t-Butyl methyl ether

ALDEHYDES AND KETONES

Aldehydes and ketones both have a carbonyl group. A carbonyl group is a carbon connected to an oxygen atom with a double bond. Because of the difference in electronegativity between these two elements, the bond is polar, represented by a δ+ on the carbon and δ− on the oxygen. An aldehyde has an atom of hydrogen on one side of the carbonyl group, whereas a ketone has carbon groups on each side. Sometimes aldehydes are written in a linear way as RCHO, which shows the hydrogen atom on the carbonyl with the R group being a carbon chain of any length. It is important to understand that a carbonyl group has to be connected with other carbon atoms or hydrogen atoms. If not, it cannot be called a carbonyl group, as shown in the picture below.

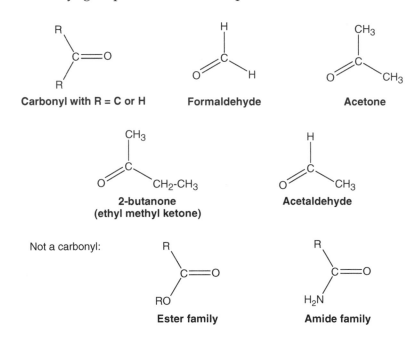

Formaldehyde could also be written simply as H_2CO or HCHO, acetaldehyde as CH_3CHO, acetone as CH_3COCH_3 and so forth. Because of their mild polarity, these molecules can be used as solvents in art restoration. Acetone is a very common solvent in the organic chemistry laboratory because it is able to dissolve and remove a lot of organic chemicals that dirty the glassware, and it evaporates quickly, making the drying process fast. Acetone is the main component of nail polish remover. Some of these molecules, such as formaldehyde and acetaldehyde, are known carcinogens so proper caution is mandatory when using these chemicals.

Learning Check

1. Classify the following molecules as an aldehyde, ketone, alcohol, or ether.

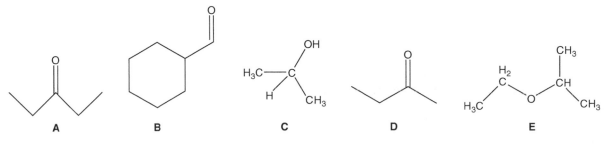

Ans: aldehyde: B, ketone: A and D, alcohol: C, ether: E

CARBOXYLIC ACIDS AND ESTERS

Carboxylic acids and esters both contain a carboxylic functional group. The acids can be written as RCOOH or RCO_2H and the esters as RCOOR or RCO_2R, with R representing as usual in organic chemistry a carbon chain of any length.

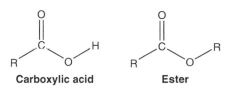

Carboxylic acid Ester

Carboxylic acids are quite ubiquitous: Formic acid, also known as methanoic acid, was named after the Latin word *formica* which means ant, because it was first isolated by distilling ants. It is the chemical that is responsible for the burning sensation of a bee or ant sting. Acetic acid, also called ethanoic acid, is the compound that provides the strong smell of vinegar whose Latin name is *acetum*. Butyric acid, also known as butanoic acid, gets its common name from the Greek word for *butter* and is responsible for the unpleasant and acrid odor of rancid butter. Benzoic acid, an aromatic carboxylic acid, is used as a food preservative under its ionic form, benzoate, and can be found in many sodas.

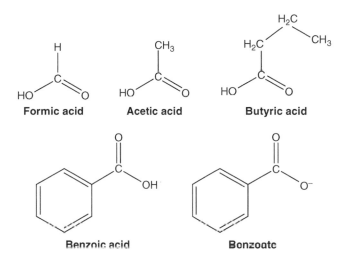

Formic acid Acetic acid Butyric acid

Benzoic acid Benzoate

Esters are carboxylic acid derivatives, where the terminal atom of hydrogen attached to the oxygen atom has been replaced by a carbon chain. Esters have a fruity smell and are responsible for many flavors in fruits and other fruit derivatives. They occur naturally as shown in Table 8.3, but they can also be made very easily in a chemistry laboratory by reacting a carboxylic acid and an alcohol. Artificial flavors of fruits are produced in the laboratory and have the exact same structure, taste and fragrance as the ester found in the natural product. The only difference which is major is the lack of other substances present in the original fruit.

Esters are good solvents: Two common examples are butyl acetate and ethyl acetate, which is found in nail polish and is responsible for its fruity smell (Figure 8.9).

Table 8.3 Some Common Esters

IUPAC name	Common name	Chemical structure	Flavor
Ethyl methanoate	Ethyl formate	$HCOOCH_2CH_3$	Rum
Propyl ethanoate	Propyl acetate	$CH_3COOCH_2CH_2CH_3$	Pears
Pentyl ethanoate	Pentyl acetate	$CH_3COOCH_2CH_2CH_2CH_2CH_3$	Bananas
Ethyl butanoate	Ethyl butyrate	$CH_3CH_2CH_2COOCH_2CH_3$	Pineapples

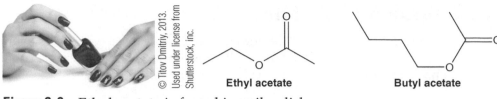

Figure 8.9 Ethyl acetate is found in nail polish

Acetyl salicylic acid, commonly known as aspirin, a familiar pain reliever, is a benzoic acid derivative that also contains an ester group. Another example of an ester used in medicinal applications is oil of wintergreen, which is applied on sore muscles; it also contains a phenol group.

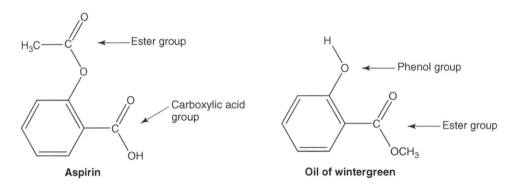

AMINES AND AMIDES

Amines and amides are organic molecules that contain a nitrogen atom. Amines are derivatives of ammonia (NH_3) and amides ($RCONR_2$) are obtained from the reaction of amines with carboxylic acids.

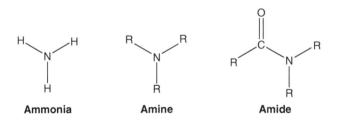

Amines have a strong and very unpleasant odor. For example, amines are responsible for the foul smell of rotten seafood. Amines and amides are not usually used as solvents, although ammonia as a dilute aqueous solution may be used to remove dirt on works of art.

Amines and amides may or may not have more than one carbon chain attached to the nitrogen atom. A nitrogen atom can have up to three bonds and still be neutral, so at least one of these bonds is used to connect to a carbon chain, making these compounds organic. The two other bonds can either be used for a connection to hydrogen atoms or other carbon chains. When the nitrogen atom has two hydrogen atoms (RNH_2 or $RCONH_2$), the compounds are said to be primary; if they have only one hydrogen atom (R_2NH or $RCONHR$), they are said to be secondary; and if they have no hydrogen atoms at all directly connected to the nitrogen atom, like in R_3N or $RCONR_2$, they are said to be tertiary. Some examples of amines and amides with their names and classification are provided here:

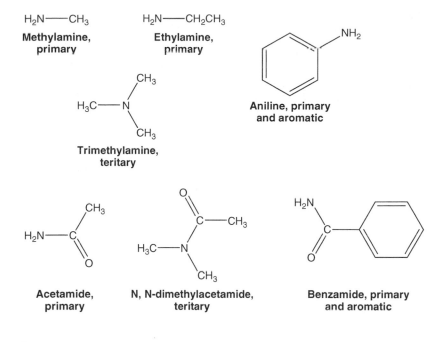

Learning Check

1. Identify the functional group of the following compounds and state whether they are primary, secondary, or tertiary where applicable.

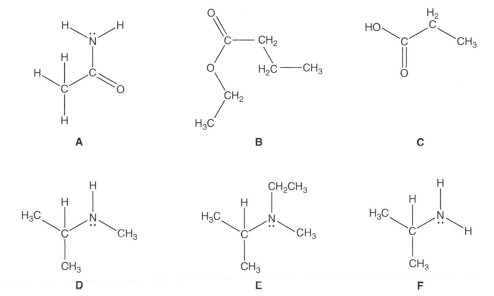

Ans: A: primary amide, B: ester, C: carboxylic acid, D: secondary amine, E: tertiary amine, F: primary amine

GENERAL SAFETY CONCERNS WITH ORGANIC COMPOUNDS

With organic molecules, it is always advisable to use caution. The degree of toxicity of these molecules varies greatly from carcinogenic for benzene to a less toxic ethanol. Some of these organic solvents dissolve well in fatty tissue like the nervous system, can easily cross the blood-brain barrier, or put stress on the liver. Therefore, the use of protective gear like goggles, gloves, ventilation, and even a laboratory coat is always a good precaution. In addition, all these molecules are usually highly flammable, so added precautions are necessary.

ORGANIC DYES

In an earlier chapter, pigments were studied. They are classified as inorganic compounds, usually contain a metal, and either come from ground rocks or are made by precipitation reactions in the chemistry laboratory. Examples include the formation of the yellow solid compound lead (II) iodide obtained from the reaction of aqueous solutions of lead (II) nitrate and potassium iodide shown in Figure 8.10.

Another class of color-imparting compounds is the family of dyes. They are organic molecules that were extracted from animals or plants throughout the ages and they are usually water-soluble. In the 19th century, great developments in organic chemistry made new dyes available and also led to a less expensive method for the synthesis of some of the natural dyes. Studies of ancient textiles from Asia or South America have shown that humans have been dyeing textiles for thousands of years. Egyptians already knew how to extract madder root to obtain a red color and the indigo plant to obtain a blue color, for instance.

Figure 8.10 Formation of yellow solid compound lead (II) iodide

COLORS FROM DYES

Organic molecules are colored if they contain a chromophore component, which is a functional group capable of interacting with light in a way that produces a specific color. These chromophore groups involve the movement of electrons involved in double bonds, like in a carbonyl group, an aromatic ring, a series of carbon-carbon double bonds, an azo group (nitrogen connected to another nitrogen by a double bond: $-N = N-$), or a quinoid ring. Many natural colors arise from a quinoid derivative such as naphtaquinone or anthraquinone derivatives.

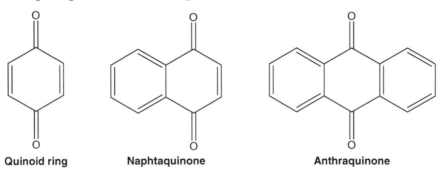

Quinoid ring **Naphtaquinone** **Anthraquinone**

This color can be intensified if additional groups are present. In this case these functional groups are called auxochrome and include an amino group ($-NH_2$), a hydroxyl group ($-OH$), or an ether group ($-OR$).

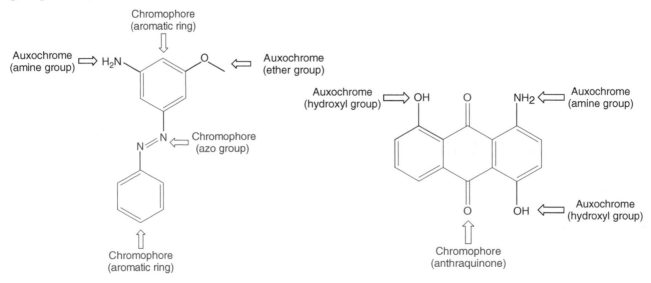

The number of dyes available now is very large since organic chemists can create new ones in the laboratory. For the purpose of this book, the focus will be limited to several dyes that have a very interesting history.

Royal or Tyrean Purple

As its name indicates, royal purple provides a purple color when used as a dye, although it is blue when in the solid form. It is also known as Tyrean purple from the city port of Tyre in the state of Phoenicia (currently Lebanon), where it was prepared and traded in ancient times, although it was found in other areas of the world. Royal purple is obtained from the mucus of marine mollusks, especially the murex, and is chemically known as 6, 6'-dibromoindigo (Figure 8.11). When extracted from the animal, it is first a greenish color that changes in the presence of light in to the famous purple hue.

Because it takes close to 10,000 animals to prepare one gram of dye, it is very expensive and was reserved for only certain groups of people, like members of royalty, emperors, or high priests, which explains the English idiomatic expression: "born to purple." The Roman emperor Nero even issued a decree forbidding anyone except himself from wearing this color. This hierarchical restriction was common to all areas where this dye was used in ancient times, from the Roman Empire to Asia or South America. At the fall of the Roman Empire, it was replaced by a cheaper purple dye, although not as vibrant, made from macerating lichens in ammonia from urine, also known as the orchil dye.

Kermes

Similar to the purple story, bright red colors were difficult to produce and were also reserved at certain periods of time for the aristocracy as a symbol of power and wealth. These sumptuary laws were especially prevalent in medieval Europe. The color red could, however, be easily extracted from the madder root, but it was not rich and bright hued, or from Brazil wood, which fades too easily. Red pigments like Vermilion cannot be used for dyeing textiles but only for painting, since by the definition of a pigment is insoluble. However, in Central America, the Aztecs and the Mayans had access to a rich and bright red that did not fade over time that was obtained by crushing a dried beetle that lives on cacti. The cactus beetle, or cactus cochineal, from which the dye (chemically known as carminic acid) is obtained was even raised on specialized farms. Figure 8.12 shows a vial containing an aqueous solution of the dye that was crushed from dried cochineals (shown next to it), as well as the formula for the dye responsible for the color.

When Cortez in 1521 plundered the Aztec treasure, he sent some of the dye back to the king of Spain, Charles V, who also controlled Venice at the time, a great center of textile dyeing. This dye from the New World turned out to be so much better than any other red dye known in Europe at the time that it became highly coveted. The Spaniards built commerce around this dye, making the cochineal the second greatest import from the Americas after silver. Consequently, the Spaniards were very protective of this secret and had to defend it for decades against the relentless attacks from British and French mercenaries trying to steal the precious cargo. It is not until 1770 that the French spy Thierry de Menonville managed to steal the cochineal to bring it back to France. However, this

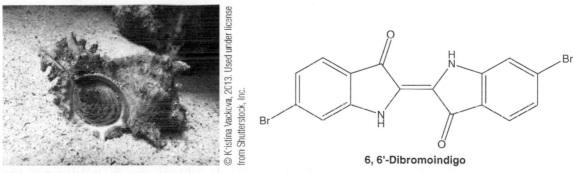

6, 6'-Dibromoindigo

Figure 8.11 Murex, the source of royal purple dye

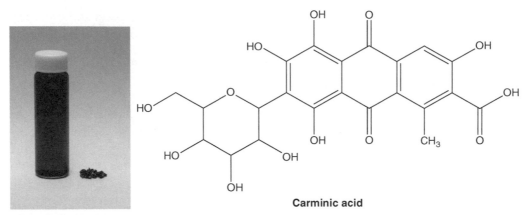

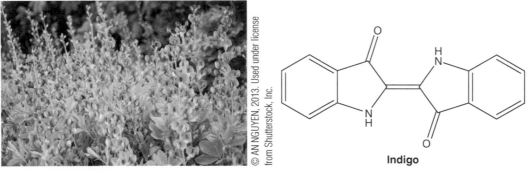

Carminic acid

Figure 8.12 Aqueous solution of red dye extracted from cochineals (shown next to it) and molecule of carminic acid

Figure 8.13 Indigo

Indigo

did not end the monopoly; it took a few more decades to do so after the Mexican war of independence. Now the dye can be found in some red food, which has alarmed vegetarian consumers.

Similar cochineals or plant parasites can be found in Europe and afford a similar red dye; examples such as the oak Kermes or the St. John's blood, which gets its name from the time of harvest of this bug around Saint John the Baptist's day; however, the light fastness, yield, and quality of the dye are far inferior than the one of the Mexican cochineal.

Indigo

The blue indigo color, famous for the Navy blue color of British sailors and our blue jeans, has been extracted from the plant Indigofera tinctoria since 2000 BCE (Figure 8.13).

It can also be found in the temperate-climate plant Isatis tinctoria (Figure 8.14), but in a much lesser amount. This plant is commonly known as the dyer's woad or the poor's man indigo. It has been found in French Neolithic cave paintings or on Egyptians' mummies. Woad is also an antiseptic used as body paint by Celtic warriors before a battle.

Figure 8.14 Isatis tinctoria

The way indigo has to be applied as a dye is quite unusual as it is insoluble in water. Indigo has to be made into leucoindigo fist, a soluble yellow compound that gets absorbed on the cloth and upon drying and reacting with the oxygen from the air becomes blue.

Mauveine

The very first synthetic dye was the purple dye called mauve, or mauveine, or aniline purple and was produced by accident by the British chemist, William Perkin (1838–1907) at the age of 18. In 1856, on Easter holiday, Perkin was assigned an important task that would help the British soldiers

that were suffering from malaria as they are fighting in India: the synthesis of the antimalarial medicine quinine in 1856. Unfortunately, for the British troops, Perkin did not succeed at the time and instead had made a dark tar that he was ready to discard before he realized it contained a purple molecule when dissolved in alcohol. Perkin went on to synthesize many other compounds, like alizarin, the first synthetic red dye and patented many other chemical syntheses and became a successful chemist. The actual chemical structure of the mauve dye was not clearly defined until 1994 and is actually composed of a mixture of two similar molecules with the same carbon skeleton, one being represented below.

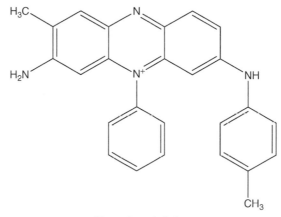

Mauveine skeleton

The access to this color that was so elusive prior to Perkin's synthesis that its ready availability created a fashion upheaval for a decade and every woman, from Queen Victoria and French Empress Eugenie to the commoner wore this color. Of course, by the end of the 1860s, it had been seen so much that people grew tired of it and mauveine was not so favored after that. However, this first synthesis led the way to many other dye syntheses, opening up a large dye manufacturing business, especially for azo-dyes.

Azo-Dyes

Azo-dyes were first synthesized not long after Perkin's mauveine in 1863. This type of dyes led to the widest range of colors possible, since a small change on the chemical structure can shift its color. However, some of them can release carcinogenic compounds and some 22 azo-dyes have been banned in Europe in 2003 from use in the textile industry. Hundreds of vibrant colors are made available, examples include methyl orange, yellow 6, yellow 2G, amaranth, blue 1, green 3, brilliant scarlet (E124), allura (red 40), and others.

Table 8.4 Certified FD&C Dyes

Name	Azo-dye
FD&C Red 3	No
FD&C Red 40	Yes
FD&C Yellow 5	Yes
FD&C Yellow 6	Yes
FD&C Blue 1	No
FD&C Blue 2	No
FD&C Green 3	No

Not all azo-dyes are toxic and some of them are safe enough to be used as food color or in cosmetics. The Food and Drug Administration (FDA) has approved the use of seven dyes in food products and this certification can be recognized by the following code: certified FD&C (colors certified for use in food, drugs, and cosmetic), whereas more dyes can be used for cosmetics only and are recognized by this code: D&C. Here is a list of the seven certified FD&C dyes, note that not all of them are azo-dyes.

Note on Lakes

So far we discussed pigments that are insoluble and dyes that are soluble. In some cases it was necessary for people who work with colors to use a dye as a pigment. In such cases, the person would chemically bind a soluble dye to an inert and insoluble support, very often aluminum hydroxide ($Al(OH)_3$), creating an insoluble color based on a dye. This hybrid compound is called a lake and is used as a pigment.

PROBLEMS

1. Why are additives added to paint?
2. What does the term *encaustic* refer to?
3. What theory or notion did Wohler's synthesis of urea disprove?
4. What innovations led to the creation of the modern paint tube?
5. How are organic molecules classified?
6. Describe the nature of a fluorine-carbon bond, placing partial charges where needed.
7. Why is benzene sometimes drawn as a cyclohexane with a circle in the middle?
8. From what molecule are all terpenes derived?
9. What is the molecular formula for butanol?
10. Convert the following skeletal structure to a condensed structural formula:

11. Convert the following condensed structural formula to an expanded structural formula:

$$CH_3CH_2CH_2SCH_3$$

12. Convert the following condensed structural formula to a molecular formula:

$$(CH_3)_3COC(CH_3)_3$$

13. Write the molecular formula for the following structure.

14. Write the condensed structural formula for the structure in #8.
15. Write two possible expanded structural formulas for C_3H_8O.
16. Write the skeletal formulas for your answers above.
17. Classify the following structure as an alkane, alkene, or alkyne:

18. For the following name **2-hexene**, what does **2** signifies?
19. Draw both the expanded structure and the skeletal structure of 3-heptyne.
20. How many double bonds does benzene have?
21. What is the difference between terpenes and terpenoids?

22. Circle and name the functional groups in each molecule.

$CH_3CH_2CH_2OCH_3$, $(CH_3)_3CCH_2OH$,

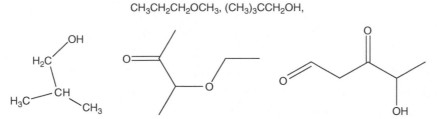

23. Label the following molecules as a carboxylic acid, ester, amine, or amide.

$CH_3CH_2CH_2CH_2NH_2$, $CH_3CH_2CONH_2$, $CH_3CH_2CH_2CO_2H$

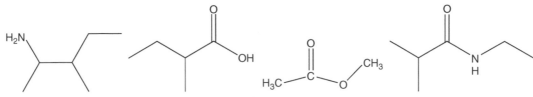

24. Is the following molecule a primary, secondary, or tertiary amine?

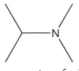

25. Red madder, a red dye extracted from the roots of plants from the madder family, contains the compound alizarin, also known as 1, 2-dihydroxyanthraquinone. At the end of the 19th century, it was the first natural dye to be reproduced in a chemistry laboratory. On its structure shown below, identify the chromophore and auxochrome groups.

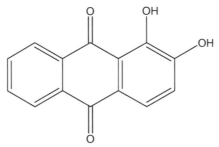

1, 2-Dihydroxyanthraquinone

26. Purpurin, also called 1, 2, 4-trihydroxyanthraquinone, is a naturally occurring yellow or red dye depending on the conditions. On its structure shown below, identify the chromophore and auxochrome groups.

1, 2, 4-Trihydroxyanthraquinone

27. The root of rubiaceae contains a red dye whose formula is shown below. Identify the chromophore and auxochrome groups.

Rubiadin

28. Circle the azo-group on the structures below.

E124

red-40

29. Show the amino group on mauveine.

Mauveine

30. Identify on the carminic structure the hydroxyl, carbonyl carboxylic, and ether groups.

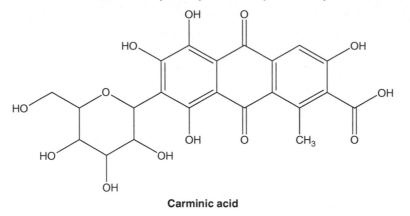

Carminic acid

ANSWERS

1. Additives are added to paint to help modify the physical and optical properties of the paint or add bulk to lower the price of paint.

2. Encaustic uses molten beeswax as a binder for the pigments. The word "encaustic" means to burn in.

3. Friedrich Wöhler, in 1828, performed and experiment in a laboratory using inorganic molecules, ammonium cyanate, and unexpectedly synthesized urea. Urea is a molecule that is found in animal urine and is considered an organic molecule. He disproved the theory that single organic molecules cannot be synthesized in a laboratory because a "vital force" is needed to generate organic molecules. This event was the beginning of the discipline of organic chemistry.

4. In the early 19th century, Henry Newton and William Winsor realized that adding glycerin to watercolors increase the ability of the paint to be spread. They combined their new paint with the new inventions of a metal tube and cap to generate the very first paint tube. Their discoveries made the painting process easily portable, and it really allowed artists to branch out from their studios and paint in more inspirational locations.

5. Organic molecules are molecules that contain carbon. Organic molecules are classified by their functional group (alcohols, esters, amines, etc. . .).

6. A fluorine and carbon come together to form a polar covalent bond (a bond that unequally shares electrons between two atoms). Fluorine is the most electronegative element on the periodic table. Therefore, when fluorine forms a covalent bond, it has the ability to better attract or pull on the shared electrons with its bonded atom. The fluorine-carbon bond is composed of a partially negative (δ-) fluorine atom and a partially positive (δ+) carbon atom. Since the fluorine atom pulls on the shared electrons between it and carbon, the fluorine feels a more negative partial charge due to the electrons. This also means that the carbon atom that is covalently bonded to the fluorine is feeling a partial positive charge due to its electronegativity being less than fluorine.

7. Benzene possesses resonant structures where the electrons in the double bond are delocalized. The circle thus represents the different possible locations of the electrons.

8. Terpenes are all derived from isoprene, which can be generated in plants and animals.

9. Butanol is a four-carbon alcohol. The molecular formula of butanol is $C_4H_{10}O$. It is commonly presented as C_4H_9OH to demonstrate that it is a hydroxyl group –OH, the common feature of all alcohols.

10. The condensed structure for 3-methyl-1-butanamine is:

 $NH_2CH_2\ CH_2CH(CH_3)_2$

11. The expanded structural formula for $CH_3CH_2CH_2SCH_3$ is:

 methyl (propyl) sulfane

12. The molecular formula for $(CH_3)_3COC(CH_3)_3$ is:

 $C_8H_{18}O$

13. The molecular formula for 3-methyl-2-hexanol is:

 $C_7H_{16}O$

14. The condensed structural formula for terpene is:

 $CH_2=CH-C(CH_3)=CH_2$

15. The two possible expanded structural formulas for C_3H_8O are:

Propan-2-ol Propan-1-ol

16. The skeletal structures for propan-2-ol and propan-1-ol are:

 &

Propan-2-ol Propan-1-ol

17. The structure is called propene, and it is an alkene because of its double bond between two carbon.

18. The number "2" in 2-hexene indicates the location of the double bond in the alkene molecule. The "hex" portion in the name refers to the six carbons in the longest continuous carbon chain. The "ene" suffix of the name designates an alkene, therefore there is a double bond between two carbons. Therefore, the double bond starts on carbon 2 towards carbon 3.

19. The expanded and skeletal structures for 3-heptyne are as follows:

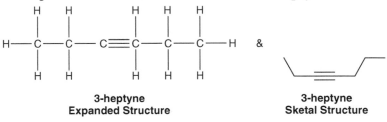

 3-heptyne 3-heptyne
 Expanded Structure Sketal Structure

20. There are three delocalized double bonds in benzene.

21. Terpenes are organic molecules that only contain carbon, hydrogen, and at least a double bond between carbons. Terpenoids are the oxygenated versions of terpenes.

22. Circle and name the functional groups in each molecule.

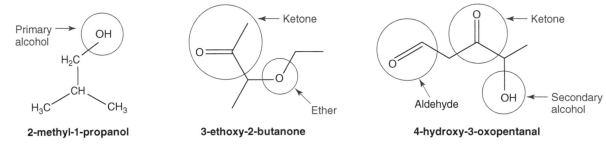

 2-methyl-1-propanol 3-ethoxy-2-butanone 4-hydroxy-3-oxopentanal

23. Label the following as carboxylic acid, ester, amine, or amide.

Carboxylic acids: Esters: Amines: Amides:
$CH_3CH_2CH_2CO_2H$ $CH_3CH_2CH_2CH_2NH_2$ $CH_3CH_2CONH_2$

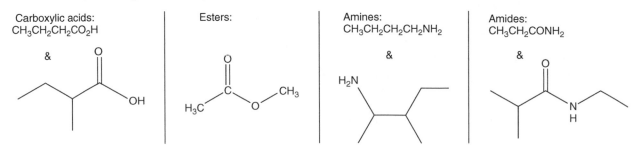

24. The molecule given is a tertiary amine because the nitrogen in the molecule has three substituants.

25.

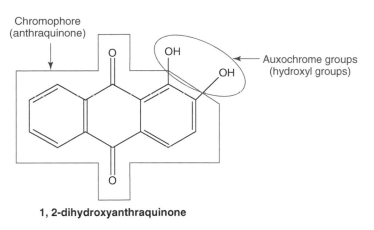

1, 2-dihydroxyanthraquinone

26.

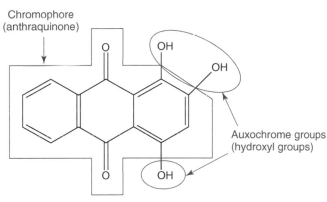

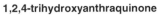

1,2,4-trihydroxyanthraquinone

27.

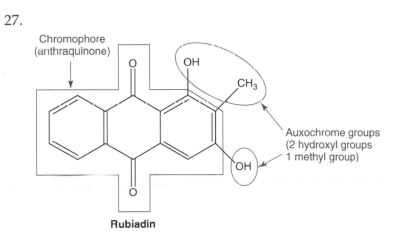

Rubiadin

28.

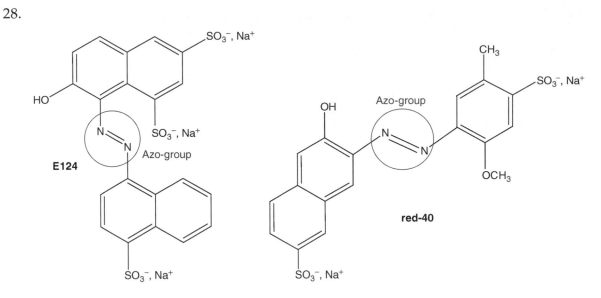

29.

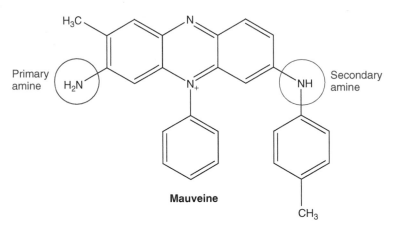

30.

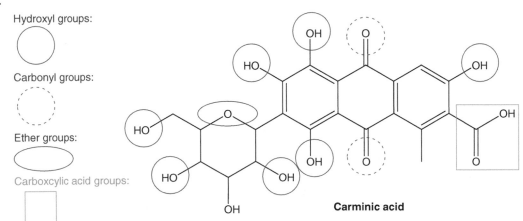

Polymers and Biomolecules

POLYMERS

A polymer is a large molecule composed of many repeating individual units called monomers. These macromolecules have a high molecular mass, compared to other smaller molecules. They can be found in nature or can be man-made. Natural polymers include DNA, proteins, cellulose, starch, and rubber. Synthetic polymers have been synthesized since the industrial revolution in the 19th century, and it first consisted in chemically modifying the structure of a natural polymer in order to improve its properties. This was the case for the vulcanization of natural rubber by Goodyear in 1839, the mercerization of cotton in 1844 by Mercer or the modification of cellulose to produce cellulose nitrate in 1845 or cellulose acetate. Cellulose nitrate also known as guncotton could be used as an explosive or upon further modification like the addition of camphor by Kodak, it could be used as photographic films and was known as celluloid. Celluloid was also used as a replacement for natural ivory in the making of pool balls or combs. The major drawback of nitrocellulose was its notorious high flammability, so it was finally replaced in the mid-1930s by cellulose acetate. The first polymer to have been fully synthesized from smaller units was made in the early 1900s by American chemist Leo Baekeland, 1863–1844, and was named Bakelite in his honor. This resin was made from two molecules of resorcinol reacting with one molecule of formaldehyde as shown below. If the process continues many times, the molecule becomes very quickly a macromolecule.

One can see easily how these macromolecules are cumbersome to write and chemists had to find a way to represent them in an efficient way. The repeating unit is shown in between brackets that overlap with the bonds that link one unit to the next as a symbol of repetition. Also since these are macromolecules, a large number of units is expected and can be written as "n" by the bottom right corner or by the actual number of units if it is known from analysis.

More similar synthetic polymers were synthesized after Bakelite, and it includes the urea-formaldehyde resin or the polyurethane that replaced it.

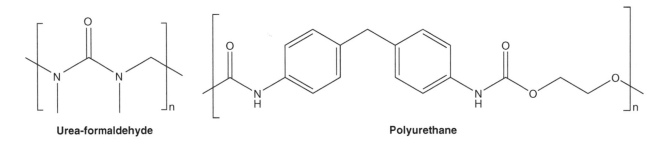

Urea-formaldehyde **Polyurethane**

There are many different kinds of polymers and it would be impossible to list all of them here. However, it is worth mentioned the two chemists, the German Karl Ziegler and the Italian Guilio Natta who received the Nobel Prize in chemistry in 1963 for working on catalysts that allowed the synthesis of polyethylene and polypropylene. Some artists are always looking for new materials to work with, and when plastics were invented, they to turn to this new type of material. The plastics that can be easily remolded into different shapes are called thermoplastic, the ones that cannot thermoset. The molecules in the thermoplastic polymer can easily slide, are flexible, recyclable, and they tend to be stretchy. These physical properties are due to the linearity or almost linearity (few branches) of their chemical structure. On the contrary, thermoset plastics are rigid, not easily recyclable, heat resistant, and hard. This is due to their chain-link fence structure where cross-connections between individual units add to the strength and rigidity of the material.

Learning Checks

1. Name one polymer produced by plants.

 Ans: Cellulose, starch, rubber.

2. The structural representations of two different polymers are shown below. Which one would most likely be a thermoset? Which one would most likely be a thermoplastic? Which one would most likely have a rigid structure?

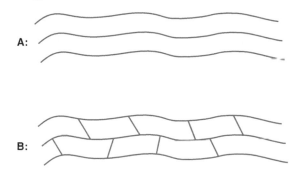

 Ans: A shows no branching between individual units, and B shows some cross linking so B is most likely to have a rigid structure and the thermoset, where A is the thermoplastic flexible one.

BIOMOLECULES

Biomolecules are molecules found in living organisms and they include lipids, carbohydrates, and proteins, which are described here. These molecules are not all polymers but many are, so this is the reason why they are presented in this chapter.

LIPIDS

Lipids are a very large family as the original definition was based on the molecules solubility, so a biomolecule is a lipid if it dissolves in a non-polar solvent. Fats, oils, waxes, steroids are all lipids although their chemical structures are quite different as we will see here. Fats and oils are esters of glycerol and one or more fatty acid. Remember that an ester is an organic compound that can be written as RCOOR, and that is made from a carboxylic acid and an alcohol. Glycerol, also known as glycerin is an alcohol with three hydroxyl groups and the following formula:

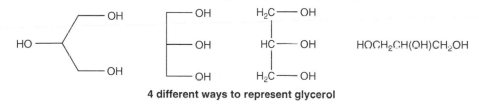

4 different ways to represent glycerol

Since glycerol has three functional groups, it can react with up to three carboxylic acids. In the case of fats and oils, the carboxylic acid is a fatty acid. A fatty acid is a carboxylic acid (RCOOH) that has a long carbon chain, usually more than 8. This long carbon chain can be saturated, i.e., there is no double bond present in the chain or it can be unsaturated, i.e., there is at least one double bond in

Table 9.1 Fatty Acids

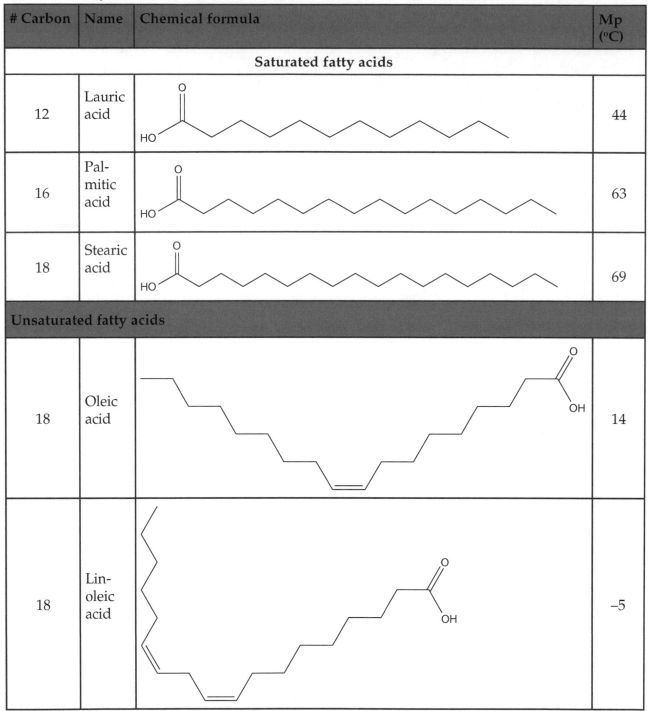

# Carbon	Name	Chemical formula	Mp (ºC)
		Saturated fatty acids	
12	Lauric acid		44
16	Pal-mitic acid		63
18	Stearic acid		69
Unsaturated fatty acids			
18	Oleic acid		14
18	Lin-oleic acid		−5

Table 9.1 Fatty Acids (Continued)

# Carbon	Name	Chemical formula	Mp (°C)
18	Lino-lenic acid	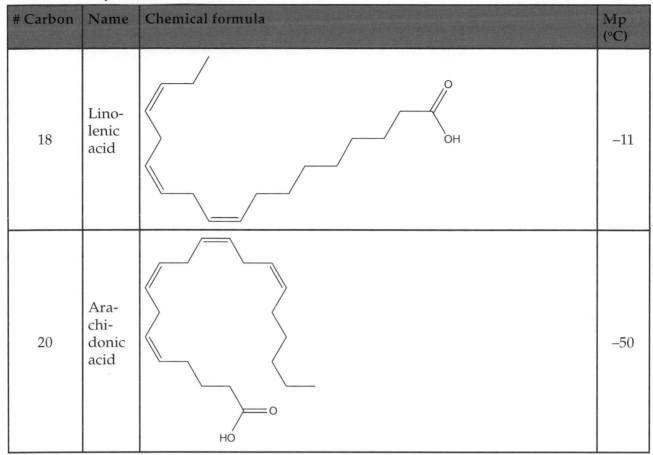	−11
20	Ara-chi-donic acid		−50

the carbon chain. Fatty acids have been given names based on what they were first extracted from. Table 9.1 shows a list of the most common ones with their chemical formula and melting point:

From looking at the data from this table, one can see that the location of the double bond can vary, which is an important nutritional fact. Everyone has heard about the omega-3 and omega-6 fatty acids that are healthy and are needed in a balanced diet. The omega symbol represents the location of the double bond on the fatty acid. So, for instance, an omega-6 fatty acid has a double bond that is located between carbon number 6 and 7 of the chain when starting the numbering from the $CH_3–$ terminal group as follows:

So, a fat or oil, both being the combination of glycerol and at least one fatty acid will have the following formulas depending on the number of fatty acids: One fatty acid makes the whole molecule a monoglyceride, two a diglyceride, and three a triglyceride.

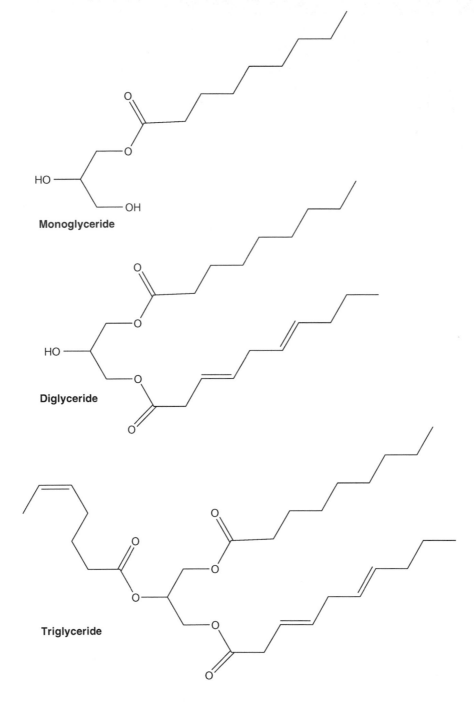

Learning Checks

1. The omega nomenclature is based on numbering from the CH_3- terminal group; basically, the carboxyl group is viewed as the end of the structure. Another method for naming fatty acids is the delta nomenclature. The delta nomenclature numbers the chain from the carboxyl group. If the following omega-6 fatty acid was converted to the delta nomenclature, how would the numbering of the double bond change?

Ans: The following structure has 14 carbons, if the carboxyl was labeled as carbon one, then it would be a delta-8 molecule instead of omega-6.

2. What do the following molecules have in common? What is different? Which would you expect to be present in an oil and which in a fat?

Ans: Both are fatty acids, and both have the same number of carbons. The top structure, however, has two double bonds (unsaturated) and the bottom has all single bonds (saturated). Since oils are mainly unsaturated fatty acids, the top structure would be most likely to be found in oil. The bottom structure is saturated, which is what fats are mainly comprised of. (The top structure is linoleic acid, the bottom is stearic acid.)

3. Draw the structure of an unsaturated fatty acid with 10 carbons, and a double bond between carbon 6 and 7.

Ans: An unsaturated fatty acid has at least one bond that isn't a single bond, and the same OH and O on the first carbon as a saturated fatty acid. So to start we draw out the chain and the ends:

We need this to be unsaturated, with a double bond between carbon 6 and 7. Counting from the first carbon it gives the following structure:

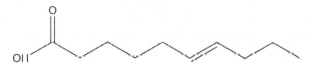

4. Draw the structure of a triglyceride composed of lauric acid, stearic acid, and palmitic acid.

Ans: The information above tells us that lauric acid has 12 carbons, stearic acid has 18, and palmitic acid has 16. Since it is a triglyceride, these three fatty acids are linked to glycerol, giving us a triglyceride with three different chains on it.

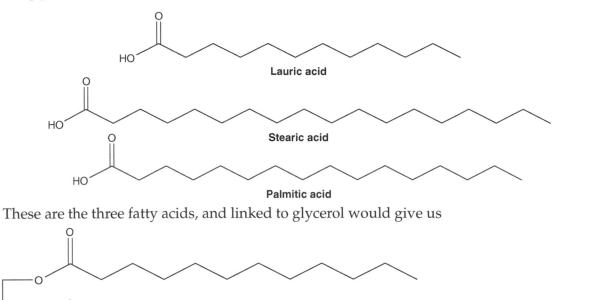

Lauric acid

Stearic acid

Palmitic acid

These are the three fatty acids, and linked to glycerol would give us

The difference between a fat and an oil resides in the nature of the fatty acids, if it is saturated, it is a fat and unsaturated, an oil. Since the melting points provided in Table 9.1 clearly show a trend that depends on the number of double bonds, it explains why fats are solid because they contain fatty acids with high melting point and oils are liquid because they contain the unsaturated fatty acid that have a low melting point.

Waxes are also esters of a fatty acid and an alcohol. This time the alcohol is a long chain alcohol, meaning it has many carbons, and the resulting high number of carbons on both sides of the carboxyl group "COO" is what gives waxes their physical properties of low melting point, smoothness, and insolubility in water. An example is shown below of a wax and what is could be made from in the laboratory:

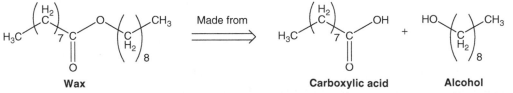

Wax **Carboxylic acid** **Alcohol**

Waxes can be of animal origin like beeswax or shellac wax, of plant origin like carnauba wax from palm trees or of petroleum origin like paraffin wax. It is important to note here that these compounds of natural origin cannot be classified at 100% as one type of molecules as by-products in smaller quantities are present as well.

Learning Checks

1. What are waxes synthesized from?

 Ans: Waxes are synthesized by condensing a long chain carboxylic acid with a long chain alcohol, forming an ester.

2. Name and draw the structure of the ester formed by ethanol and acetic acid?

 Ans: Ethyl acetate, the structure is:

 Ethyl acetate

3. What other compound is formed when ethanol and acetic acid combine to form ethyl acetate?

 Ans: Water.

The last kind of lipids that is discussed here is the steroid family. Steroids are infamous because many drugs used by athletes in illegal doping activities are called by the media, steroids. They indeed belong in this category, but many other molecules do, too. It is not our scope to talk about vitamins, hormones, and other medicines that belong to the steroid family. Just know that for a molecule to be a steroid, like cholesterol does, it has to contain the steroid ring structure like cholesterol does.

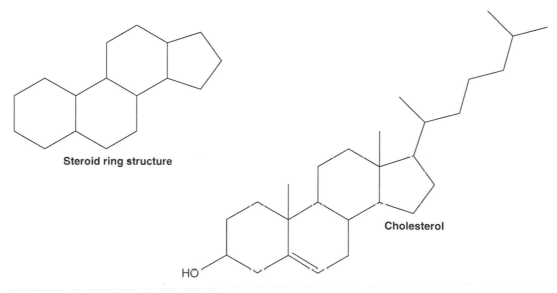

Steroid ring structure

Cholesterol

HO

So what is the connection between lipids and art? Why have we selected only a few lipids in this text? As we saw in an earlier chapter, paint binders may be made of eggs, oils, or beeswax. If the analysis of a binder in a painting has to be performed, the nature of the molecules potentially present has to be known because the analysis and the subsequent conservation treatment will depend on it. For instance, an encaustic is expected to contain waxes, an egg tempera painting will show some oils, fats, and cholesterol, since they are all present in the egg yolk, whereas the binder of an oil painting should contain mainly oils. Also the nature of the fatty acids present can inform the scientist of the type of oil that was used. It is known that poppy seed, walnut, and linseed oils were used as early as the 15th century as a paint binder, at first only in certain parts of Europe where they were locally produced. Of course, as trading between countries became more prominent and they

eventually appeared all over Europe. As suggested here, not all oils can be used in paintings, they have to be drying oils or at least semi-drying oils. The non-drying oils like olive or peanut oil cannot be used as they stay in their liquid form overtime and never seem to "dry." The drying process with the drying oils is not a true drying, like when water evaporates from a water-based paint, but an actual chemical reaction. Semi-drying and drying oils have unsaturation in the chain of the fatty acids and these double bonds get oxidized over time to create links like in a resin-type polymer that hardens and traps the pigment inside. The series of chemical reactions involved in this radical process can be simplified as the overall diagram below where two unsaturated portions of the fatty acid combine with oxygen eventually connecting them together.

This curing process may require up to two coating cycles to be completed, depending on the type of oil. If the oil has many double bonds, it will dry faster and as the number of unsaturation decreases, the time to harden increases. This explains why some artists would exhibit their recently painted work unvarnished and varnish it after the exhibit with a damar resin, for instance, once the paint is cured. Some metals present in the pigments, like cobalt, are known to speed up the curing of linseed oil, whereas some others, like zinc, slow it down.

CARBOHYDRATES

Carbohydrates, commonly known as sugars, are molecules made of carbon ("carbo") and water (hydrate). Most of them have a name that ends with "–ose" and the general formula $C_m(H_2O)_n$ with have at least three carbon atoms. This family is divided into subcategories according to their degree of polymerization: monosaccharide (from the Greek words *mono* meaning one and *sacchar* for sugar), disaccharide, oligosaccharide (from the Greek word *"oligo"* meaning a few), and the more complex polysaccharide.

The simplest monosaccharide is called glyceraldehyde; it is a triose because it has three carbon atoms, but it is also an aldose because of the aldehyde functional group. Thus, by combining these words, it can be said that it is an aldotriose. If the functional group had been a ketone, the sugar would have been a ketose.

Glyceraldehyde

A ketose with 4 carbon atoms

Table 9.2 summarizes the classification of monosaccharides.

Table 9.2 Monosaccharides

#Carbons	Name Based on Carbons	If Aldehyde	If Ketone
3	triose	aldotriose	ketotriose
4	tetrose	aldotetrose	ketotetrose
5	pentose	aldopentose	ketopentose
6	hexose	aldohexose	ketohexose

Ketopentose Aldohexose

Learning Check

1. Categorize the following structure, using Table 9.2.

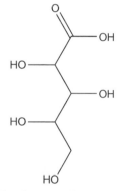

Ans: The structure has 6 carbons and a ketone functional group, making it a ketohexose.

Monosaccharides can be represented in two ways: As a Fischer projection, which is linear and shows the sugar in its open structure; or for sugars with more than 5 carbons, with a Haworth projection that represents the cyclic structure a pentose or hexose can take when it reacts with itself. An example for glucose is shown below.

Glucose

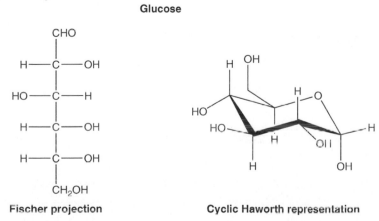

Fischer projection Cyclic Haworth representation

Most people know at least by name a few monosaccharides, like for instance glucose, also called blood sugar; galactose, which is present in cell membranes; fructose, found in fruits, or ribose, which is part of RNA and in its altered form is part of DNA.

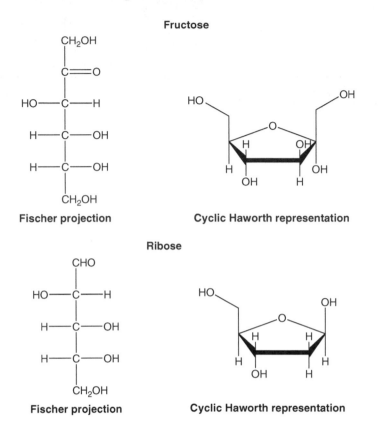

Fructose

Fischer projection

Cyclic Haworth representation

Ribose

Fischer projection

Cyclic Haworth representation

Disaccharides are drawn as their cyclic structures and are thus easily recognizable by the presence of two rings. They are made of two monosaccharides linked together with a glycosidic bond. When a disaccharide is hydrolyzed, from the Greek words *lyz*, which means to dissolve and *hydro* for water, the two monosaccharides it was made from are obtained. The nature of the glycosidic bond decides if the sugar will be digested by humans or not. Sucrose, commonly known as table sugar, is the most common disaccharide and is made of one glucose molecule and one fructose molecule. Lactose, the sugar present in milk that may indispose lactose intolerant people, is made of a glucose linked to a galactose.

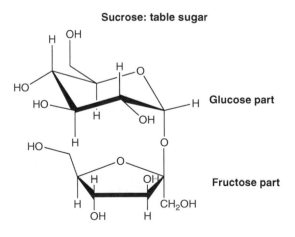

Sucrose: table sugar

Glucose part

Fructose part

Lactose: milk sugar

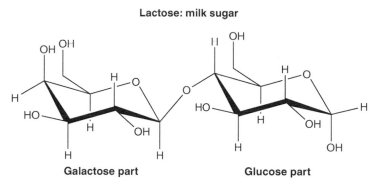

Galactose part Glucose part

Lactose intolerance is a condition that humans may suffer from as they age and lose the ability to digest lactose. It is an uncomfortable condition that can be avoided by drinking lactose-free milk or using lactase supplements, which provide the missing enzyme for the digestion of lactose. It is not to be confused with galactosemia, a more serious genetic disease present at birth that prevents the body from transforming the monosaccharide galactose into glucose, thus creating an accumulation of galactose residue known as dulcitol in the body. This can lead to mental retardation or even death if left undiagnosed.

Common polysaccharides, like cellulose, starch, and glycogen, are macromolecules made of at least hundreds of glucose units. Cellulose and starch are both found in plants, and the difference between them is the nature of the glycosidic bond between the glucose units. The glucose units in the starch are all aligned in the same way, whereas in the cellulose they alternate the way they align. This difference in the geometry creates a difference in the strength of the glycosidic bond, making cellulose a much more resistant molecule than starch. For instance, humans can digest starch, but not the fiber cellulose; therefore, cellulose can be used to make textiles or even furniture. If one were to analyze chemically a linen canvas or a piece of cotton cloth, one should not be surprised to find the presence of a polysaccharide. The structure of cellulose is provided below, showing a portion of only four glucose units connected one to another with glycosidic bonds:

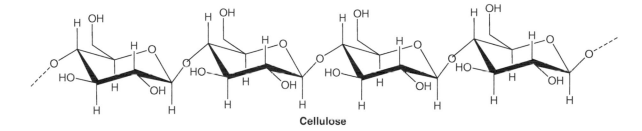

Cellulose

Carbohydrates have been used mainly in art as gums, which are produced by a wound inflicted to a plant. The most familiar gum is the gum Arabic from the acacia tree, which has been used as a binder in watercolors, gouache, or pastels. Edgar Degas (1834–1917) was a French impressionist who used pastel as a medium a lot, especially when representing his favorite subjects: the ballet dancers (Figure 9.1).

Figure 9.1 Blue Dancers by Edgar Degas

PROTEINS

The macromolecule proteins are the building blocks of life: They make up bones and muscles and transport molecules in the body such as hemoglobin and enzymes. From a chemical aspect, they are polymers whose single units are amino acids. An amino acid is an organic molecule that contains two functional groups: an amine and a carboxylic acid carried by the same carbon. Amines are basic since there are organic derivatives of the base ammonia, and acids are acidic since the proton on the carboxylic acid (RCOOH) can easily be ionized. So, an amino acid can be represented as a molecule with no charge or with charges that represent the ionized state of both the amine and the acid. In that case it is called a zwitterion.

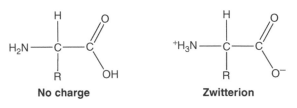

General structure of an amino acid

The carbon that carries the two functional groups also has one hydrogen atom and one side chain R whose structure determines the identity and the properties of the amino acid. There are only 20 amino acids that are needed to form all proteins in animals, so with this limited number each one of them could be assigned a name, a one-letter and a three-letter symbol (Figure 9.2).

In a similar fashion to carbohydrates, individual amino acids can link together through a peptide bond to form dipeptides, tripeptides, oligopeptides, and polypeptides. Upon hydrolysis of a polypeptide, the number of individual amino acids obtained equals their number in the original macromolecule. The molecule below has been drawn from four different amino acids (four different side chains, R_1, R_2, R_3, R_4) and thus has three peptide bonds "CO-NH".

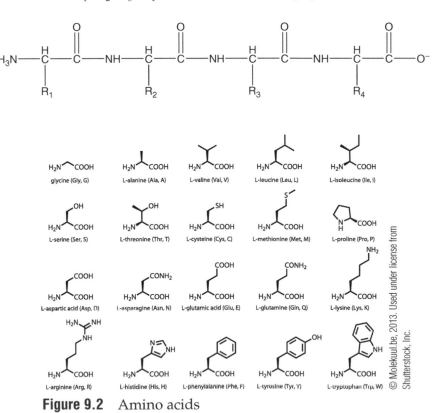

Figure 9.2 Amino acids

Learning Check

1. How many peptide bonds does the following tripeptide have? If the peptide were to undergo hydrolysis, which amino acids would be released?

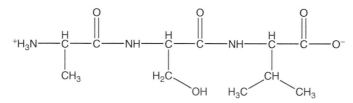

Ans: There are three side chains, so three amino-acids made this peptide and will be released by hydrolysis. There are only two peptide bonds "CONH."

The polypeptide chain described above is what forms the primary structure of the protein, which counts a total of four levels of structure. Indeed, once the polypeptide is formed, it coils in different ways that depend on the nature of the R side chains and reaches a high level of complexity outside of the scope of this book. This process will also involve the inclusion of a non-peptide portion like a metal, or a small organic molecule, often a vitamin. For instance, scurvy, the disease resulting from a deficiency in vitamin C, occurs when collagen, a protein whose synthesis requires vitamin C, is not synthesized by the body. Since collagen is part of connective tissue, the patient loses first the teeth and may eventually die of internal bleeding. A simple remedy is to absorb vitamin C on a regular basis. This disease was a serious problem for the British sailors who were at sea for extended periods of time and little access to fresh food rich in vitamin C. The solution was eventually found when they realized that eating limes from their cargo would keep them healthy.

Figure 9.3 Silkworm cocoon

When artists use egg yolk as a binder, or even egg white or milk, as it has also been reported, proteins are expected to be present. Also, most natural glues were made from animal hides, dissolved bones, fish, or even hooves, all of which are protein-based material. As an art support, proteins can be found in parchments, since they are made from animal skin, but they are also in some textiles, like silk, a fibrous protein produced by the silkworm. Figure 9.3 shows a silkworm cocoon hanging from the top by silk.

PROBLEMS

1. What does the term *polymer* imply?

2. This naturally occurring polymer can be found in all living organisms. What is it?

3. Upon heating, what do you think will happen to the following polymers?

 (a) A thermosetting (polymer). (b) A thermoplastic (polymer).

4. What is the difference between saturated and unsaturated fatty acids?

5. How many functional groups does glycerol have? How many fatty acids can be attached to glycerol?

6. Draw the structure of a 17-carbon saturated fatty acid.

7. Draw the structure of a triacylglyceride composed of arachidonic acid, oleic acid, and linolenic acid.

8. Describe the structural similarities and differences between wax and triacylglycerides.

9. Why can't humans digest cellulose?

10. What general structure do all steroids have in common?

11. Categorize the following sugars as aldose or ketose and triose, tetrose, or others.

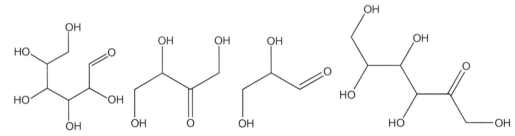

12. Categorize the sugar as an aldose of ketose.

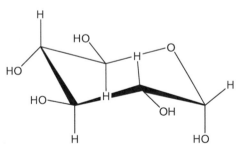

13. For the following disaccharide, circle the glycosidic bond.

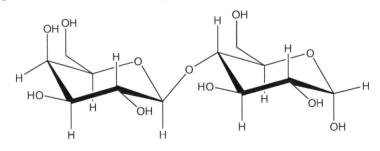

14. How many peptide bonds does the following tripeptide have? Which amino acids would be produced if the tripeptide were to undergo hydrolysis?

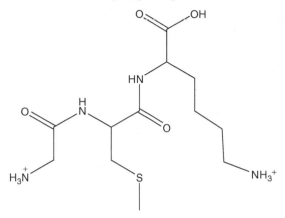

ANSWERS

1. A polymer is a large molecule composed of many repeating individual units called monomers. Polymers are macromolecules that have a high molecular mass when compared to other small organic molecules.

2. DNA is a natural polymer that exists in all living organisms.

3. A thermosetting polymers are usually liquid or very malleable. Upon heating a thermosetting polymer, it will irreversibly change the polymer from a liquid or malleable state into an insoluble, harder thermoset resin. Thermoplastic polymers cannot thermoset. This means that thermoplastic polymers will not undergo a permanent change with the addition of heat. This polymer is flexible, recyclable, can easily slide, and is usually stretchy.

4. A saturated fatty acid does not have any double bonded carbon in its long carbon chain. Unsaturated fatty acids do have one or more double bond between carbon in its long carbon chain. Since both are classified as fatty acids, then they both share a terminal carboxylic acid group.

5. Glycerol has three hydroxyl groups, so glycerol can react with up to three fatty acids.

6. Draw the structure for a 17-carbon saturated fatty acid.

7. Draw the structure of a triacylglyceride composed of arachidonic acid, oleic acid, and linolenic acid.

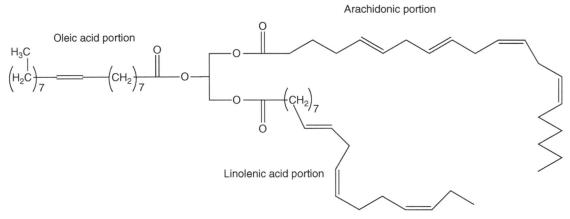

8. Fatty acids are composed of a polar carboxylic acid end and a long carbon chain that may contain one or more double bond. Waxes are esters of fatty acids and long chain alcohols.

9. Human's cannot digest cellulose because cellulose has a $\beta(1 \rightarrow 4)$ glycosidic bond linking the glucose molecules together. Our bodies do not have the enzyme that can hydrolyze such a $\beta(1 \rightarrow 4)$ glycosidic bond therefore humans cannot digest this polymer.

10. All steroids have the steroid ring structure in common.

11.

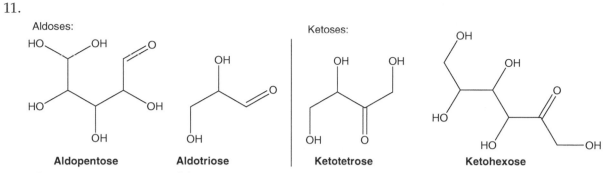

Aldoses:

Aldopentose **Aldotriose** Ketoses: **Ketotetrose** **Ketohexose**

12. The sugar given is an aldose.

13.

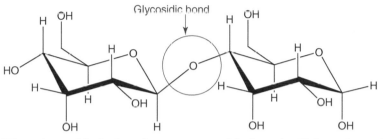

Glycosidic bond

14. The tripeptide below has two peptide bonds. If the tripeptide were to undergo hydrolysis, it would give rise to three amino acid residues: glycine, methionine, and lysine.

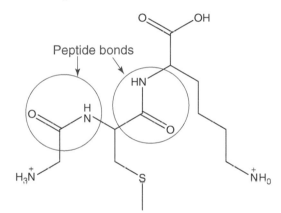

Peptide bonds

Introduction to Some Techniques Used in Cultural Heritage Analysis

The primary function of technical analysis in archeology and art is the characterization of ancient and historic materials. Scientists working in art museums or with archeologists need to use non-destructive analytical techniques in order to assess how to preserve, restore, or authenticate the works in their care. In very specific cases, however, destructive tests can be carried out on a very small, even microscopic scale. Many different types of instrumentation are employed to carry out this kind of study, but only the most common ones are discussed here.

VISUAL EXAMINATION

After a first visual examination of the object and review of the documents that accompany it, the scientist may decide to take a small representative sample, selected by avoiding areas of contamination, corrosion, plating, glazing, and so forth. A paint chip could be cut off from a painting or a fiber from taken from a piece of textile so that it can be analyzed further with a light microscope, infrared reflectance video camera, or polarized light. The analysis of a paint chip under a powerful light microscope provides information on the number of layers of paint, the presence of dust between the upper layer of paint and the varnish, or the mixing of the pigments and their particle size and shape. Pigments are usually ground into a fine powder in order to provide a strong light scattering effect in the final artwork; microscopic analysis can help find out, based on the particle size and the regularity of the shape, if the grinding was done by hand or mechanically, which is a technique much more recent. Art historians have documented the habits of famous artists, so in authentication processes the evidence on similarities of techniques known to be used by the suspected author of the work are searched for. Polarized light as seen in Chapter 1 can also be used to detect specific pigments or fibers that interact with it. The paint chip can also be stained prior to being mounted for microscopic analysis. The chemicals employed may stain different molecules in the binders in different ways, enabling the scientists to identify the binder by microscopy. Finally, an infrared-sensitive video camera can reveal underdrawings made from charcoal or a dark ink. This technique, called infrared reflectography, is based on the fact that white pigments do not absorb in this infrared area of the

spectrum but that darker colors do. Since underdrawings are often made from charcoal, they will show up as a dark area, whereas the lighter paints on top of it will be transparent to infrared light. It is quite important to observe the underdrawings from a forensics and an art history point of view because they may reveal the thought process of the artist and the *pentimenti*, which are the changes that occurred during the making of a particular piece. Another method to see through paint layers is X-ray radiography, or the similar but more modern technique of computer tomography. In the same way bones are shown on a photographic plate or computer screen, some hidden details of a painting can be exposed with this technique. The X-rays are absorbed, especially by the lead-containing pigments, leaving a white shadow revealing the under paint. However, an important drawback of this technique is that if the canvas has been primed by a layer of lead white paint, no X-ray can go through and be detected, leaving a white photographic plate. This technique is used for paintings but also for sculptures and ceramics, or mummies, because it provides information on what is hidden within the object.

ELEMENTAL ANALYSIS

Elemental analysis consists in detecting the nature and proportions of the chemical elements present in a sample, thus establishing a chemical fingerprint. Using fingerprints, samples can be compared to establish similarities or differences, leading to answers to the following questions: What is it made of? Is it the same material? Where was it made? When was it made?

Two main modern techniques are discussed here: One based on plasma and the other on X-rays. ICP, Inductively Coupled Plasma, relies on a very high temperature (7000–8000 K) excitation source that efficiently desolvates (removes molecules of solvent), vaporizes, excites, and ionizes atoms. It is a destructive method; however, because plasma sources are very reproducible and consistent, it makes this method perfect for quantitative elemental analysis. The sample is prepared by heating it in a strong oxidizing acid like nitric acid for all components. The sample is then injected into the instrument, and as the atoms enter the plasma, they get excited by the energy, eventually releasing light, whose spectrum is analyzed and correlated with known spectra of elements. The intensity of the light emitted is proportional to the quantity of a specific element in the sample, so concentrations can also be provided. Another technique using ICP is the combined LA ICP (Laser Ablation, Inductively Coupled Plasma), which does not require the digestion of a sample in a strong solvent. Instead, the laser beam removes a tiny piece of the object, which is at the same time vaporized and analyzed by the plasma as before. Because of the danger of lasers, the following sign is applied on these instruments, asking the person to wear special dark goggles (Figure 10.1).

The size of the sample removed is so small that it can be considered a non-destructive method. This fast and efficient analytical technique has been used to identify the origin of natural pigments, to provide the geographic origin of clay in ancient pottery, or to authenticate the purity of gems.

The other modern technique used to find the elemental composition of a sample is based on X-rays and is called XRF (X-Ray Fluorescence) spectroscopy. It is a non-destructive surface method, so it is used to quantify elements on the outside of an object, like the pigments in a painting, the

Figure 10.1
Warning sign
for lasers

© Fabio Berti, 2013. Used under license from Shutterstock, Inc.

composition of the alloy on a metallic sculpture, the clay in a piece of ceramic, the metallic salts used on an ancient photography, as well as other uses. It is available as a tabletop and as a portable instrument so it can be taken to a museum or to an archeological site if needed. Of course, when an instrument is made portable, there is some loss in the detection limit. With this kind of X-ray-based technique, the interaction of the X-ray beam with the atom leads to an ejection of an inner core electron that will be replaced by another electron. This replacement process will emit a radiation characteristic of the element present. Remember from Bohr's atomic model that each atom has a

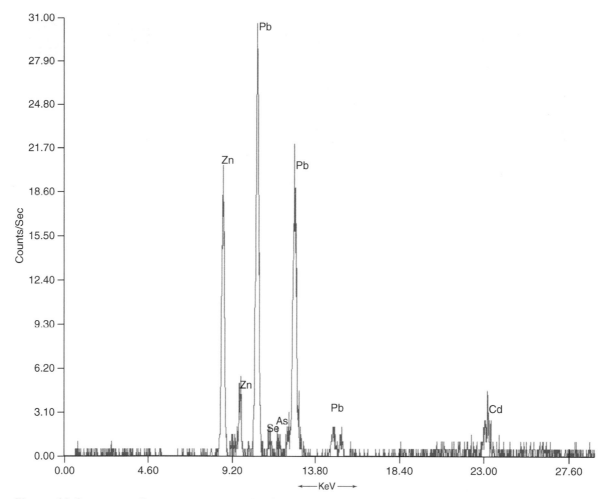

Figure 10.2 X-ray fluorescence (XRF) of a Brazilian bead

unique set of energy levels, therefore each element produces X-rays at a unique set of energies. The term *fluorescence* reflects the fact here that an element had absorbed X-rays and emitted a different kind of radiation. Figure 10.2 shows the analysis of a bead belonging to a Brazilian bracelet, showing on its surface zinc, lead, and cadmium. The unit ion the x-axis is keV (kiloelectronVolt), a unit for energy, whereas the unit on the y-axis only reflects the relative abundance of that element.

CRYSTALLOGRAPHY

When compounds arrange themselves in a fixed geometric system, called a Bravais lattice or a crystal lattice, they form what is called a *crystal*. The geometric arrangement of the atoms in the structure depends on the nature of the atoms, on their relative proportions, and on the conditions under which the crystal was produced. Atoms crystallized in a cubic and a hexagonal structure respectively are shown in Figure 10.3.

The atomic arrangement is reflected as the macroscopic level by the overall shape of the naturally occurring mineral, like the aquamarine gemstone in Figure 10.4.

The nondestructive way to analyze the crystalline structure is to use X-ray diffraction, also called X-ray crystallography. This method is based on the work of father and son Australian physicists W. H. and W. L. Bragg, who received the 1915 Nobel Prize in physics for their work. Using what is now known as Bragg's equation, they showed how to correlate the way X-rays are diffracted by crystals to their geometric crystalline structures.

Figure 10.3 Crystallized atoms in cubic and hexagonal structures

Figure 10.4 Aquamarine gemstone

THERMOLUMINESCENCE

Radiodating with carbon-14 or potassium-40 has already been discussed in Chapter 7. Another dating technique for pottery, rocks, and ceramics, although not very precise, is thermoluminescence, which is based on the fact that almost all natural minerals are thermoluminescent. Minerals store energy when exposed to ultraviolet and other naturally occurring ionizing radiation and release this energy when heated. By recording the intensity of the released energy upon heating, the time of the last heating can be found. This is of value for ceramic objects, since their making involves heating in a kiln, so it can be calculated when an item was last fired or for rocks that have been formed from the cooling down of lava. This technique, because of its simplicity, is not very accurate and therefore has to be used with great caution.

INFRARED SPECTROSCOPY

The energy of infrared radiation is too low to affect the electrons within an atom, so as seen previously it can be used to detect in a nondestructive way pigments that are darker using an especially fitted video camera. Another way to measure the interaction between the molecules and infrared radiation is to use it as a spectroscopic tool, since infrared energy corresponds to the energy required for molecular movement like translation, rotation, and vibration, which are all unique to the molecular structure. This uniqueness makes IR (infrared) spectroscopy a very powerful analytical tool for all compounds, especially organic compounds. Organic compounds are classified by their functional groups, and each of them will have a different response in IR spectroscopy. For instance, all carbonyl containing groups show a peak around 1700 cm^{-1} on the IR spectrum; all aromatic compounds display a peak right above 3000 cm^{-1} and so forth. Two spectra are shown below with the chemical formula of the compounds. On the left one, one can see peaks between 2850 and 2950 cm^{-1} characteristic of an aliphatic compound. On the right one, the same kind of peaks appear, and in addition there is a carbonyl peak around 1700 cm^{-1}.

Infrared spectroscopy is not a definitive and complete way of analyzing compounds, but it provides an idea of the functional groups present or not. For instance, the absence of a peak 1700 cm^{-1} proves there is no carbonyl group, so the compound cannot be a ketone, protein, a carboxylic acid, an ester, a fatty acid, for example but does not provide an actual final answer.

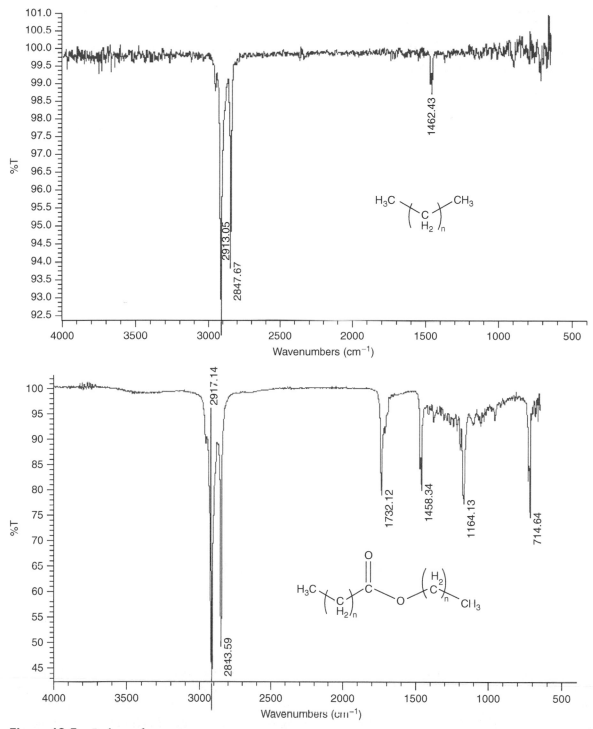

Figure 10.5 Infrared spectroscopy

Learning Check

1. Analyze the major peaks on the IR spectrum and conclude if they are consistent with the functional groups present in the molecule drawn.

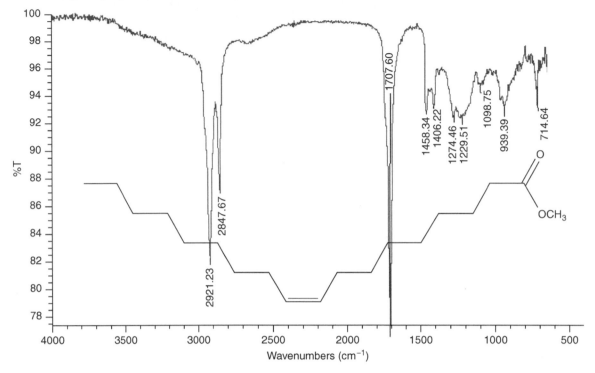

Ans: The structure has two aliphatic carbons, so there should be two peaks in the 2850–2950 cm^{-1} range. It also contains a carbonyl group, so a peak around 1700 cm^{-1} is expected. The spectrum above is consistent with the structure drawn.

GAS CHROMATOGRAPHY MASS SPECTROMETRY

Chromatography involves the separation of compounds in a liquid mixture by allowing it to pass through an extremely small column that will selectively retain specific compounds. Depending on the type of chromatography, the separation will be based on compound size, volatility, ionic strength, polarity, or other physical properties. After the separation has occurred, the compounds are injected automatically in a mass spectrometer that ionizes them, fragments them, and measures the mass of each ion produced. The identity of the eluted compound can be determined by mass spectrum, which can give molecular mass and fragment ions specific to the molecule of interest. The chromatography technique is widely used in organic chemistry and can be applied for the identification of dyes, binders, or resins. The two most common types of chromatography are liquid chromatography (LC) and gas chromatography (GC)—liquid chromatography when the solvent used in the column is a liquid

© Tanewpix, 2013. Used under license from Shutterstock, Inc.

Figure 10.6 Column in a Gas Chromatograph

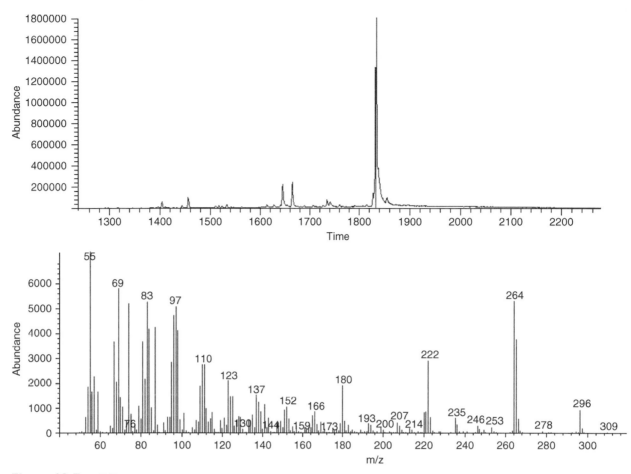

Figure 10.7 GC spectrum

and gas chromatography when a gas, like helium, is used to push the compounds through the column. Figure 10.6 shows a picture of a column inside a gas chromatograph. It might be interest to note that the column is on the order of 30 meters long and has an internal diameter of .25 mm (This is smaller than the diameter of a hair.)

In Figure 10.7 one can see the GC spectrum of a mixture with a major peak at about 18.5 minutes, which corresponds to the time it took for the compound to exit the column under these conditions. The mass spectrum below it provides the fragmentation pattern, and it can be seen that the parent peak is at 296 units (mass/charge ratio, m/z), corresponding the molecular mass of the molecule before fragmentation. The other peaks at 264, 222, 180, etc. . . correspond to the mass of the molecular fragments arising from functional group loss such as methyl alcohol (H_3COH). This, along with the other peaks, suggests to a trained chemist that the molecule is a fatty acid. Other fragment ions in the mass spectrum suggests that this is the compound is methyl oleate, a fatty acid.

In the case of the comparison of egg tempera with an oil binder, the analysis can be done without the mass spectrum and only the gas chromatogram trace is needed because the area ratio between the various fatty acids present in these two types of compounds is well defined. For instance, in linseed oil, the peak corresponding to the azelaic fatty acid is much bigger than the one corresponding to the palmitic acid, whereas in egg tempera the former is almost nonexistent. Chromatography is a destructive method since the compounds have to be dissolved prior to separation in the column, but the amount is so small that it is widely used in art forensics.

Learning Check

1. What peak correlates to the following ionized structure?

Ans: Find the molar mass of the ionized structure (101 g/mol); the peak should correspond to the molar mass. The peak that has a charge-to-mass ratio of 101 correlates to the ionized structure shown above.

PROBLEMS

1. What information can be obtained from studying a paint chip under a powerful light source?
2. Infrared reflectography can yield what sort of information about a painting? How does this process work?
3. Why and when is X-ray radiography used? When can it not be used?
4. In your own words, describe how ICP works.
5. Why is ICP so destructive and why is it used?
6. What is the difference between LAICP and ICP?
7. Although LAICP does destroy a portion of the object being studied, it is still considered a non-destructive method. Why?
8. In your own words describe how XRF works.
9. If only the outer part of an object is being studied, will only XRF be needed? What if the inner part is to be studied?
10. What are the advantages of XRF compared to ICP and LAICP? What are the disadvantages?
11. In reference to XRF, what does the term *fluorescence* mean?
12. For the XRF spectrum shown above, what are the y and x axes in terms of?
13. With respect to a crystal lattice structure, what does the arrangement of the atoms depend on?
14. How does the arrangement of atoms affect the physical appearance of the structure?
15. What is X-ray crystallography based on?
16. What is thermoluminescence based on? Is it accurate?
17. Why is thermoluminescence useful with respect to ceramics?
18. In your own words, describe how mass spectroscopy works.
19. In reference to chromatography, what factors does separation depend on?
20. What are the two most common types of chromatography?
21. If chromatography is a destructive method, why is it so widely used in art forensics?
22. What technique(s) would be appropriate to:
 - Determine the age of a cotton cloth?
 - Determine the age of a porcelain vase?
 - Determine the chemical composition of that porcelain vase?
 - Determine the identity of precious stones?
 - Determine the crystalline structure of a crystal>
 - See the underdrawing of a painting?
 - Determine the type of binder used in a painting?
 - Determine the type of canvas used (potential candidates: silk or cotton)?

23. For the following spectrum decide what functional groups are likely to be contained in its structure.

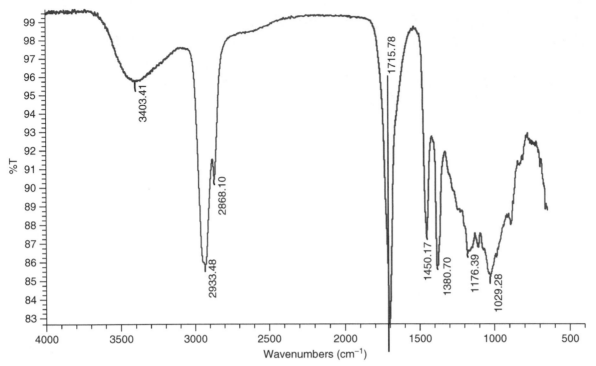

24. Identify the functional groups that are present in the following molecule.

25. Is the following IR spectrum in agreement with the structure of linseed oil? Why or why not?

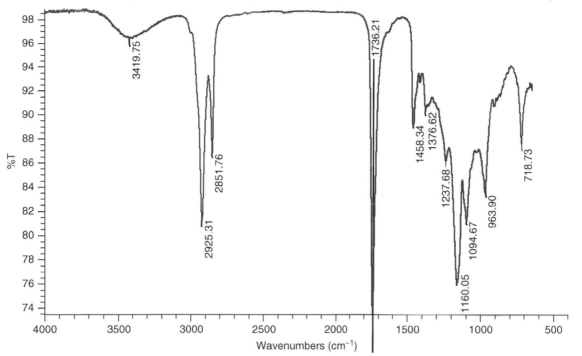

26. In mass spectroscopy, the molecular ion is an ion that has the same molecular mass as the original structure/molecule. For the following mass spectrum, which of the peaks belongs to the molecular ion (structure and molar mass provided)?

Scan 1436 (11.295 min): FAMIX1.D\data.ms

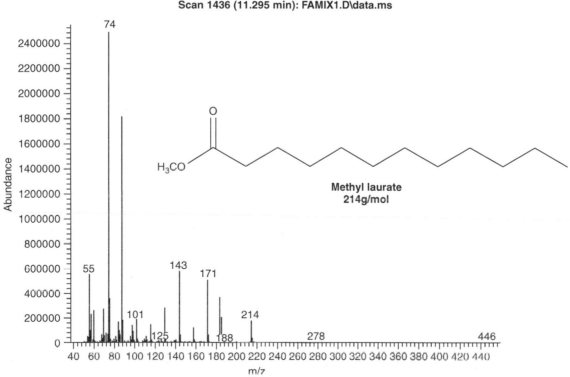

27. For the following mass spectrum, which of the peaks belongs to the molecular ion (structure and molar mass provided)?

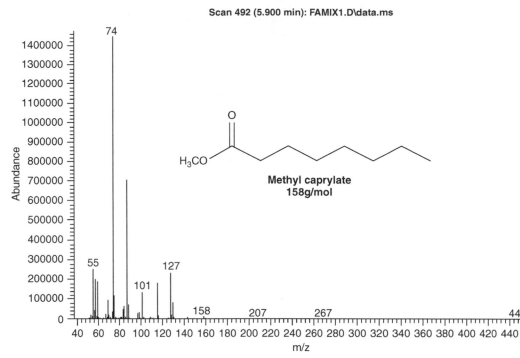

Scan 492 (5.900 min): FAMIX1.D\data.ms

Methyl caprylate
158g/mol

28. Compare the spectra of methyl palmitoleate and methyl palmitate. How are the different? How are they similar?

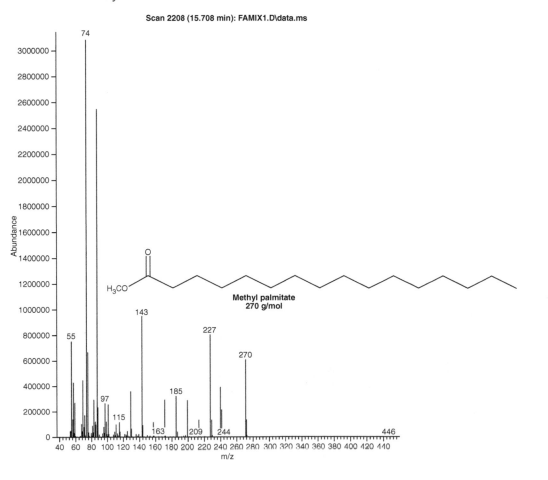

Scan 2208 (15.708 min): FAMIX1.D\data.ms

Methyl palmitate
270 g/mol

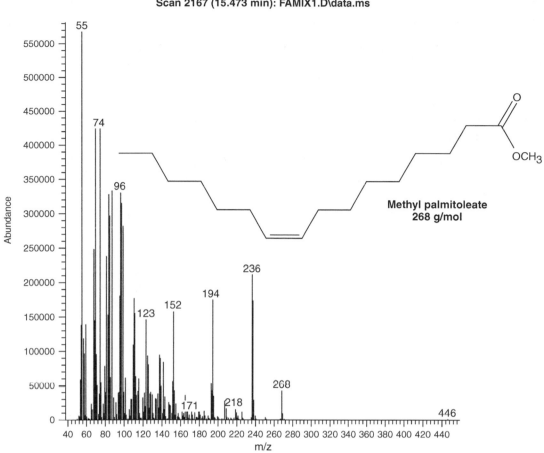

ANSWERS

1. The analysis of a paint chip under a powerful light source gives insights on the number of layers of paint, the presence of dust between the upper layer of paint and the varnish, and the mixing of the pigments and their particle size and shape.

2. Infrared reflectography is a technique involving an infrared-sensitive camera that reveals the under drawings of charcoal and dark ink in a painting. The basis of this technique is that the white pigments do not absorb in the infrared area of the spectrum, but dark ones do.

3. X-ray radiography can be used to show under-layers in a painting. This method is very similar to the way that X-rays are used to show human bones in a body. Some hidden details of a painting can be exposed on photographic plates with X-ray radiography. The X-rays are absorbed by leaded pigment, like lead-white used to brighten paints, leaving a white shadow on the radiography.

4. Inductively coupled plasma (ICP) is a technique that relies on a very high temperature (7000–8000K) excitation source that efficiently desolvates (removes the molecules of solvent), vaporizes, excites, and ionizes atoms of the painting sample. When the atoms return to their ground state after having been excited, they emit a characteristic wavelength that is recorded and analyzed.

5. ICP is highly destructive to the sample because it has to be dissolved in concentrated nitric acid.

6. Laser ablation, inductively coupled plasma (LAICP) does not require the digestion of the sample in concentrated nitric acid. A laser beam chips off a piece of the sample and vaporizes it so it can be injected in the the plasma for analysis.

7. LAICP is technically a destructive method. However, it can be considered a non-destructive method because the sample size is very small.

8. X-ray fluorescence (XRF) is a non-destructive surface method that can be utilized to find elemental composition of a sample. Some of its common uses involves the analysis of pigments that are on the outside of a painting, the composition of the alloy that makes up a metallic sculpture, the clay in a piece of ceramic, or the metallic salts used on an ancient photography.

9. XRF is great for analyzing the outer part of an object. It is not an effective method to analyze elemental composition on the inner part of an object since the X-ray does not penetrate into the object.

10. XRF is a relatively fast and efficient method that is non-destructive to the sample and that is portable. But XRF is a surface analysis. ICP is a destructive method that is usually performed in a laboratory setting. LAICP is a non-destructive method that can give rise to a highly quantitative elemental composition. ICP and LAICP are great techniques that can give an entire elemental analysis of a sample.

11. Fluorescence with respect to an XRF describes the atoms absorbing X-ray light and emitting a different kind of light. The atoms that absorb in the incoming light are "fluorescing" and giving off light as the atoms stabilize their internal energy.

12. An XRF spectrum contains a y-axis that provides the abundance of elements analyzed and an x-axis that shows the energy of the induced fluorescence (kiloelectron volts, keV).

13. The atomic arrangement for a crystalline structure is dependent on the nature of the atoms, their relative proportions, and the conditions under which the crystal was produced.

14. For a crystalline structure, the atomic arrangement is reflected as the macroscopic level by the overall shape of the naturally occurring mineral.

15. X-ray crystallography is a non-destructive analytical technique that utilizes X-ray diffraction to understand geometric crystalline structures. Atoms in the crystal diffract the X-ray based on

their relative position in the lattice. The diffraction patterns are analyzed and interpreted using Bragg's equation to elucidate the crystalline structure.

16. Thermoluminescence is a technique that is used to analyze rocks, pottery, and ceramics with a small level of precision. All natural minerals are thermoluminescent. Minerals store energy when ultraviolet light or naturally occurring ionizing radiation irradiates them. The energy from the mineral is released when heated and is proportional to the time the object was last heated.

17. Thermoluminescence is good technique for ceramics since their production involves heating in a kiln. 18. Mass spectrometry is a technique that involves a sample undergoing ionization, vaporization, fragmentation, and analysis. The mass spectrum gives the fragmentation pattern that can be analyzed to reconstitute the original molecule.

19. Chromatography involves the separation of compounds by allowing it to pass through a column that selectively retains compounds. The main factors that can affect chromatography are compound size, volatility, ionic strength, and polarity, depending if it is a liquid or a gas chromatography.

20. The two most common types of chromatography are gas and liquid chromatography. These two phases are the best to yield a desired organic molecule.

21. Chromatography is a destructive method, but it is widely used in art forensics owing to its ability to precisely identify when coupled with mass spectrometry many different dyes, binders, and resins.

22. Find the method that is best for the following:

Determine the age of cotton cloth: **Carbon-14 dating**

Determine the age or porcelain vase: **Thermoluminescence**

Determine the chemical composition of a porcelain vase: **X-ray fluorescence**

Determine the identity of precious stones: **X-ray crystallography**

See the underdrawing of a painting: **Infrared reflectography**

Determine the type of binder used in painting: **Chromatography (GC or LC)**

Determine the type of canvas used (potential candidates: silk and cotton): **Infrared spectroscopy.**

23. The infrared spectrum given shows two aliphatic carbons at peaks of 2933.48 and 2847.67 cm^{-1} and asymmetrical and symmetrical stretches, respectively. The peak at 3403.41 cm^{-1} is a stretch in a hydroxyl group. There is also a carbonyl group at 1715.78 cm^{-1}.

24. The infrared spectrum given shows two aliphatic carbons at peaks of 2929.40 and 2843.59 cm^{-1} and asymmetrical and symmetrical stretches, respectively. The peak at 3423.84 cm^{-1} is a small stretch in a hydroxyl group. There is also a carbonyl group at 1703.52 cm^{-1}.

25. Linseed oil has 3 ester groups, 6 double bound carbons, 36 CH_2 groups, and 3 CH_3 groups. It should have infrared peaks:

Two aliphatic carbon peaks in the range 2850–2950 cm^{-1}; one peak around 1700 cm^{-1} to account for the carbonyl groups in the three esters; a scissoring CH_2 peak around 1450 cm^{-1}; finally, there should be a wagging CH_2 peaks in the range 1100–1175 cm^{-1}. Based on the expected peaks, the IR spectrum given looks to be a match for linseed oil.

26. For the mass spectrum given, the molecular ion of methyl laurate is located at 214 m/z.

27. For the mass spectrum given, the molecular ion of methyl caprylate is located at 158 m/z; the loss of 31 units in the fragmented compound at 127 m/z is the loss of "CH_3O".

28. The molecular ion for methyl palmitate is 270 m/z and for methyl palmitoleate it is 268 m/z, which is easily understood since the only difference between the two structures is the presence of a double bond in the methyl palmitoleate and a double bond removes two hydrogen atoms from the structure (2 m/z).